Kurt Vonnegut, Jr was present during the firebombir
1945 when tens of thousands of its inhabitants w
in the underground meat locker of a slaughterho
and emerged the morning after the air raid to find what he called 'possibly
the world's most beautiful city' completely destroyed. Twenty-four years
later he finally published **Slaughterhouse-Five**, where he wrote: 'People aren't
supposed to look back. I'm certainly not going to do it anymore. I've finished
my war book now. The next one I write is going to be fun. This one is a
failure, and had to be, since it was written by a pillar of salt.'

CONFLICT·TIME·PHOTOGRAPHY takes as its starting point the great challenge
of looking back, considering the past without becoming frozen in the
process. It contains works made by artists and photographers from the
mid-nineteenth century to the present. Each has looked backwards from
different vantage points on moments of conflict to consider the ongoing
effects on the people and places that survive in the shadows of these
traumatic events. Rather than offering a history of conflict told through
photographs, **CONFLICT·TIME·PHOTOGRAPHY** is ordered through the act of
looking backwards. First come images made moments after the events
they depict, then those made days later, then weeks and months later, and
finally years later: photographs about conflicts made 10, 20, 50, even 100
years after the events to which they relate. The resulting sequence becomes
'unstuck in time' like the narrative of **Slaughterhouse-Five**, shifting without
warning from one moment in history to the next, following the perspectives
of those making the pictures.

Like many survivors of conflict, Kurt Vonnegut spent much of his life dealing
with its aftermath, trying to reach the point, where as he put it: 'Everything
was beautiful and nothing hurt.' Until the end of his life he continued to sign
off his texts and essays as follows:

PEACE

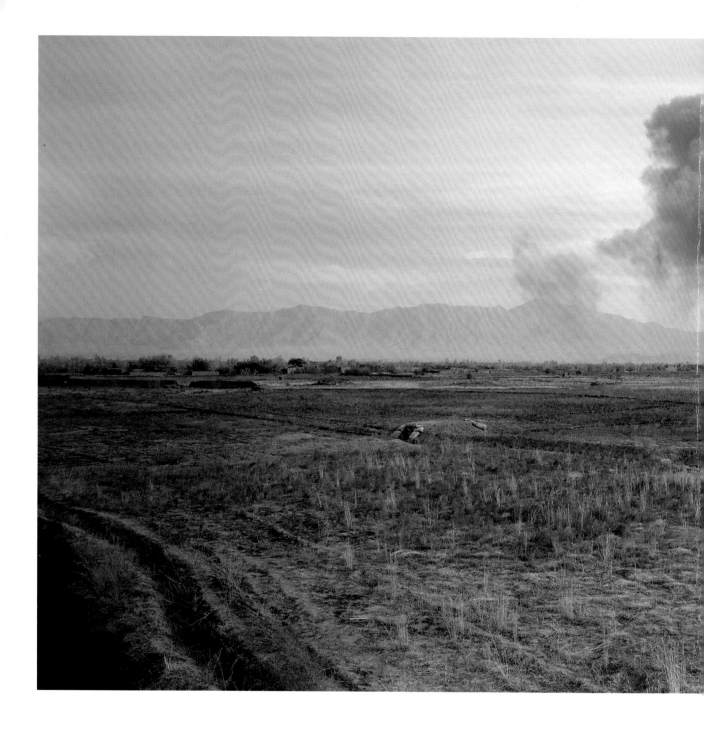

Luc DELAHAYE
US Bombing on Taliban Positions
2001

Moments afterwards, Luc Delahaye photographed the smoke rising from a US bombardment during the war in Afghanistan that began in October 2001. Having worked for fifteen years as a photojournalist in different combat zones, in 2001 Delahaye turned away from conventional reportage, employing a large-format camera to produce images with a greater scale and depth. The US-led invasion of Afghanistan began with the intensive bombing of air defences, Taliban strongholds and training camps. Over the next few months, the US continued to rely on air support and missile strikes to eradicate

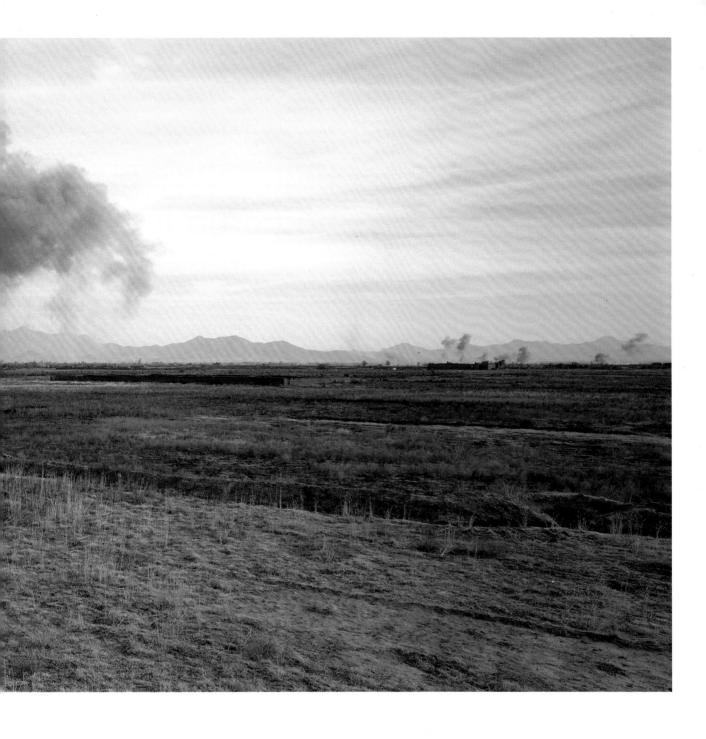

Taliban positions. Delahaye's photograph bears witness to one such attack. However, rather than the scene of chaos and violence usually associated with the reporting of a conflict, Delahaye depicts a distant plume of smoke that dissipates calmly above a deserted landscape.

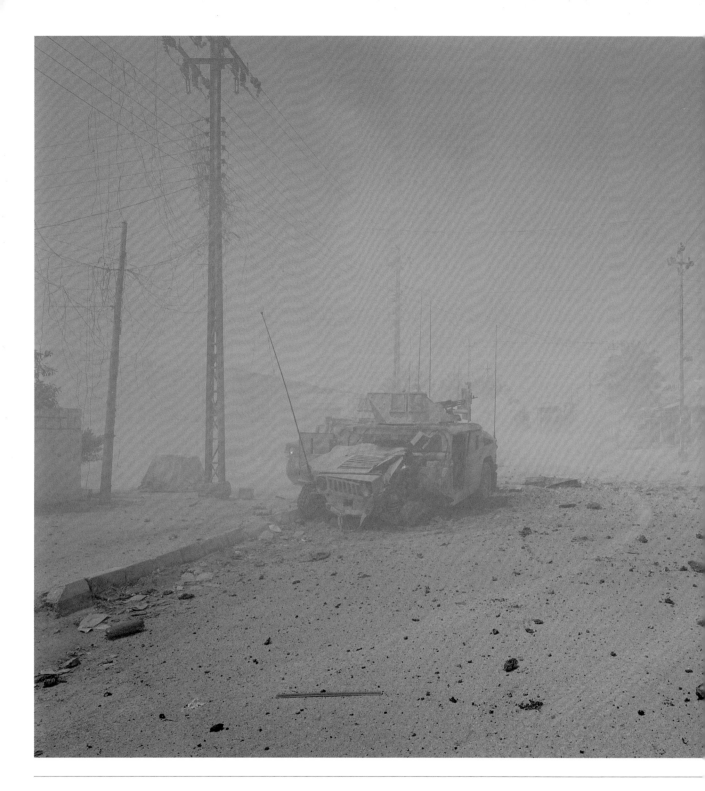

Luc DELAHAYE
Ambush, Ramadi
2006

In July 2006, seconds after an attack on US forces in Iraq, Luc Delahaye recorded the scene of destruction. Ramadi, in central Iraq, was one of the centres of the insurgency that followed the US-led invasion in 2003. Characterised by guerrilla-style attacks and the use of homemade bombs, the number of attacks on US forces intensified in the summer of 2006. In *Ambush, Ramadi*, a vast dust cloud smothers a street following the explosion of an 'improvised explosive device', or IED. With the details of the scene obscured in a thick haze, the image suggests the shock and confusion of the blast, but also an eerie sense of calm before the dust has settled.

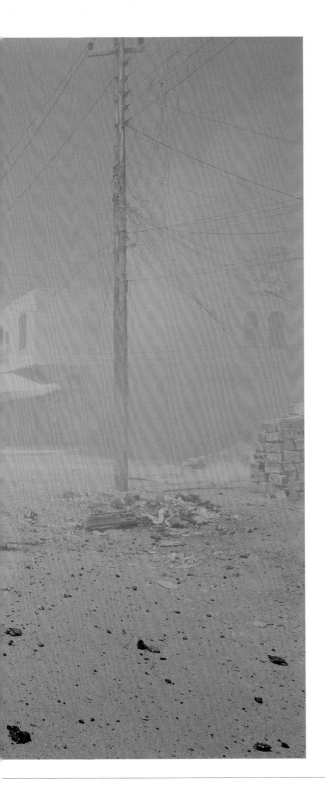

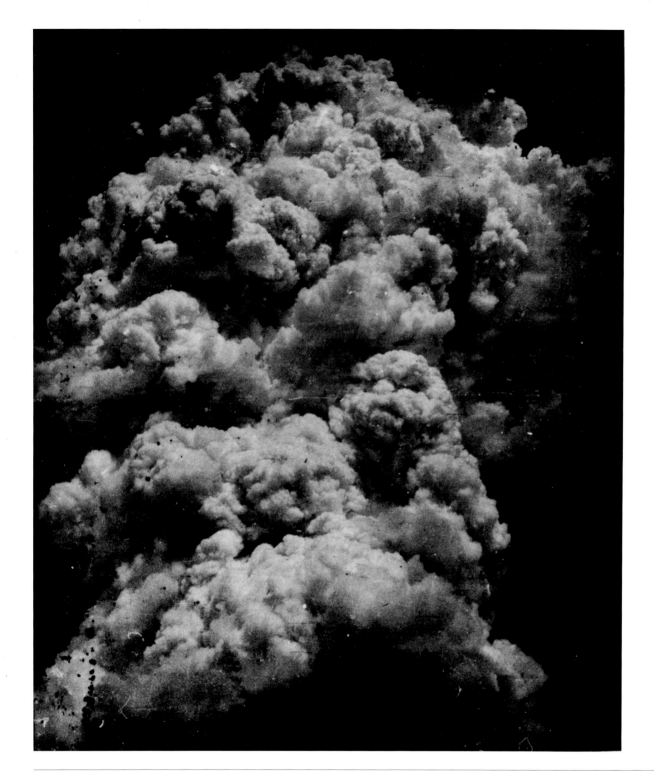

Toshio FUKADA
*The Mushroom Cloud – Less
than twenty minutes after the
explosion*
1945

On 6 August 1945,
twenty minutes after
the explosion, Toshio Fukada
photographed the mushroom
cloud produced by the atomic
bomb dropped by US forces
over Hiroshima. A seventeen-
year-old student at the time,
Fukada was working at the
Army Ordnance Supply depot
in Kasumi-cho, approximately
one mile from the hypocentre
of the explosion. Following the
intense flash of light, Fukada
ran to the second floor of the
building and photographed the
mushroom cloud hanging over
the sky. Captured here in black
and white, the mushroom
cloud was recalled by witnesses
as bright orange and pink in
colour, unlike anything they

had seen before. Fortunately
for Fukada, Kasumi-cho
was protected by the nearby
Hijiyama Hill, which shielded
the area from destruction.

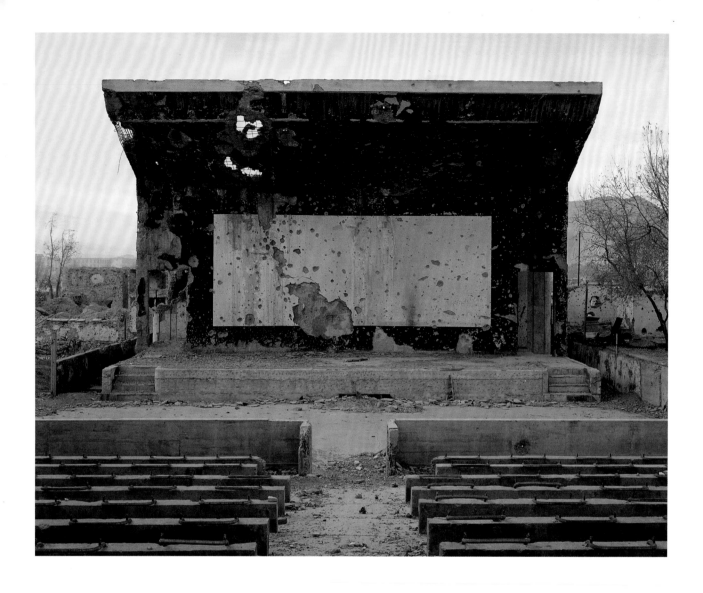

Simon NORFOLK
Afghanistan: Chronotopia
2001–2

During 2001–2, in the brief lulls between the fighting in the war in Afghanistan, Simon Norfolk made this series recording the ruins left after decades of warfare. Norfolk sees Afghanistan as a landscape marked by thirty years of conflict that includes the Soviet invasion in 1979 and the Civil Wars which followed in the 1990s. When US-led forces attacked the Taliban in 2001, Norfolk photographed the fresh destruction added to these layers of history. He has written that 'the sheer length of the war ... means that the ruins have a bizarre layering; different moments of destruction lying like sedimentary strata on top of

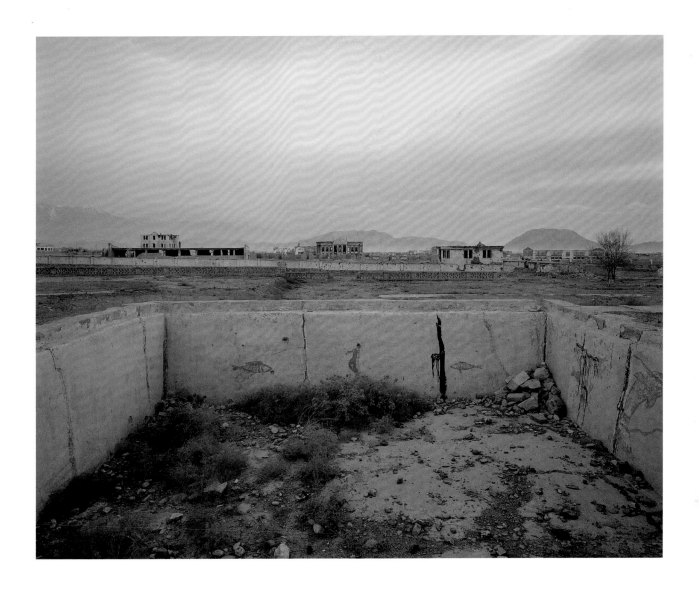

each other.' The series title
is borrowed from literary
philosopher Mikhail Bakhtin's
idea of the meshing of space
and time in literature and
art. For Norfolk, 'seeing
Afghanistan as a chronotope
can reconnect the evidence in
the landscape to the story of
human disaster.'

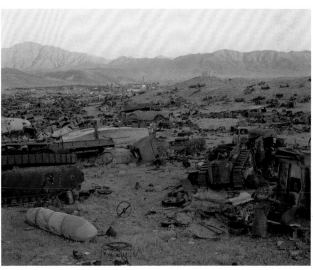

Matsumoto EIICHI
Shadow of a soldier remaining
on the wooden wall of the
Nagasaki military headquarters
(Minami-Yamate machi, 4.5 km
from Ground Zero)
1945

Between 25 August and 15 September 1945, approximately three weeks after the atomic bomb exploded over Nagasaki, Matsumoto Eiichi photographed the devastated city and its surrounding areas. Working as a press photographer for the publication *Scientific Asahi*, Eiichi photographed the aftermath of the atomic explosions in both Hiroshima and Nagasaki, focusing mainly on the damaged buildings and architecture. This image taken in Nagasaki documents the remains of a Japanese guard who was exposed to the blast while stationed approximately two miles from the hypocentre. The intensity of the explosion

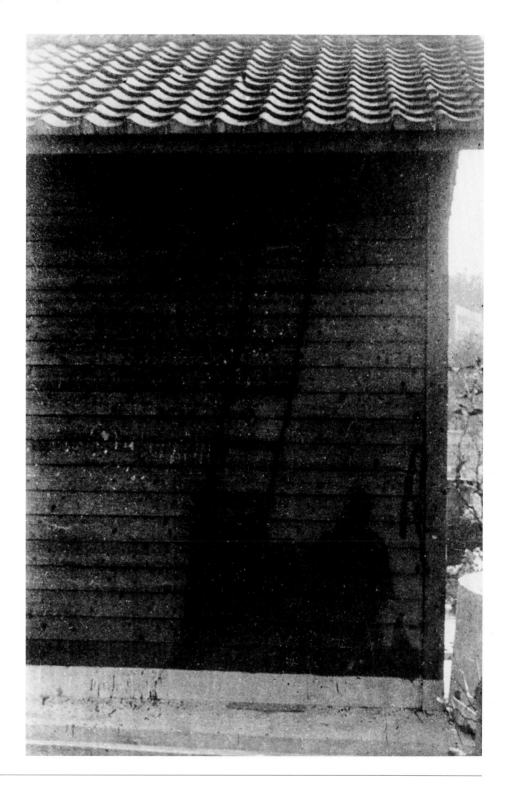

created 'burned in' shadows,
here leaving the imprint of the
guard, his sword and a ladder
that had been propped against
the building.

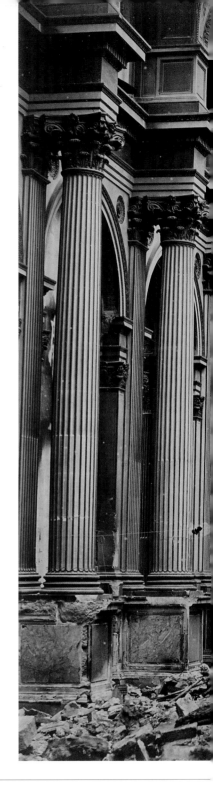

Jules ANDRIEU
Désastres de la Guerre: Hôtel de Ville, Galerie des Fêtes
Disasters of War: Hôtel de Ville, Galerie des Fêtes
1871

In 1871, weeks after the end of the Commune, Jules Andrieu photographed the ruins of Paris. Andrieu's series *Désastres de la Guerre* (Disasters of War) shows the destruction caused to Paris during the Franco-Prussian War (1870–1) and its aftermath, when the radical socialist government that took power in the city – known as the Commune – was brutally suppressed by the French army. His photographs revealed the damage inflicted upon familiar landmarks such as the Palais de Justice, the Théâtre de la Porte Saint-Martin, the Tuileries, the arsenal, and the Pont d'Argenteuil. Demand quickly grew for

ALL THAT REMAINS OF BERMÉRICOURT VILLAGE

Brimont Fort and Château

(See Itinerary, p. 134, and summary of the Military Operations, p. 154.)

Situated to the west of the road from Rheims to Neufchâtel (formerly a Roman causeway which crossed the hill at *Cran de Brimont*) Brimont was already important in Roman times. It was fortified in the Middle Ages, and traces of its ancient fortifications are still to be found on the hill. The discovery of a Roman tomb in 1790 caused considerable excitement in archæological circles, as it was believed to be the burial-place of the Frankish Chief *Pharamond* who, according to one chronicler, had been buried on a hillock near Rheims.

In 1339, during the siege of Rheims by the English, the Duke of Lancaster had his camp at Brimont.

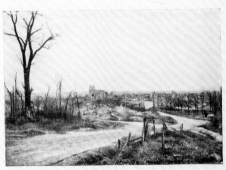

RUINS OF BRIMONT VILLAGE

In the foreground, on the left : Road to Brimont Fort. On the right : Beginning of the road to the Château (entirely destroyed).

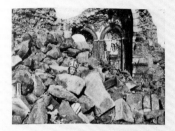

RUINS OF THE CHURCH OF BRIMONT

On several occasions, since September, 1914, the Germans deported the inhabitants of Brimont and Coucy to the Ardennes. The village is now destroyed and its church a heap of ruins.

The church was built at the beginning of the 15th century.

The four last bays of the nave, which was partly Romanesque, were altered in the middle of the 16th century.

The sacristy occupied the lower storey of the square, pointed-arch tower.

Several ancient statues were placed at the entrance to the Choir : *St Remi*, with a woman in late 15th century dress kneeling at his feet ; a *Virgin* offering grapes to the Infant Jesus in her arms (late 15th century) and a large *Christ Crucified*, dated from the middle of the 16th century. A beautiful 18th century *lectern* of carved wood, representing an eagle standing on a massive three-sided pedestal of red and white marble, stood in front of the Choir.

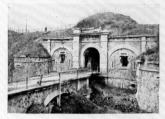

BRIMONT FORT

the same 'sights' as normal tourist guidebooks – churches, châteaux and town halls – albeit with the repeated caveats 'all that remains of …' or 'ruins of …'. In the aftermath of the war, the Austrian critic Karl Kraus wrote a furious denunciation of what he called 'Promotional Trips to Hell', lampooning the discrepancies between the well-organised tours and the appalling conflict: 'You receive your newspaper in the morning. You read how comfortable survival has been made for you. You learn that one and a half million had to bleed to death in the very place where wine and coffee and everything else are included.'

REIMS à SOISSONS

CHEMIN DES DAMES

CORBENY - CRAONNE

VENDRESSE - TROYON - CERNY - SOISSONS

BAUDET, ÉDITEUR - REIMS

SÉRIE 2

Reims à Soissons
Reims to Soissons
c.1919

The months after the end of the First World War saw an explosion of tourism in north-eastern France, with people coming from all over the world to see the battlefields and devastated villages, towns and cities. Hundreds of millions of postcards were sent home from these 'pilgrimages', as they were often described by those wishing to witness for themselves the almost unbelievable levels of destruction. The postcards produced by local photographers in places like Reims and Soissons in the so-called 'red zone', which sustained the greatest damage, are distinctive as in many cases the places depicted had

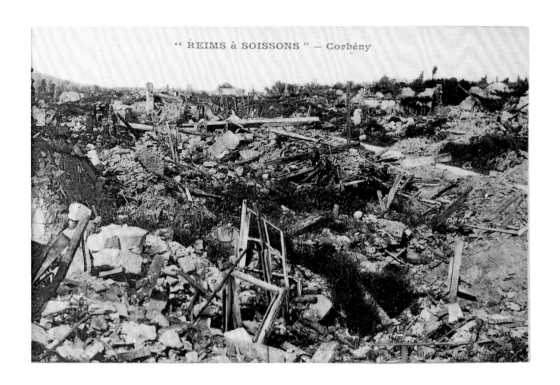

" REIMS à SOISSONS " — Corbény

completely ceased to exist. Often the captions and titles are the only means of identifying villages such as Corbeny or Craonne. To this day, Craonne remains one of the most moving monuments of the war. It was rebuilt on a nearby site, leaving the ruins of the original village to become slowly overgrown with a memorial forest in which the foundations of houses are visible underfoot.

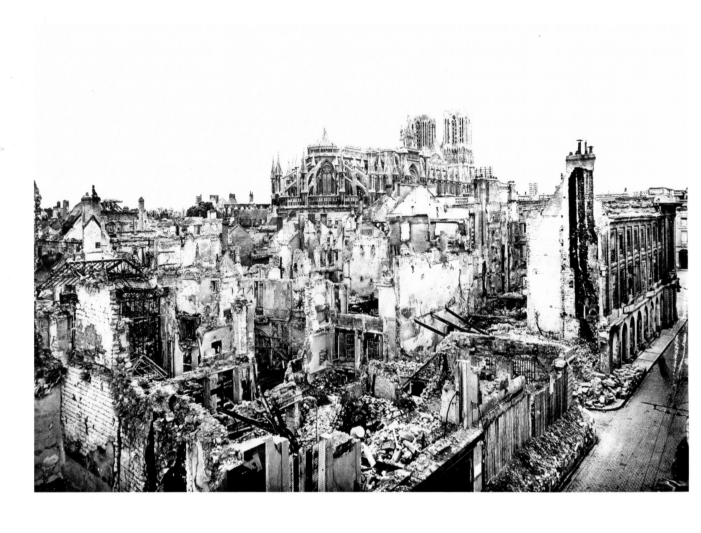

Pierre ANTONY-THOURET
Reims au Lendemain de la Guerre
Reims after the War
1927

In the weeks and months after the end of the First World War, the architect Pierre Antony-Thouret began to document the destruction of the historic city of Reims. Antony-Thouret not only took his own photographs of the devastated city and its iconic cathedral, but also collected photographs by other artists, assembling them into a luxurious portfolio. Finally published in 1927, almost ten years after the end of the conflict, all profits were intended to benefit the reconstruction of the 'mutilated cathedral', as it was described at the time. Though it evidently had no military significance, Notre-Dame de Reims was

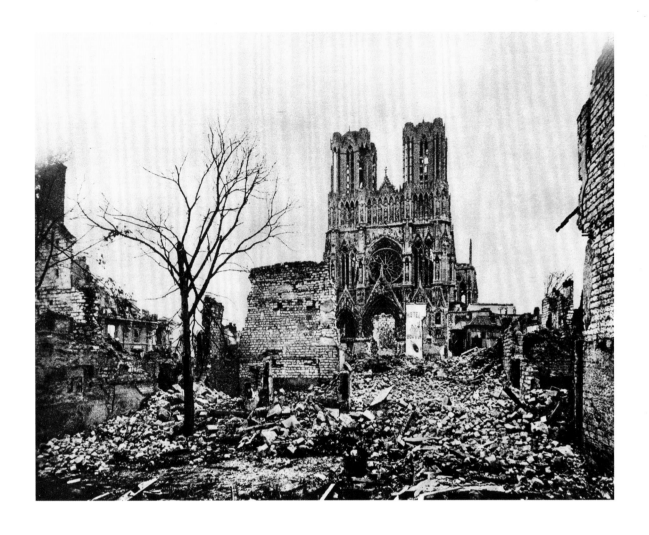

subject to repeated artillery and
incendiary bombardment from
the nearby front line, becoming
a highly emotive symbol of the
widespread collateral damage
suffered in the towns and cities
of north-east France.

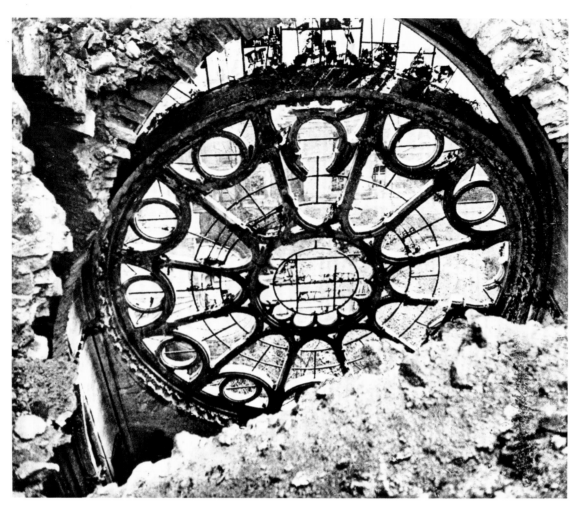

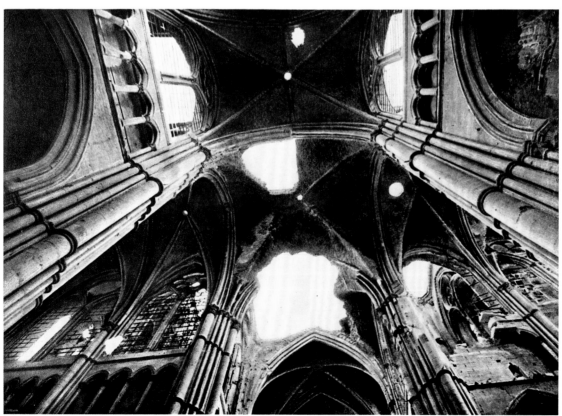

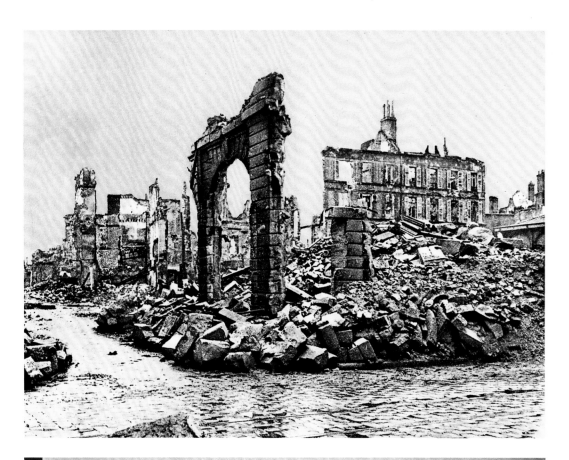

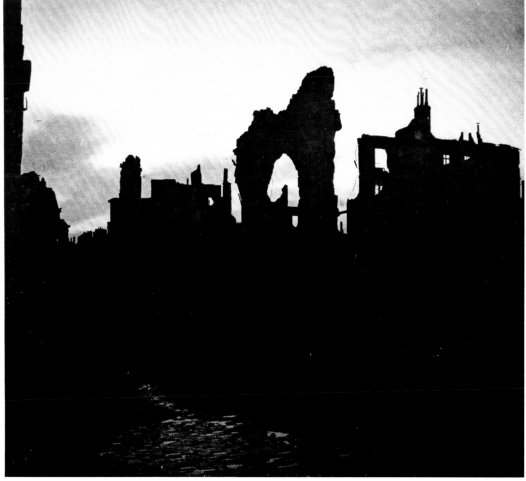

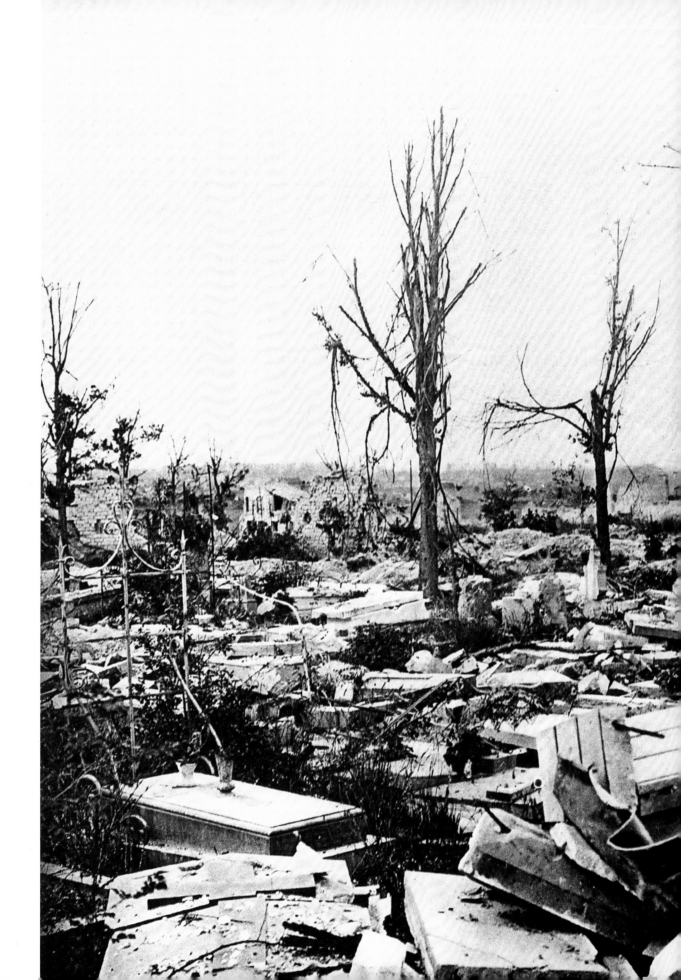

vehicle tracks and bomb craters. I was very moved by this dual abandonment of men and objects of war.' The aerial views in particular evoke the technology of modern warfare, which relies on surveillance, aerial bombardment and missile strikes. But as Ristelhueber has said: 'For me the work is not about information and it's not about that war. It's only a work about our scars.'

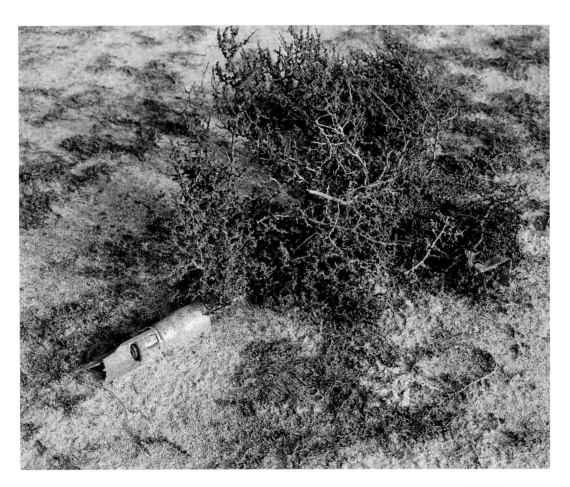

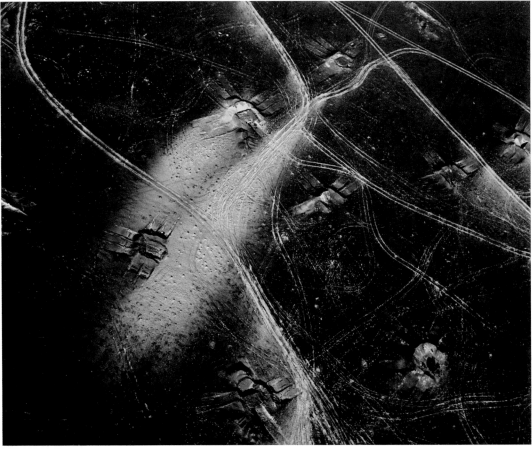

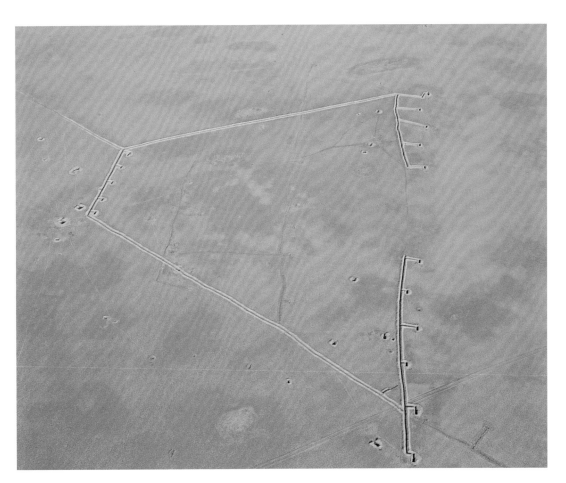

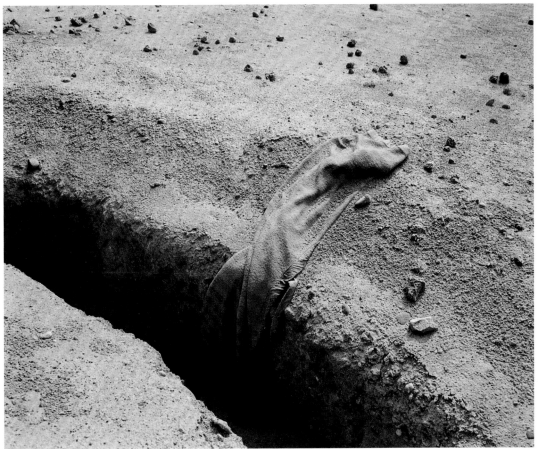

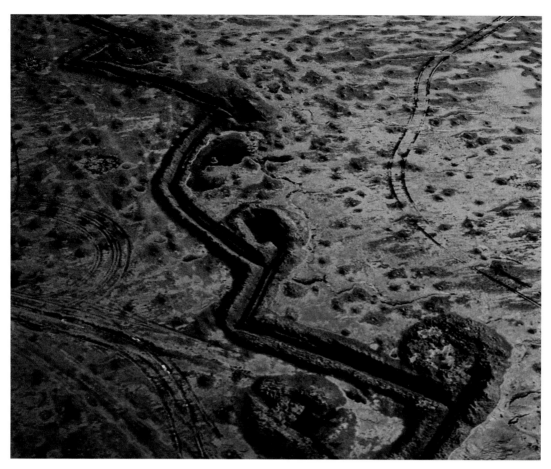

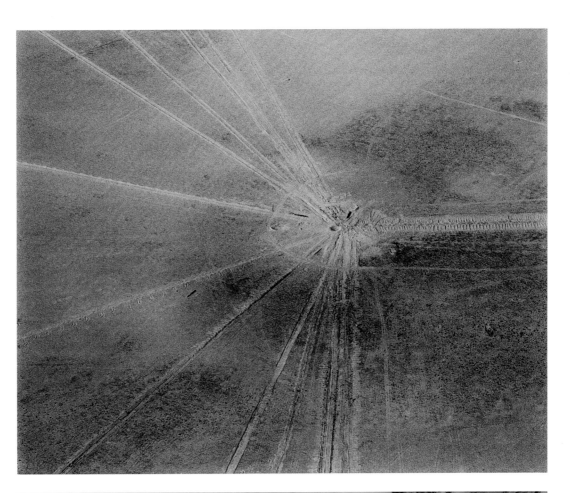

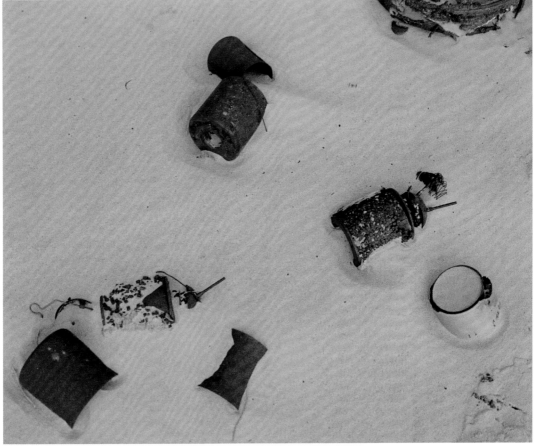

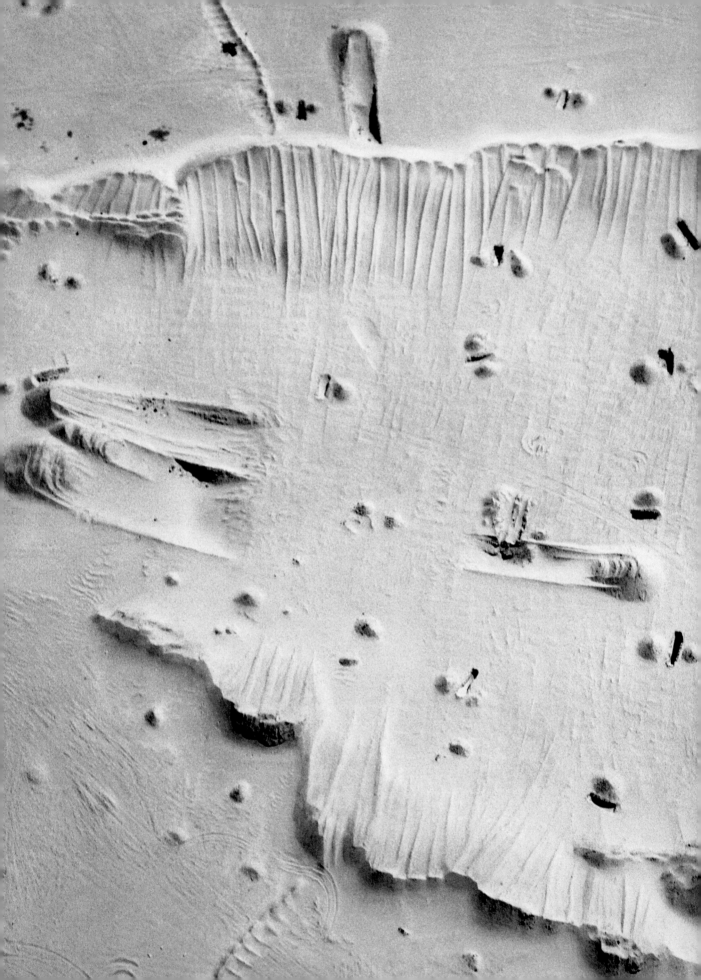

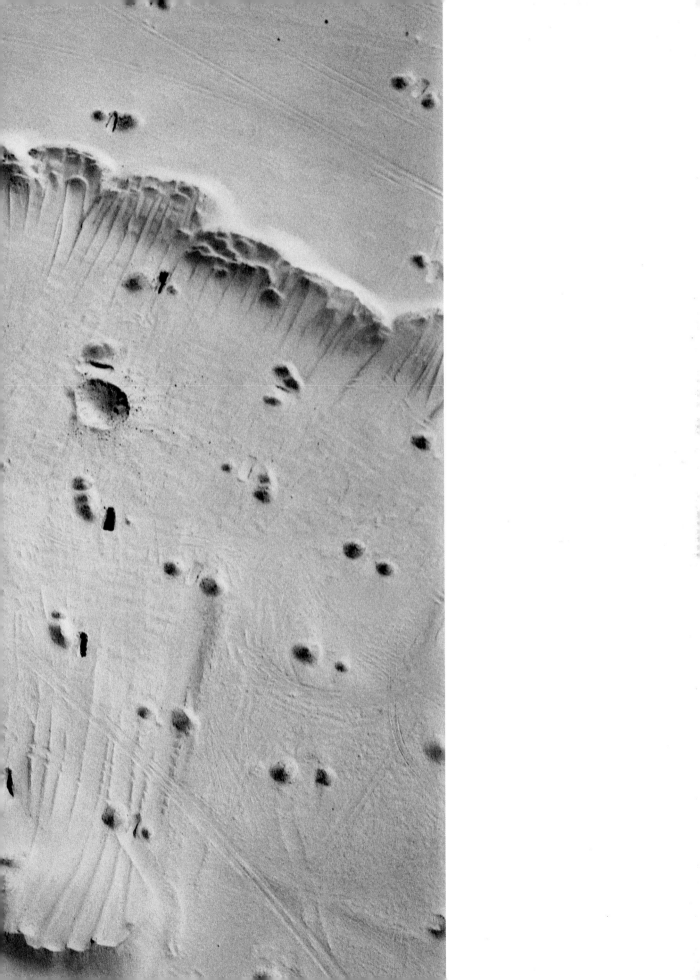

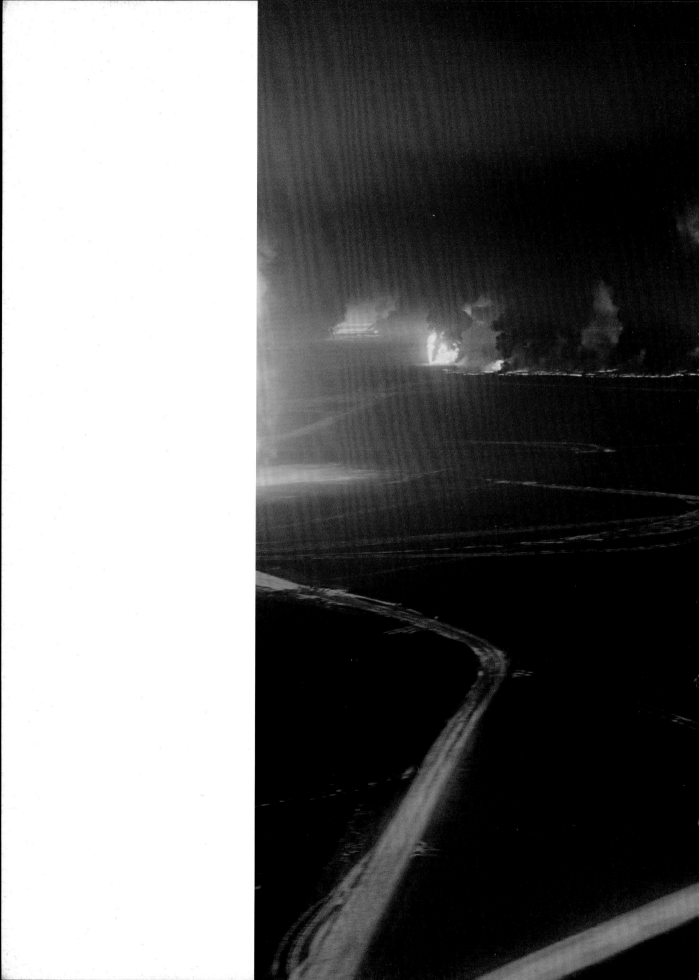

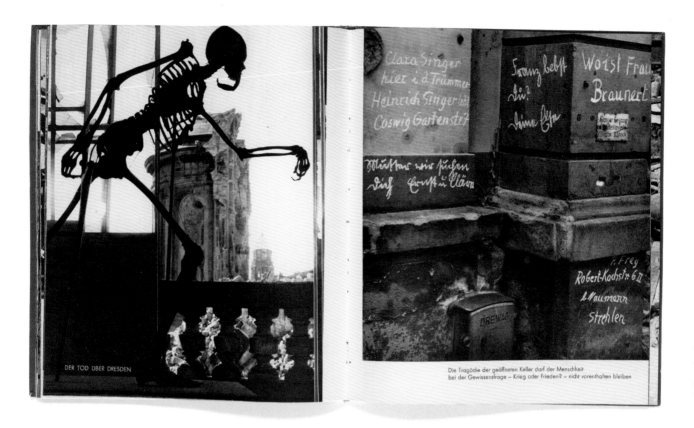

DER TOD ÜBER DRESDEN

Die Tragödie der geöffneten Keller darf der Menschheit
bei der Gewissensfrage – Krieg oder Frieden? – nicht vorenthalten bleiben

INDUSTRIE
UND HANDWERK

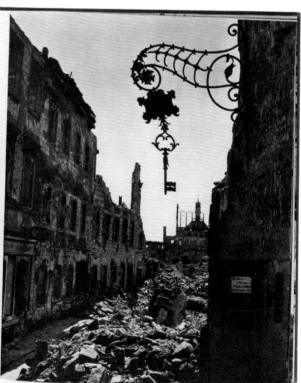

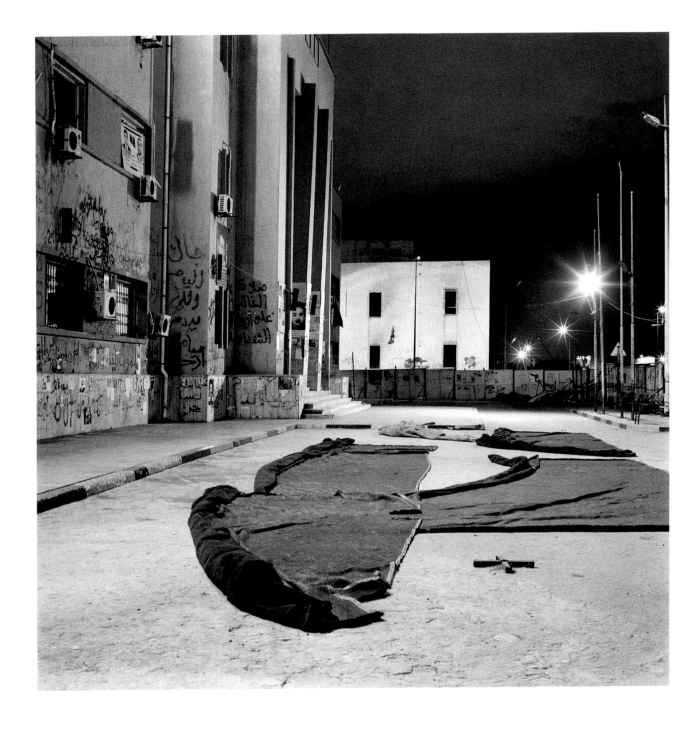

Diana MATAR
Evidence
2012–13

In 2012, seven months after the fall of the Gaddafi regime, Diana Matar travelled to Libya to photograph sites of political violence. Responding to atrocities dating from 1977 to 2011, *Evidence* presents landscape and architectural spaces where human rights violations took place during both the Gaddafi regime and the ensuing Libyan Civil War. 'As is often the case with human rights violations there is rarely any physical evidence of the crime, no body, no marked grave and no forensic proof', Matar has said. Here the images stand in as 'evidence' to acts of violence that went undocumented. The accompanying personal

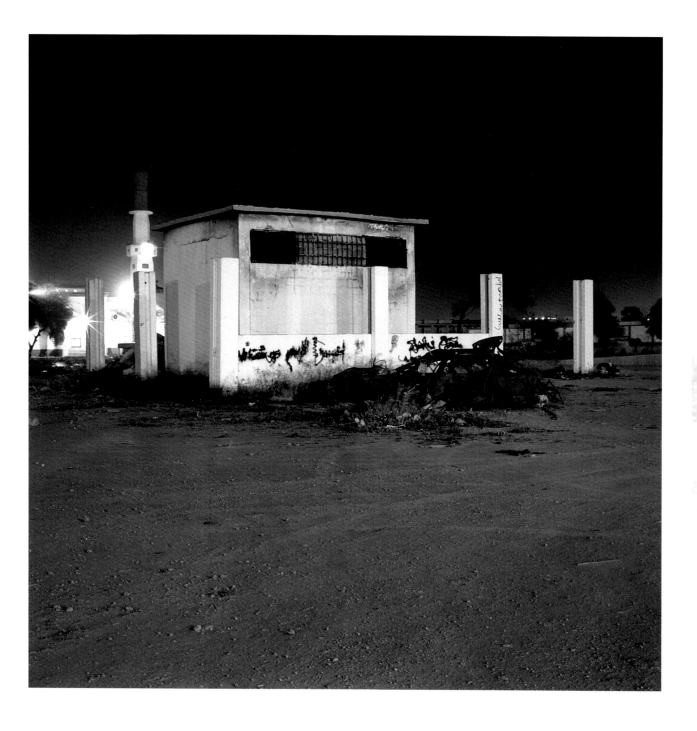

and historical text provides
a testament to the events.
Matar has described *Evidence*
as 'a response to the political
disappearance of my father-
in-law', commenting on the
effects of dictatorship not only
on a nation but equally on
family and communities.

Emeric LHUISSET
*I heard the first ring of my death
/ Homage to Sardasht Osman*
2011

On the first anniversary of the kidnapping and murder of the Kurdish journalist Sardasht Osman, a student at Salahaddin University in Iraq, Emeric Lhuisset, who was at the time resident on the campus, produced *I heard the first ring of my death / Homage to Sardasht Osman* in memory of the event. The title of the work is taken from the final article written by Sardasht in which he denounced corruption in Iraqi Kurdistan and predicted the likely consequences of his free expression of this criticism. Lhuisset's homage was produced exactly one year after Sardasht's body was found in the street with a gunshot to the

head, a murder that was never explained and for which nobody was prosecuted. The work itself consisted of an intervention in the urban spaces where the events took place. Lhuisset made photographic copies of portraits of Sardasht Osman which he left 'un-fixed' so that they would fade in contact with direct sunlight. At dawn he pasted these portraits all over the town so that its residents would wake to find the face of the murdered journalist in many public spaces. By midday, however, the strong sunlight in Iraq caused these portraits to completely fade to black, leaving more abstract and sinister memorials in their place.

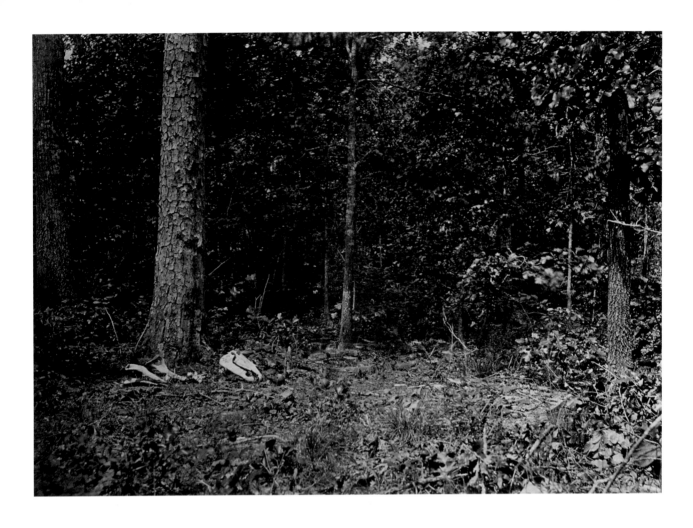

George N. BARNARD
Photographic Views of Sherman's Campaign
1866

In 1866, one year after the end of the American Civil War, George N. Barnard published the album *Photographic Views of Sherman's Campaign*. Barnard was an official photographer with General William T. Sherman's army during its 1864 march through the Confederate states. The march was intended to wreak as much havoc as possible, destroying civilian property as well as roads, railway lines, and anything that could contribute to the South's ability to wage war. Employed by the Department of Engineers, Barnard's photographs were used to assist in the preparation of maps and to record fortifications,

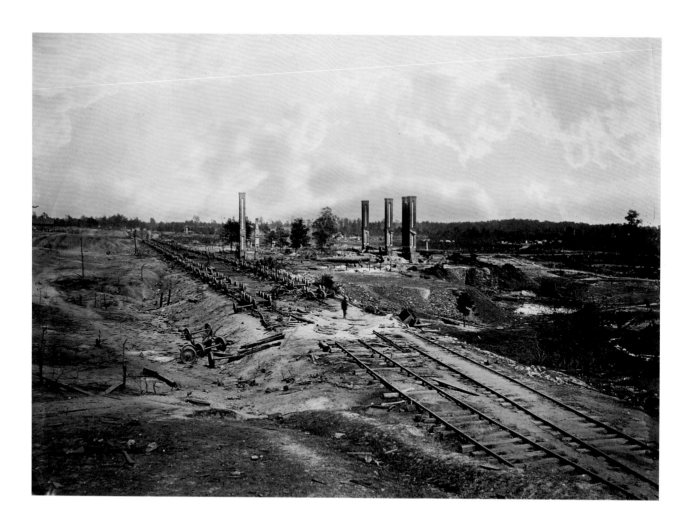

bridges and other strategically significant landmarks. Shortly after the war, he retraced the route of the campaign and took a further series of images to complete his depiction of the ruined landscapes left in Sherman's wake. He sometimes used symbolic imagery to allude to the events to which his photographs refer, such as using an animal skull to mark the scene where the Union General James B. McPherson was fatally shot from his horse.

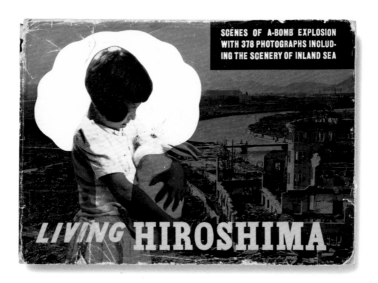

SCENES OF A-BOMB EXPLOSION WITH 378 PHOTOGRAPHS INCLUD-ING THE SCENERY OF INLAND SEA

LIVING HIROSHIMA

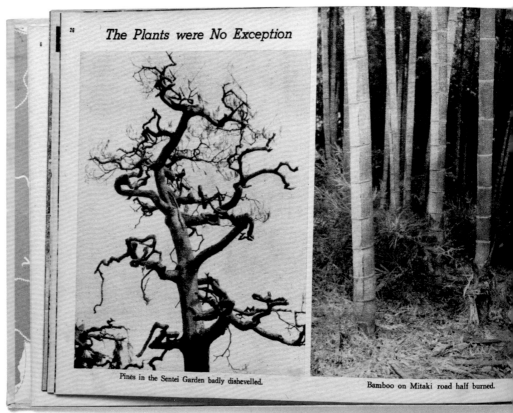

26 The Plants were No Exception

Pines in the Sentei Garden badly dishevelled.

Bamboo on Mitaki road half burned.

*Living Hiroshima: Scenes of
A-Bomb Explosion*
1948

Published only three years after the atomic bomb was dropped on Hiroshima, and while Japan was still under Allied occupation, *Living Hiroshima* is one of the earliest publications of its kind. *Living Hiroshima* offers a visual guide to the city, both as it had been in the immediate aftermath of the bomb, and as it was in 1948, after years of reconstruction. Containing nearly four hundred photographs by leading Japanese photographers, the book offers various kinds of evidence of the short- and long-term effects of both the bombing itself and the radiation that accompanied it. The text is presented in the

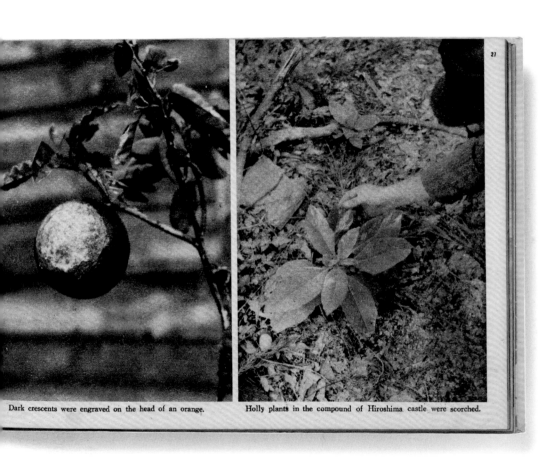

Dark crescents were engraved on the head of an orange. Holly plants in the compound of Hiroshima castle were scorched.

style of a tourist guide with a strangely positive tone that was perhaps unavoidable given the political circumstances. 'Visiting Hiroshima for the first time', Kenzo Nakajima claims in the introduction, 'a traveller would never realise that he had come to the city of the atomic bomb explosion.'

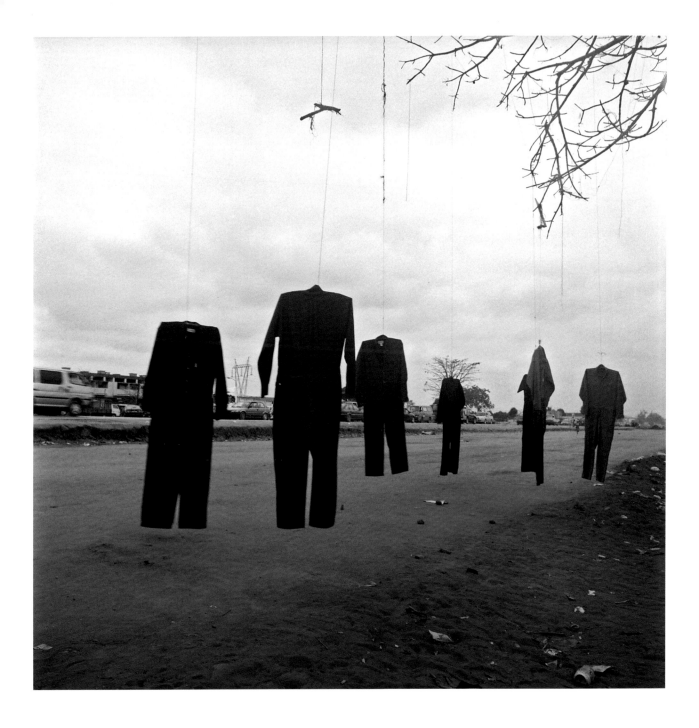

Jo RACTLIFFE
Terreno Ocupado
2007

In 2007, five years after the end of the Angolan Civil War (1975–2002), South African photographer Jo Ractliffe made a series of journeys across the border to record the aftermath of the conflict. Ractliffe's project was partly inspired by Ryszard Kapuściński's book *Another Day of Life*. The Polish journalist described the last days of Portuguese colonial rule in 1975, as rival rebel liberation movements were already tearing the country apart. The United States, the Soviet Union, Cuba and South Africa all sent military support to Angola during the ensuing twenty-seven-year conflict, which became one of the proxy sites of the Cold War. When

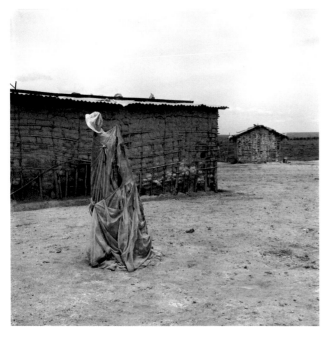

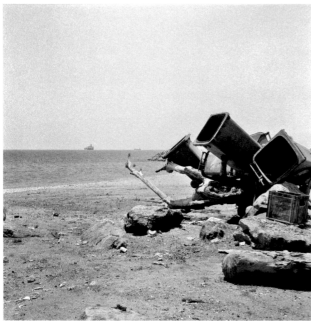

she travelled to Luanda, the capital city, Ractliffe discovered what she described as 'a landscape that appeared both medieval and postapocalyptic simultaneously – as if *Mad Max* had collided head-on with the *Canterbury Tales*.' Two areas in particular seized her imagination: Roque Santeiro – a sprawling market – and Boa Vista, the vast shantytown overlooking the harbour.

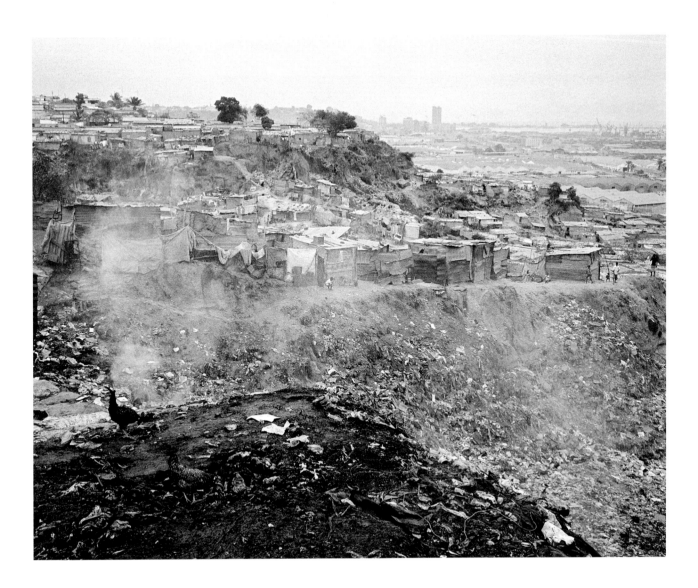

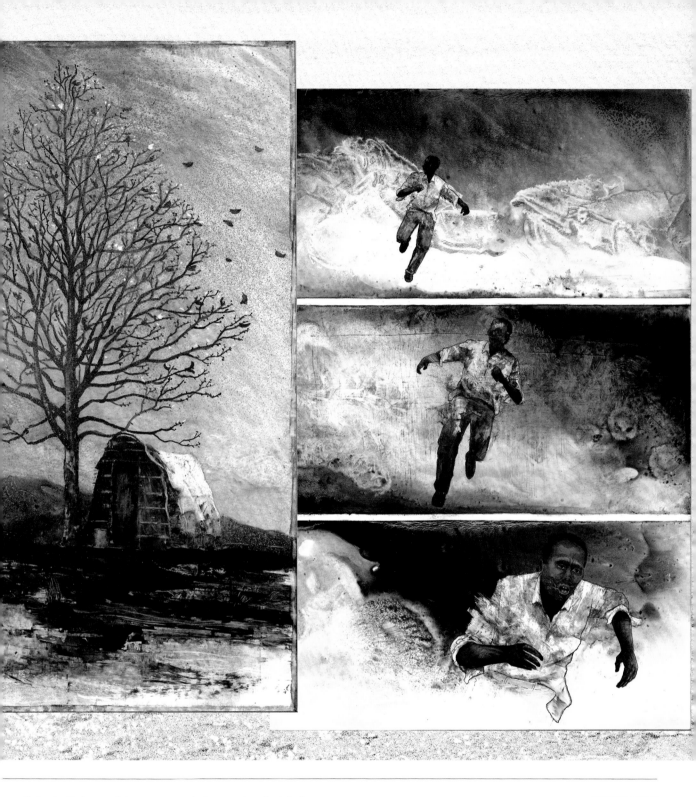

living in ditches, and then moving from one settlement to another. A large number are still wounded or crippled and continue to live in camps or with host families. Goldberg travelled to the DRC as part of his work for *Open See*, a long-term project documenting refugees, immigrants, and trafficked persons who flee their countries of origin for a safer life in Europe. For this piece, Goldberg has collaborated with France-based Algerian artist Kamel Khelif, who has created a series of drawings that illustrate Goldberg's stories of war and displacement.

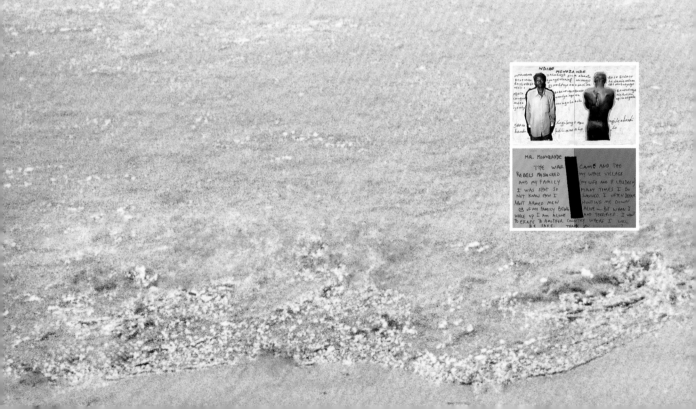

SHE WAS FROM THE

NEXT VILLAGE. SH

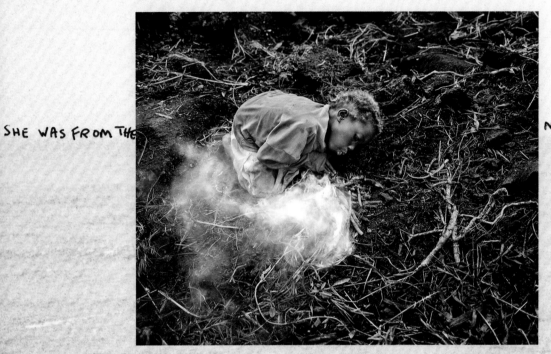

NDIHE MONOZANDE

MR. MONOZANDE
THE WAR CAME AND THE REBELS MASSACRED MY WHOLE VILLAGE AND MY FAMILY MY WIFE AND 8 CHILDREN I WAS SHOT SO MANY TIMES I DO NOT KNOW HOW I SURVIVED. I OFTEN DREAM ABOUT ARMED MEN HUNTING ME DOWN OR OF MY FAMILY BEING ALIVE — BUT WHEN I WAKE UP I AM ALONE AND TERRIFIED. I WANT TO ESCAPE TO ANOTHER COUNTRY WHERE I WILL BE SAFE. THANK YOU

'AS WORKING IN THE FIELDS WHEN THE SOLDIERS CAME

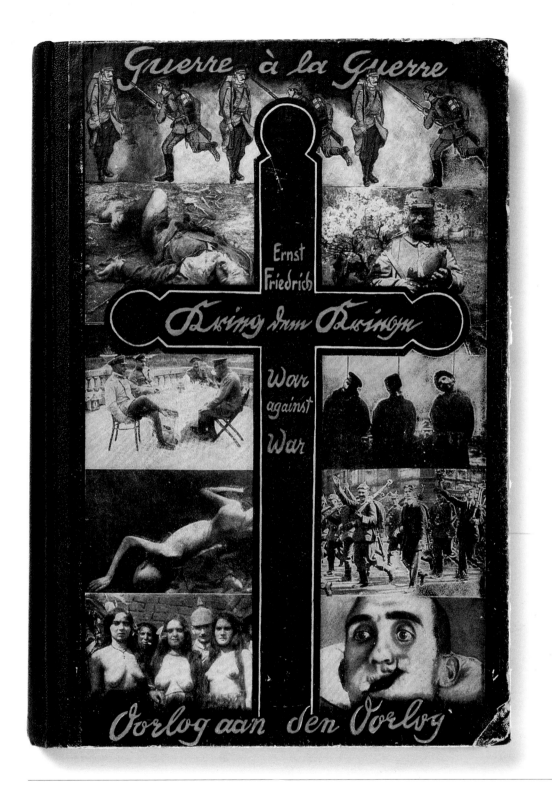

Ernst FRIEDRICH
Krieg dem Kriege
War against War
1924

In 1924, six years after the end of the First World War, Ernst Friedrich published the two-volume photobook *Krieg dem Kriege* (War against War). Friedrich was a pacifist-anarchist, who gathered material and images relating to the conflict, much of which was not generally accessible to the public. The book included text in German, English and French, with a fourth language of either Dutch, Norwegian or Russian. Originally published in two volumes, the book was later condensed into one, and by 1930 had been through at least ten editions and sold hundreds of thousands of copies. Beginning with images of toy soldiers and cannons

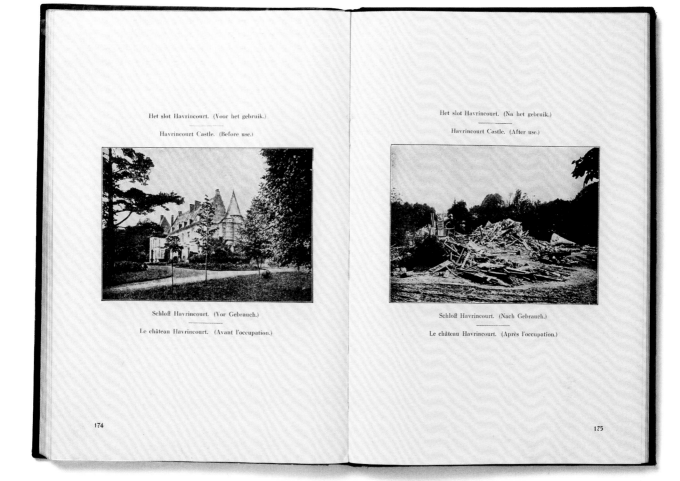

Het slot Havrincourt. (Voor het gebruik.)

Havrincourt Castle. (Before use.)

Het slot Havrincourt. (Na het gebruik.)

Havrincourt Castle. (After use.)

Schloß Havrincourt. (Vor Gebrauch.)

Le château Havrincourt. (Avant l'occupation.)

Schloß Havrincourt. (Nach Gebrauch.)

Le château Havrincourt. (Après l'occupation.)

174

175

denoting the culture of militarisation, it also featured propaganda material, military documentation, medical images of disfiguring wounds and records of atrocities, all taken out of their original context and accompanied by text to denounce the official message of the war. In 1925 Friedrich opened the Anti-War Museum in Berlin, placing the displays in a window as if it was a shop front, so that passers-by could not avoid seeing them. After the Nazis came to power in 1933, the museum was destroyed. The building became a meeting place for the SS and eventually a notorious torture chamber.

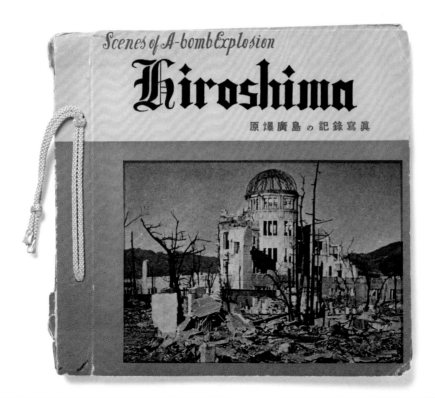

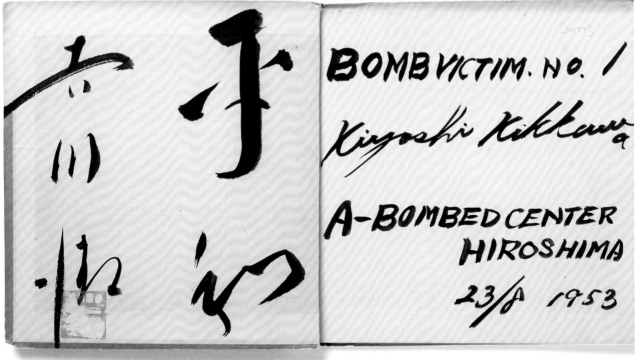

*Hiroshima: Scenes of A-Bomb
Explosion /
Hiroshima Photograph*
1953

Published in 1953, eight years after the atomic bombing of the city, *Hiroshima* is among the first publications about the attack to have been produced after the end of the Allied occupation of Japan. *Hiroshima* is a bold and direct book, which offers an unflinching account of the devastation of what is referred to as the 'city of death' and tries to communicate, in visual terms, the horror and extent of the attack. Such publications fulfilled an important function in revealing to the world the awesome impact of nuclear warfare on a civilian population, and acted as important memorials, both for those affected by the bomb

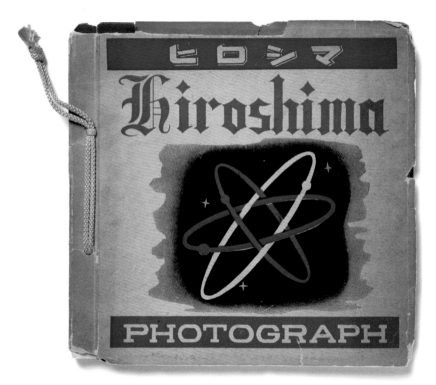

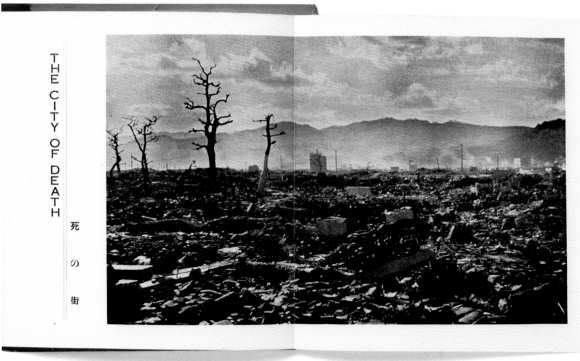

THE CITY OF DEATH 死 の 街

itself, and those who visited the site afterwards, as the inscribed copy (above left) suggests.

Marc VAUX
Untitled photograph
1924

In 1924, nine years after he was injured fighting in the French Infantry during the Second Battle of Champagne of the First World War, photographer Marc Vaux returned to the village of Aubérive in the Marne to make a self-portrait at the exact site of his injury. Vaux's postcard-like image is a time capsule of event, aftermath and personal memory. Vaux shows himself sitting by a collapsed building, indicating with an X 'the place where I was injured, shot in the right arm on the 14th October, 1915'. He also demonstrates the effects of the passage of time since the end of the war, drawing arrows on either side of the

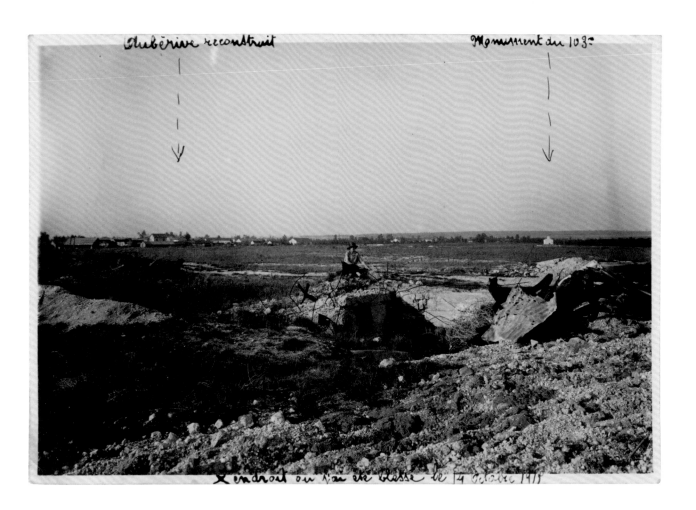

photograph from captions showing the reconstructed village of Aubérive, and the newly completed monument to the 103rd French Infantry Regiment. After the war Vaux became a celebrated photographer, living and working in the same studio buildings as Pablo Picasso and Amadeo Modigliani, and earning himself the nickname 'the painters' photographer'.

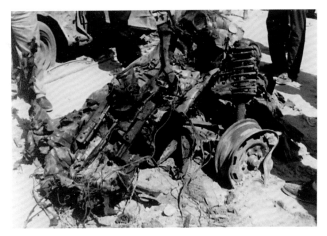

Date 3 August 1990
Photographer Unknown
Original Archive Arab Documentation Center (Beirut, Lebanon)
Notes on Back Lebanon_Internal Affairs

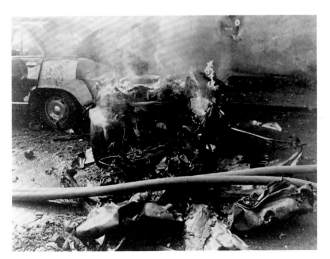

Date 8 March 1989
Photographer Unknown
Original Archive Arab Documentation Center (Beirut, Lebanon)
Notes on Back Lebanon

Walid RAAD, The Atlas Group
My Neck is Thinner than a Hair:
Engines
2000–3

In 2000, nine years after the end of the Lebanese Civil War (1975–91), artist Walid Raad compiled this installation exploring the aftermath of car bombs in Beirut. Raad's imaginary-turned-actual foundation The Atlas Group 'seeks or produces documents … that shed light on the contemporary history of Lebanon'. Between 1975 and 1991, 245 car bombs exploded in major cities in Lebanon, remotely detonated by various religious and political factions, killing thousands of people. The cars' engines tended to be the only part of the vehicle to remain intact, though the blast would often hurtle them far from the site of the

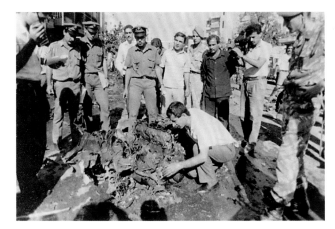

Date 14 October 1988
Photographer Unknown
Original Archive Arab Documentation Center (Beirut, Lebanon)
Notes on Back Lebanon explosions

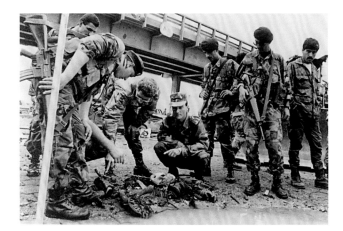

Date 21 March 1991
Photographer Fadl Fares
Original Archive Arab Documentation Center (Beirut, Lebanon)
Notes on Back Lebanon_Internal Affairs

explosion. This work consists
of a grid of 100 images of these
engines taken from press
photographs, with handwritten
notes recording the date and
photographer.

**Adam BROOMBERG and
Oliver CHANARIN**

*People in Trouble Laughing
Pushed to the Ground*
2011

In 2011, thirteen years after the Good Friday Agreement, artists Adam Broomberg and Oliver Chanarin produced a series of images derived from the era of the Troubles in Northern Ireland. The Troubles are generally seen as lasting from the late 1960s to the Good Friday Agreement in 1998. In 1983, a group of photographers from across the sectarian divide formed Belfast Exposed to show life in the city from the inside. They also established an archive to preserve hundreds of thousands of images taken by both professionals and amateurs. The archive has become an important resource for researchers, editors and historians and, whenever

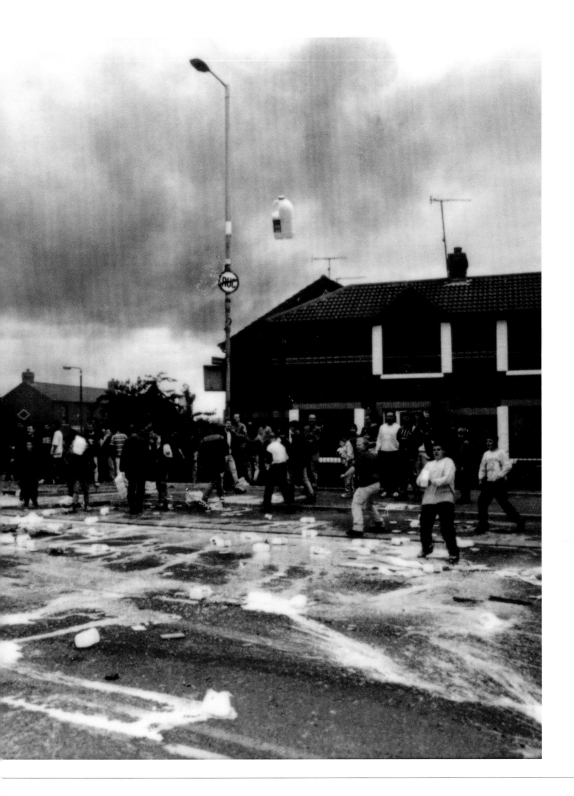

images are selected for use, the contact sheets are tagged with blue, red or yellow dots. Broomberg and Chanarin looked out for these markers and in *People in Trouble Laughing Pushed to the Ground* reprinted the fragmentary details covered over by the stickers. This idiosyncratic method of selection restores to view moments in time ordinarily concealed by archival processes.

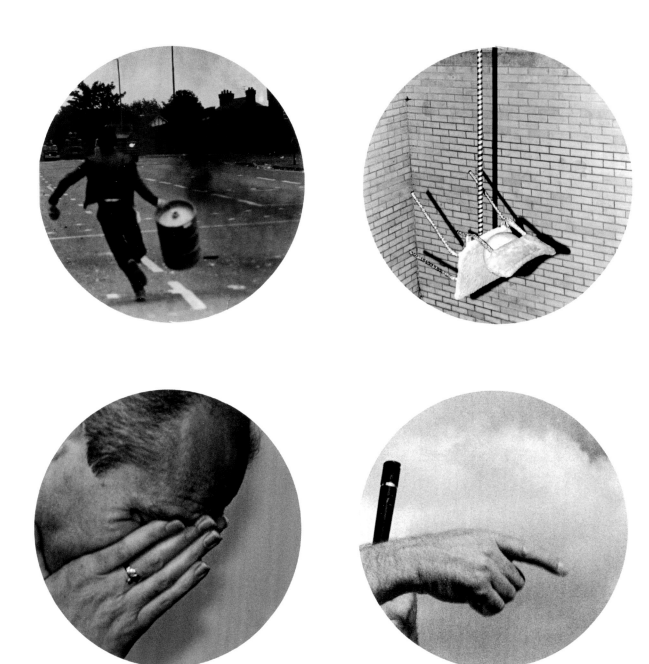

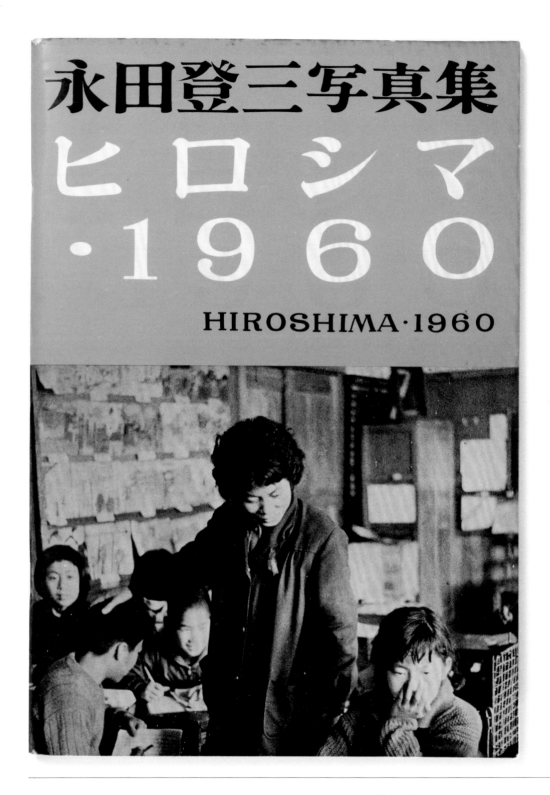

Hiroshima 1960
1960

Published fifteen years after the event, *Hiroshima 1960* is part of a series of small format magazine-style publications called 'Unforgivable Times: Collection of Photographs for the Defence of Democracy', produced by a photographic collective that included Shigeichi Nagano, Hiroshi Kawajima and Shozo Sato.

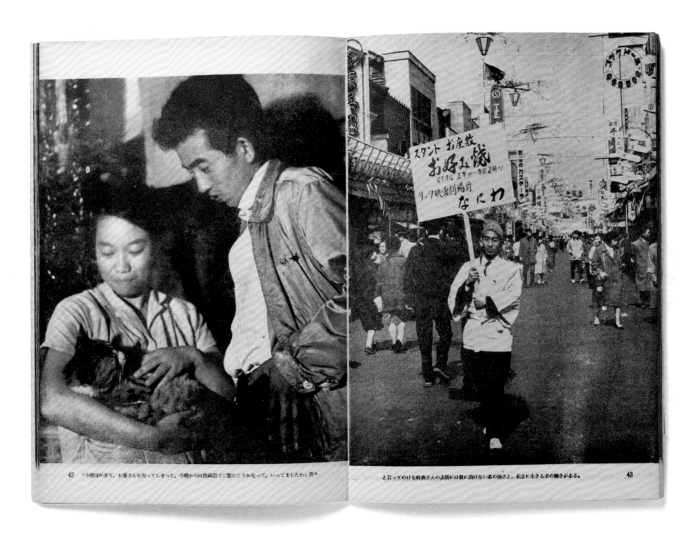

42　「今朝はお米で、お釜さんを売ってしまった。今後からは兵面器でご飯たこうかなって、いってましたわ」浜々

と言ってのける時恵さんの表情には誰に負けない愛の強さと、信念に生きる者の輝きがある。　43

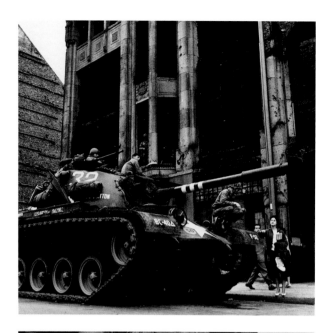

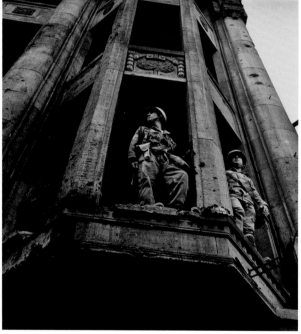

Don McCULLIN
Berlin
1961

In 1961, sixteen years after the end of the Second World War, Don McCullin travelled to Berlin to record the construction of the Berlin Wall. In July 1945 the Allies agreed to divide Germany into four occupied zones, controlled by Britain, the US, France and Russia. The three western areas later formed the Federal Republic of Germany, while the Soviet-controlled zone became the German Democratic Republic. Berlin, located within the Soviet zone, was similarly divided. When the border between East and West Germany was officially closed, it remained relatively easy to cross over in Berlin. In 1961, after a fifth of East

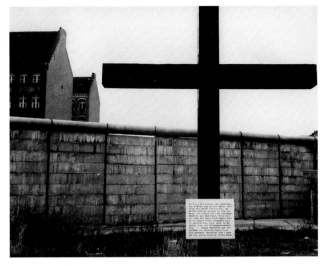

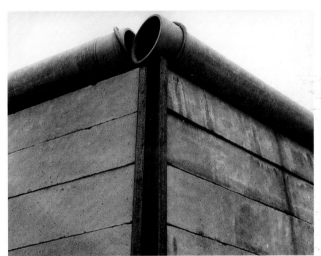

later built up as a forbidding
concrete wall that came to
symbolise the 'Iron Curtain'
separating Western Europe
and the Eastern Bloc during
the Cold War. These formal
studies of the architecture and
concrete construction show
the static landscape around the
wall, with its checkpoints and
watchtowers.

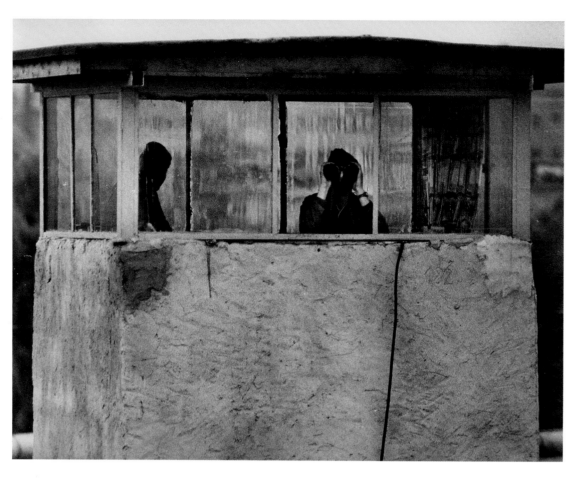

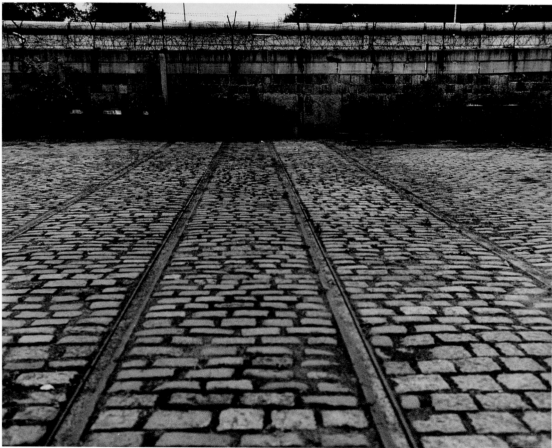

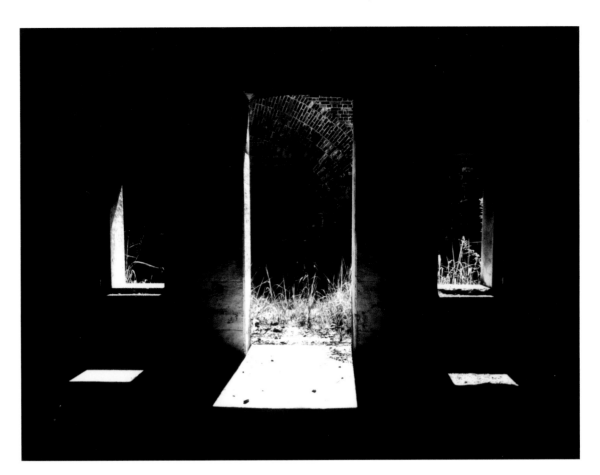
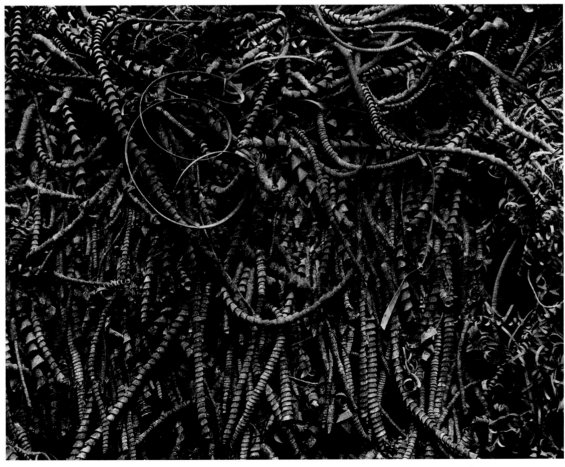

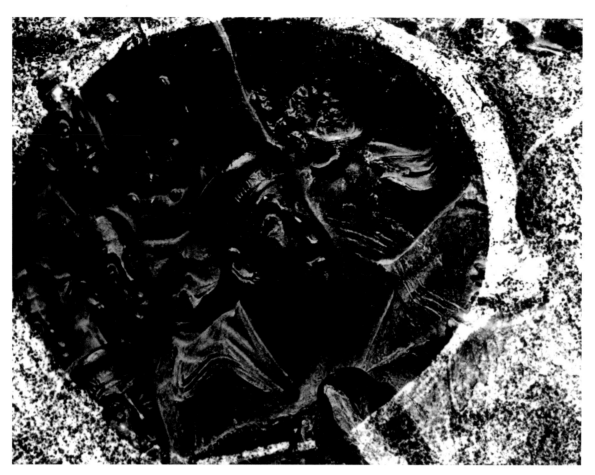

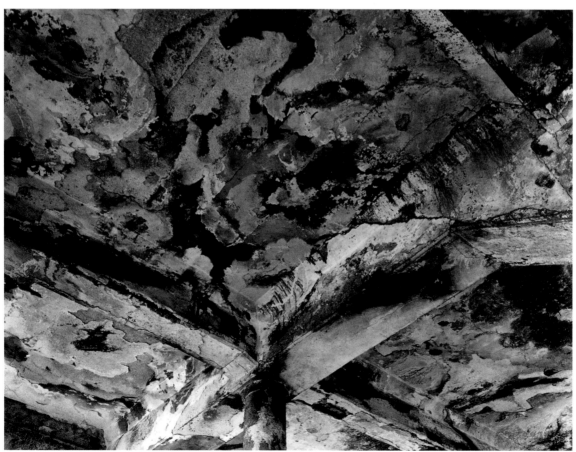

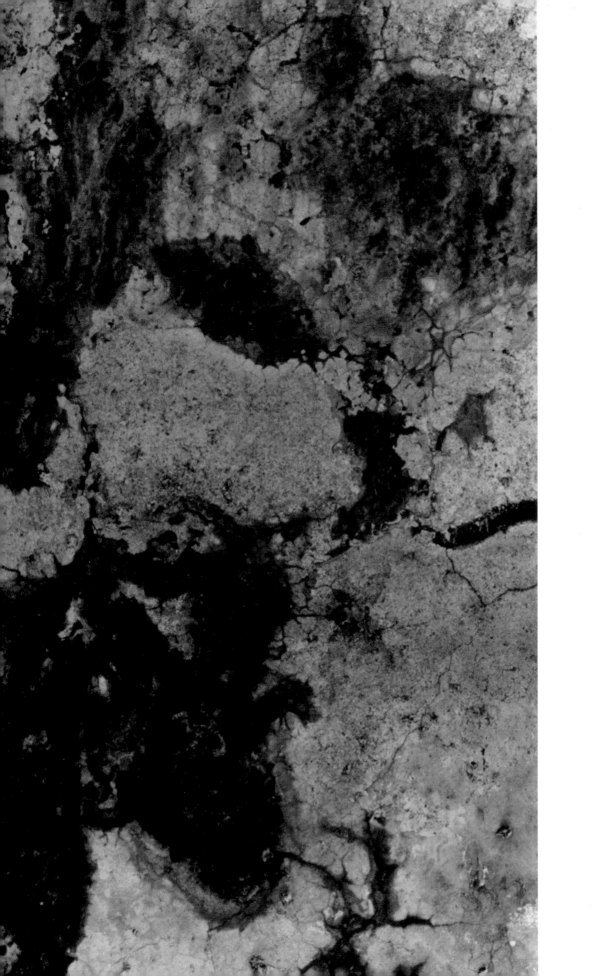

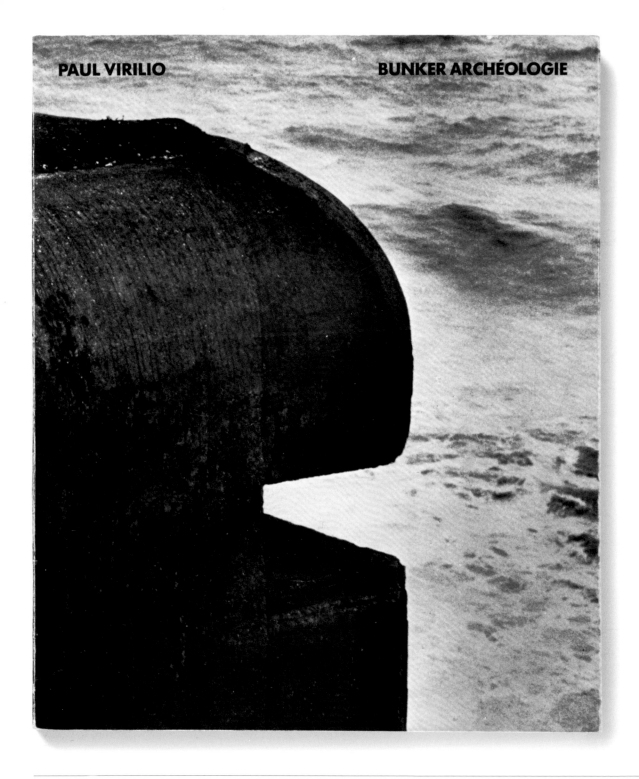

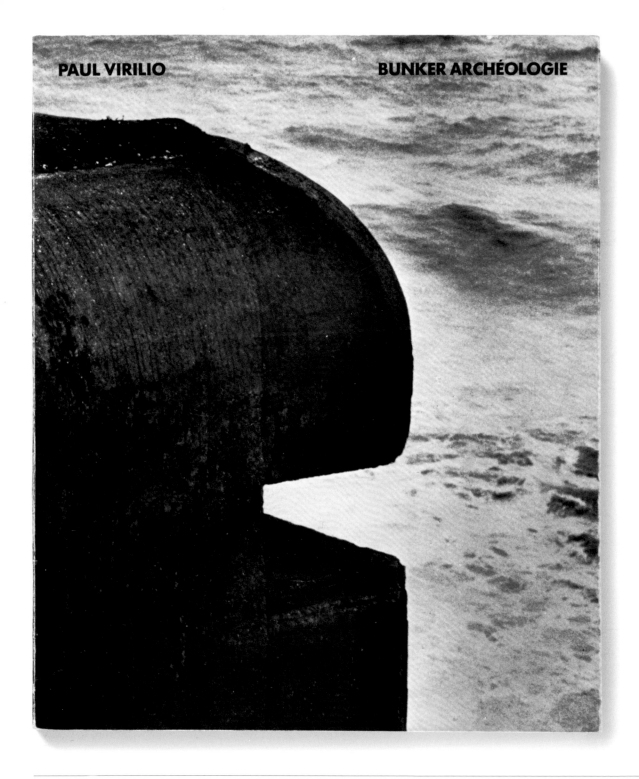

Paul VIRILIO
Bunker Archéologie
Bunker Archeology
1975

From 1958 until 1965, twenty years after the end of the Second World War, Paul Virilio photographed the elaborate coastal defences constructed by Germany along the western coast of Europe. In the summer of 1958, Virilio was on holiday in Brittany and became fascinated by the monumental concrete bunkers that remained on the beaches. This vast chain of defensive posts was built during the Second World War by the occupying German army in preparation for an anticipated Allied invasion from Great Britain. For Virilio, the sheer scale of construction was a potent symbol of total warfare, transforming the

of Nicaraguans seeing the photographs, which became a vehicle for collective memory and a reflection on the legacy of the revolution in a much-changed country. Some of her photographs, such as a man hurling a Molotov cocktail, were widely reproduced and adopted as iconic symbols of the revolution (see pp.214–15).

The history of this shared authorship is traced through the installation *The Life of an Image: 'Molotov Man'*.

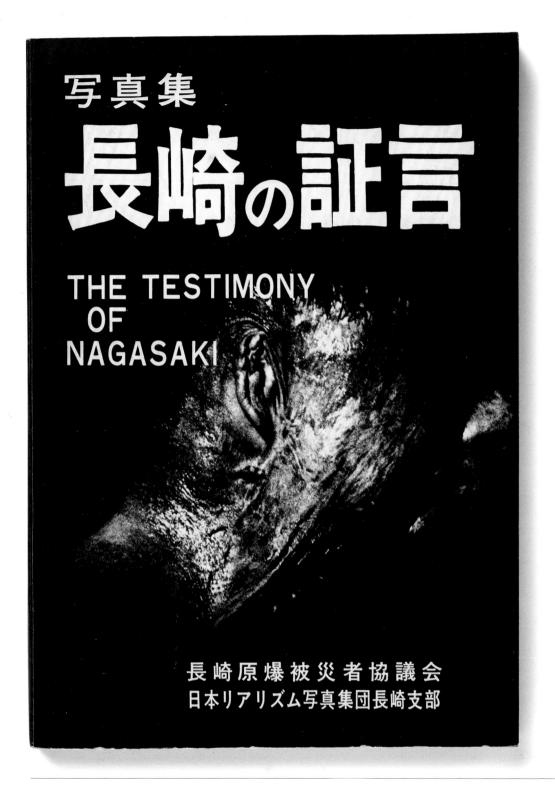

写真集

長崎の証言

THE TESTIMONY
OF
NAGASAKI

長崎原爆被災者協議会
日本リアリズム写真集団長崎支部

The Testimony of Nagasaki
1970

Produced in 1970, twenty-five years after the atomic bomb was dropped on Nagasaki, *The Testimony of Nagasaki* is a radical and visually explicit account of the lives of survivors struggling with the effects of radiation. It begins: 'Here you will see a sublime mixture of resignation and furious rage to accuse the most inadmissible criminality against human beings. These are the records of the sufferers of a-bomb in Nagasaki, who have been living and struggling against death for these twenty-five years.' The photographic essay that follows shows severely scarred, blinded and critically ill people, many of them very old, both through

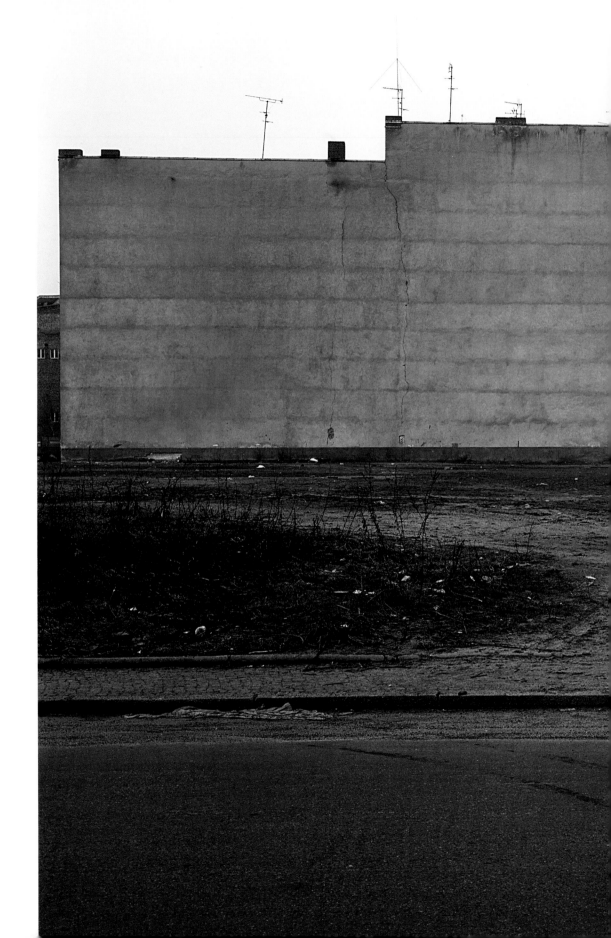

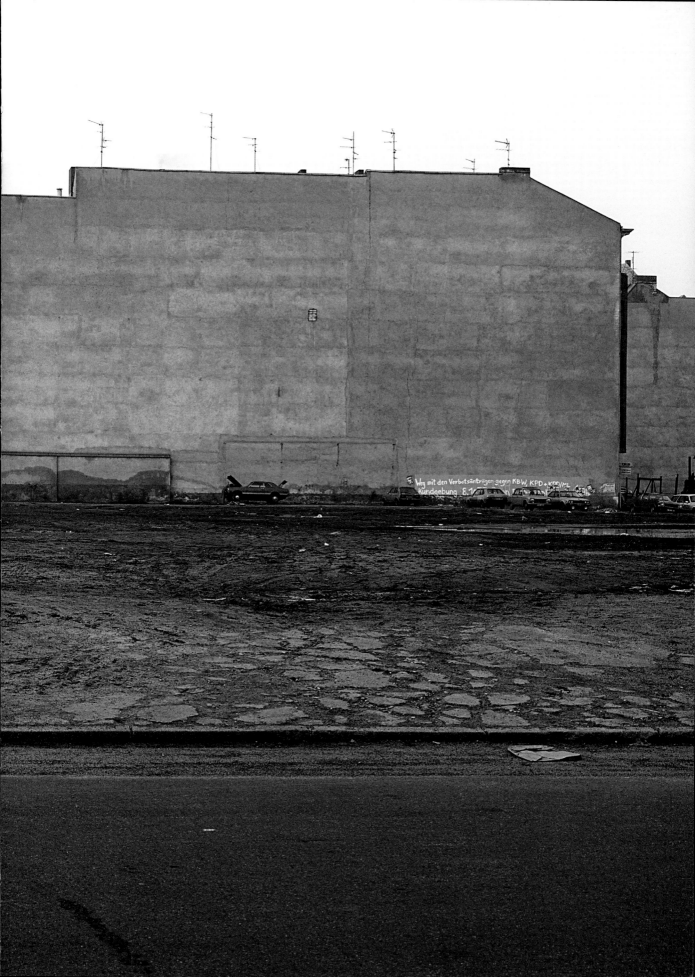

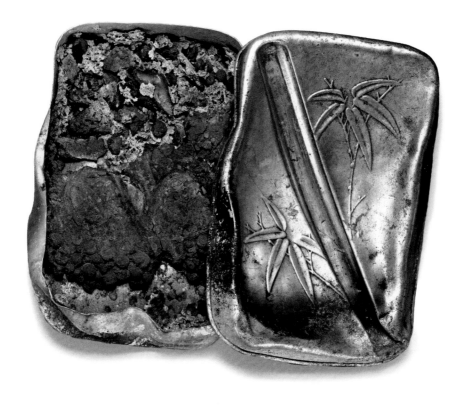

Lunch Box

Reiko Watanabe (15 at the time) was doing fire prevention work under the Student Mobilization Order, in Zaimoku-cho (500 meters from the hypocenter). Her lunch box was found by school authorities under a fallen mud wall. Its contents of boiled peas and rice, a rare feast at the time, were completely carbonized. Her body was not found.

Hiromi TSUCHIDA
Hiroshima korekushon
Hiroshima Collection
1982–95

Beginning thirty-seven years after Allied forces dropped an atomic bomb on Hiroshima, Hiromi Tsuchida photographed objects from the Hiroshima Peace Memorial Museum, continuing the project for more than a decade. 'The event at Hiroshima did not end in 1945; but began a new historical era leading toward the twenty-first century,' Tsuchida has said. Neither he nor any of his family was present at the explosion, and it is this gap between experiencing the blast and encountering traces of it that his work explores. He has written of his desire 'to record this event as a documentarian'. The neutrality of that role

Damaged Lens with One Frame

Although the body of Moto Mosoro (54 at the time) was not found, a part of her burned head was discovered on September 6th, 1945 in Hirosekita-machi (1,500 meters from the hypocenter). These articles were stuck to her eye.

comes across in the simple presentation of each object, accompanied by a note about its owner and their distance from the hypocentre at the moment of the atomic blast. As museum artefacts, these ordinary things have been called upon to represent the devastating physical impact of the bomb. They might also be seen as stand-ins for their owners, making Tsuchida's work a form of posthumous portraiture.

Nick WAPLINGTON
Wir leben wie wir träumen:
allein
We live as we dream, alone
1993

In 1993, forty-eight years after the end of the Second World War, Nick Waplington photographed drawings and inscriptions left by German prisoners of war on the walls of the Island Farm camp in South Wales. Island Farm's inmates included high-ranking SS officers, some of whom would be tried at Nuremberg at the end of the war. Waplington's treatment of the graffiti divorces them from their particular historical moment, evoking cave painting or dilapidated frescos, although some of the subject matter – such as a guard dispensing porridge – hints at the context in which they were made. The series title is taken from

Joseph Conrad's novel *Heart of Darkness*, and is a character's lament for the impossibility of communicating one's own experience. Presumably the prisoners created these images for themselves alone, as sources of solace, whether nostalgic, patriotic, romantic or defiant. Most of the camp was demolished in 1994.

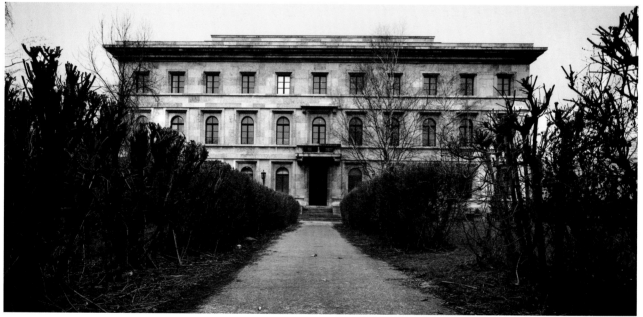

Julian ROSEFELDT
Hidden City
1994

Shot forty-nine years after the end of the Second World War, German artist Julian Rosefeldt's photographic series exposes the former residences of the National Socialist Party (NSDAP, also known as the Nazi party) in Munich. In 1931, Adolf Hitler and German architect Paul Troost began planning new buildings at the edge of the city's classicistic Königsplatz, including Hitler's main office, the 'Führerbau', the 'NSDAP administrative building', and the two 'Ehrentempel' (temples of honour), exhibiting the sarcophagi of Hitler's comrades killed during the attempted putsch of 1929. Beneath these two sites a complex network

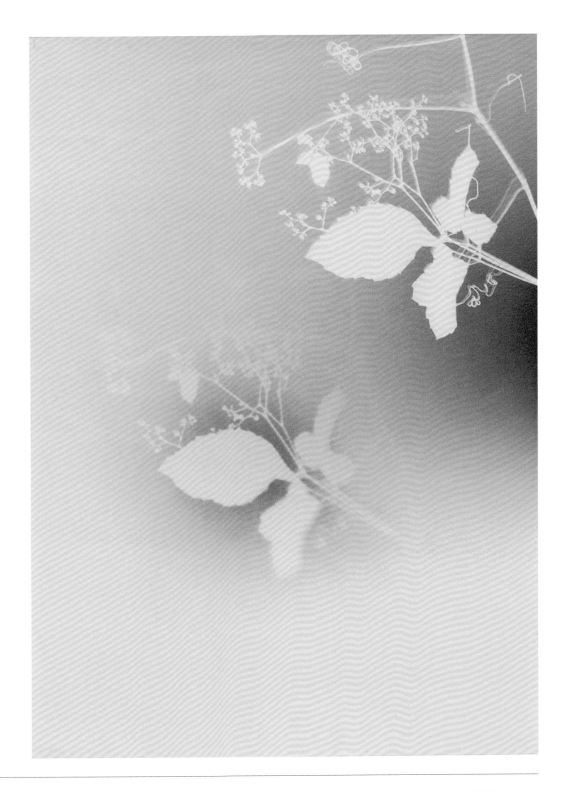

Weeds of Hiroshima was made after this initial collaborative work, presenting ghost-like forms that are far from the destructive graphic images usually associated with war. As photograms, they are created by placing an object onto light sensitive paper. When the paper is exposed, the object wholly or partially blocks the light, creating a negative imprint. Though they seem innocuous, the images also resemble the horrifying imprints of people and wildlife that appeared throughout Hiroshima, caused by the immense light of the nuclear explosion – including the shadow of a soldier photographed by Matsumoto Eiichi. Penalva's solarised photograms can therefore be seen as an echo of those last fleeting traces of life at the moment of the city's destruction.

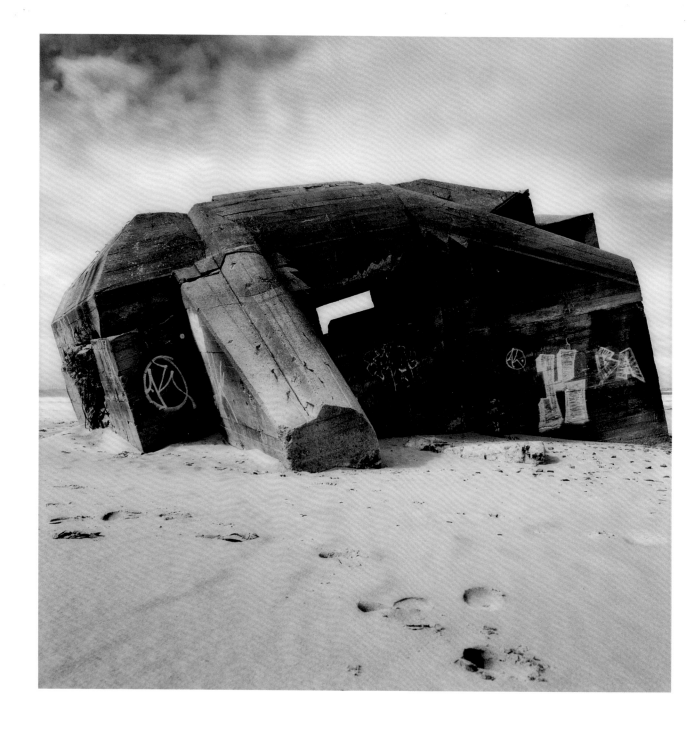

**Jane WILSON and
Louise WILSON**
Urville, Biville
2006

In 2006, Jane and Louise Wilson photographed structures in northern France built sixty-four years earlier by Germany to defend occupied Europe from the threat of Allied invasion. German forces invaded France in May 1940. It remained under Nazi control for the next four years and the Atlantic coastline was declared a military zone. Built in late 1942, these defensive bunkers formed part of Hitler's 'Atlantic Wall', a string of fortifications stretching from the Spanish border to Norway. Construction was overseen by Organisation Todt, the Nazi civil and military engineering group, with much of the building work done by local men as compulsory

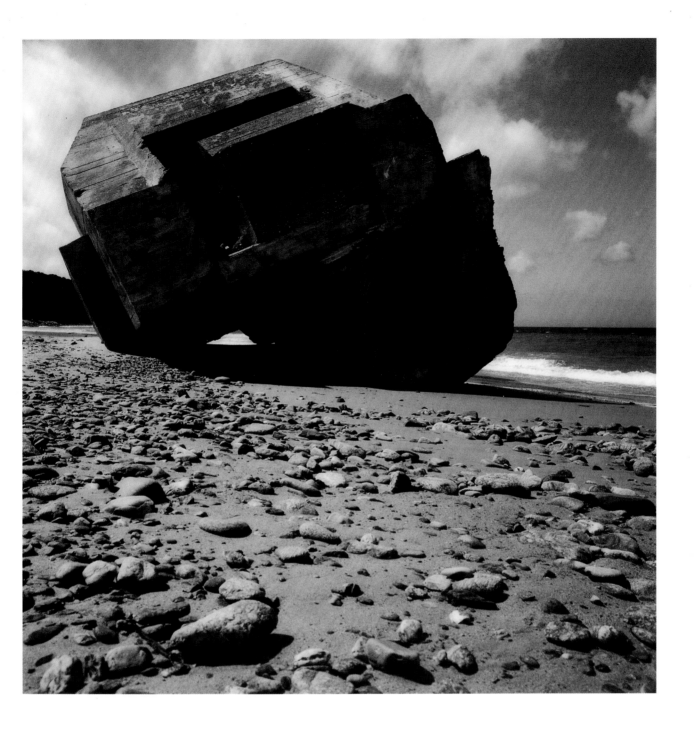

labour. The large-scale black and white of the Wilsons' photographs lend these structures a corporeal quality despite their obsolete and derelict state. Whether such remnants of occupation should be preserved as historical buildings is currently a matter of debate in France.

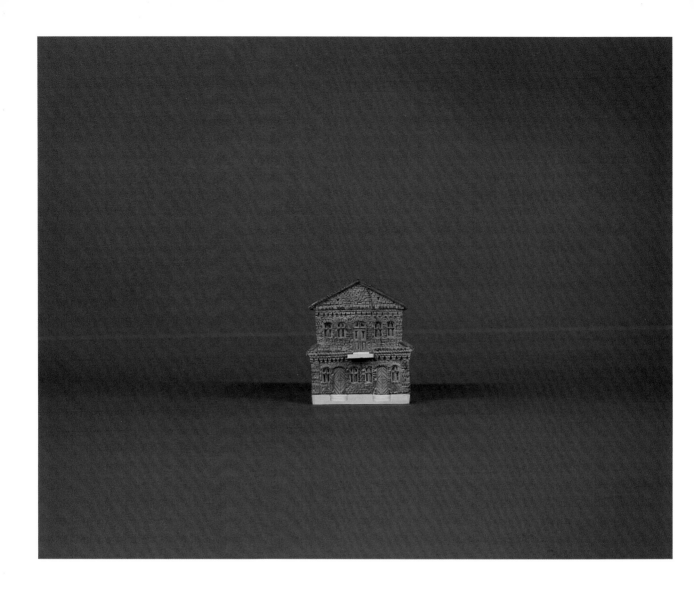

Indrė ŠERPYTYTĖ
(1944–1991) Former NKVD –
MVD – MGB – KGB Buildings
2009

In 2009, sixty-five years after the Soviet annexation of Lithuania in 1944, Indrė Šerpytytė researched and photographed buildings used by repressive Soviet security agencies. In an online archive Šerpytytė found the addresses of buildings used for interrogation and torture. She visited these locations, expecting 'well preserved and memorialised sites' but instead finding and photographing 'mostly crumbling homes that are slowly disappearing with time'. A traditional Lithuanian woodcarver created replicas from her images and she photographed the resulting models. The buildings are resolutely ordinary, and many

have become homes once again. Their failure to 'read' as sites of historical significance is reinforced by the blank facades of the carved models. According to Šerpytytė, the secret police deliberately selected such unassuming domestic buildings: 'We associate homes with a feeling of security and safety and it is exactly for these psychological reasons that these once familiar environments were turned into prisons and places of torture.'

Nobuyoshi ARAKI
Tokyo Radiation August 6–15,
2010
2010

In 2010, sixty-five years after the end of the Second World War, photographer Nobuyoshi Araki made a series of pictures from 6 to 15 August, the nine days between the anniversaries of the dropping of the first atomic bomb and the end of the war. Araki's book contains many images of his daily life and photographic practice, including his medical treatment using radiation, giving a double meaning to the title. Perhaps the most moving are the first photographs taken on each day, evident in the digital date codes on the lower right-hand corner of each picture. According to a daily practice maintained over many years, Araki always photographs the sky from

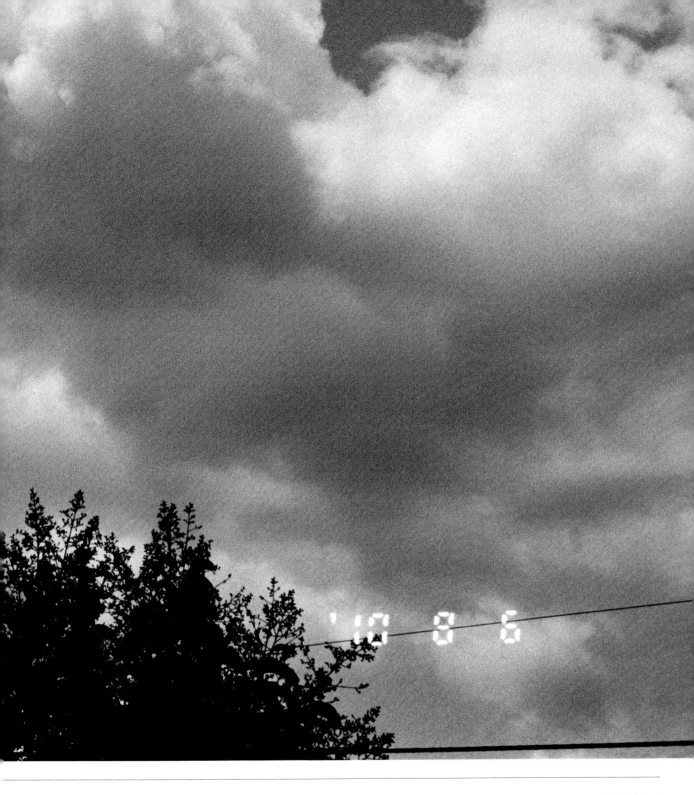

the balcony of his apartment, 'brushing his eyes' as he puts it, as other people brush their teeth. On the anniversaries of Hiroshima and Nagasaki, the act of looking up into the sky from which the bombs fell is a memorial act charged with emotion.

Taryn SIMON
A Living Man Declared Dead
and Other Chapters I–XVIII,
Chapter XI
2011

In 2011, sixty-six years after the end of the Second World War, Taryn Simon documented the living descendants of Hans Frank, Hitler's personal legal advisor and Governor-General of occupied Poland. The bloodline includes empty portraits representing those individuals who refused to be photographed as they did not want to be associated with the narrative at stake. Others sent clothing to substitute for their presence, and one man sat from behind and is pixilated to maintain anonymity. The text panel reveals Hitler's rise to power through the use of the law. The footnote panel includes photos of a makeshift bar in Hans Frank's now

c.

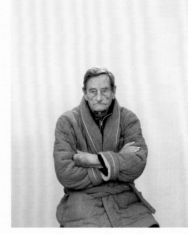

7.

e.

f.

derelict family home; press cuttings of his early interactions with Hitler, a relationship which grew increasingly tense. An Adolf Hitler postage stamp and Hans Frank imitation are presented side by side: the replica stamp with Frank's image was produced by British intelligence to provoke friction between Frank and Hitler. There are also images of stolen artworks and diary entries detailing Frank's actions in Poland, both of which served as evidence against him during the Nuremberg Trials. Frank was executed in 1946. It is estimated that he contributed to the deaths of over five million people.

Stephen SHORE
Ukraine
2012–13

In 2012, sixty-seven years after the end of the Second World War, American photographer Stephen Shore travelled to Ukraine to photograph Holocaust survivors and their homes and surroundings. During this extensive project, Shore photographed the last remaining survivors who had been displaced and resettled in various towns and cities across the Ukraine. Shore documents everyday objects and surroundings, presented in groups, titled with the name and location of the subject. Although the images often seem ordinary, Shore comments that he 'had never photographed content

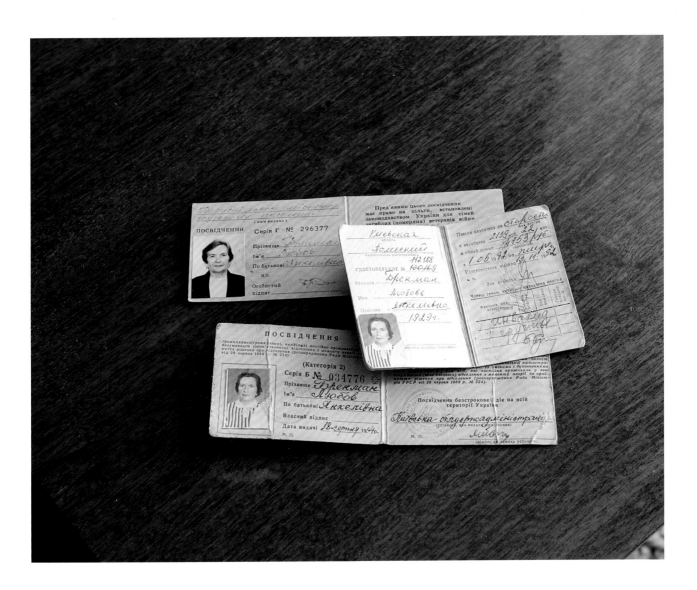

as charged as this before.'
Ukraine was one of the
countries that fell under the
Nazis' 'Generalplan Ost' for
domination of Eastern Europe,
which included the systematic
murder or deportation of Jews
and Slavs. Approximately three
million Ukrainians were killed
between 1941 and 1945.

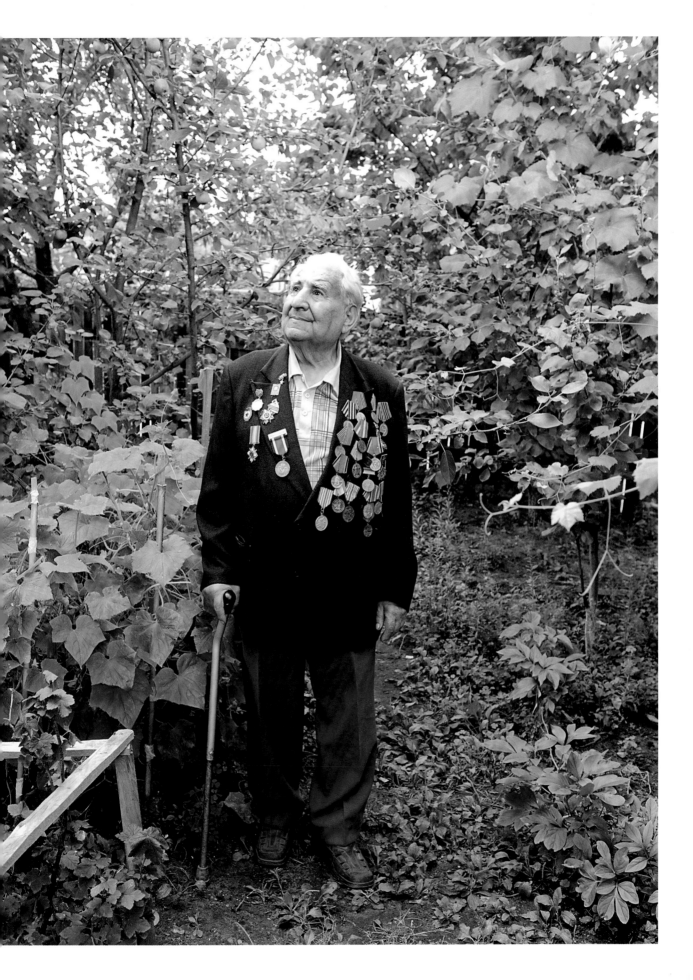

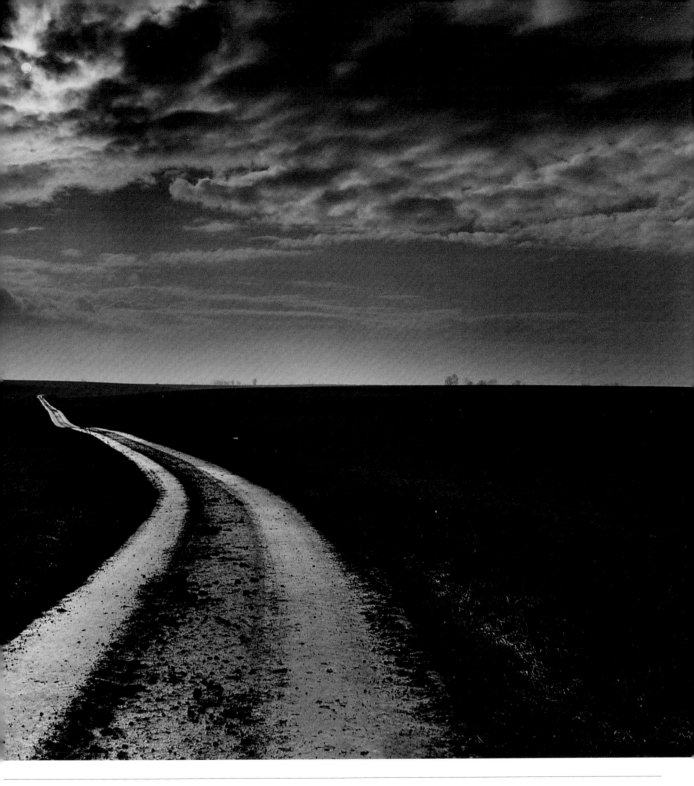

and overcast skies shows a landscape that still seems haunted by the carnage of battle, with a road winding into the distance that emphasises the sense of absence and loss. To this day, farmers continue to uncover the bodies of the dead, as well as the shrapnel, bullets and unexploded ordnance known as the 'iron harvest'.

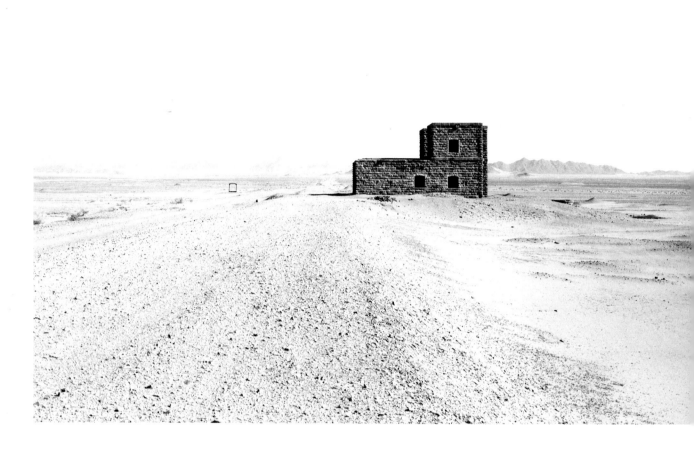

Ursula SCHULZ-DORNBURG
*Train Stations of the Hejaz
Railway*
2003

Eighty-five years after the
end of the First World War,
German photographer Ursula
Schulz-Dornburg retraced the
Ottoman railway line that once
linked Damascus and Medina,
sections of which were blown
up by Arab guerrillas during
the war. The Hejaz Railway was
one of the great engineering
projects of the Ottoman

Empire. When work began in
1900, it was intended to run
between Mecca and Damascus,
ultimately connecting
to the empire's capital in
Constantinople. The railway
would therefore serve pilgrims
to Mecca, but also strengthen
the Ottomans' administrative
and military hold over the
Arab region. By the outbreak

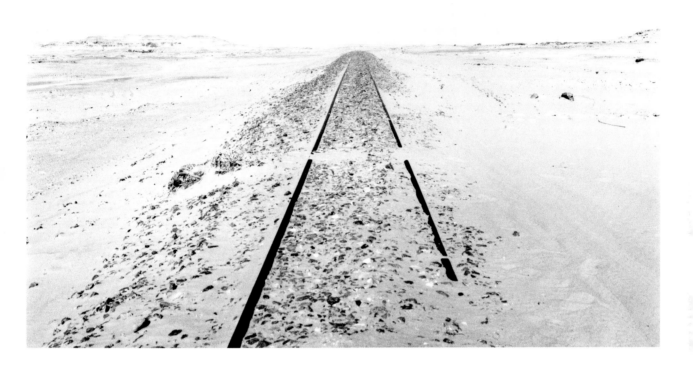

of war in 1914, the route
from Damascus to Medina
was complete, but it became
a prime target for bands of
Arab guerrillas that famously
included T.E. Lawrence. After
the war, as the Ottoman
Empire itself disintegrated,
the project was abandoned.
Following the path of the
Hejaz Railway in 2003, Schulz-

Dornburg discovered that while
much of the track has been
destroyed, the station buildings
remain, standing purposeless
and empty in the desert. Her
photographs memorialise the
relics of a vanished empire.

85 YEARS LATER

Agata MADEJSKA
25–36
2010

In 2010, ninety-two years after the end of the First World War, Agata Madejska made this image of a monument to Canadian troops. *25–36* is part of a series, *The Order of Solids*, in which Madejska photographs parts of various memorials and public sculptures. Exact sites are often difficult to identify and the photographs come close to abstraction. The subject here, only just discernable in the huge white image, is the Canadian National Vimy Memorial to soldiers from the Canadian Expeditionary Force, built on the site of the Battle of Vimy Ridge, part of the Second Battle of Arras in spring 1917. The enormous

limestone structure took eleven
years to build, more than twice
the duration of the war itself.
Madejska's title echoes the
dates of the construction: from
1925 to 1936.

Hrair SARKISSIAN
istory
2011

In 2011, ninety-six years after his grandparents were forced to flee from Eastern Anatolia to Syria to escape what the artist describes as 'the systematic extermination of the Armenian population', Hrair Sarkissian spent two months documenting the history sections of various semi-private and public libraries and archives in Istanbul that relate to the history of the Ottoman Empire. Sarkissian was interested in archives relating to the forced resettlements that affected his family in 1915, a controversial period before the Ottoman Empire shifted into the Republic of Turkey, including events which, to this day, are carefully shaped by

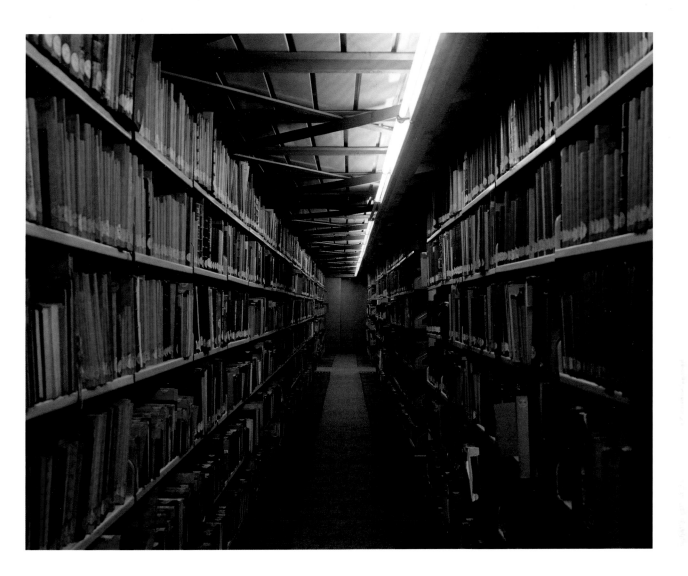

the official historical narrative bent on erasing and replacing the traces of an undesirable past. The specific contents of the archives remain hidden, and Sarkissian's photographs of rows of shelving caught in time, and racks of files that appear rarely to be opened, in dark and oppressive spaces, were shot only with available light. For the artist, this work expresses the complexity of the information that each archive contains, either by denying or confirming his inherited history, his identity and his existence in the present.

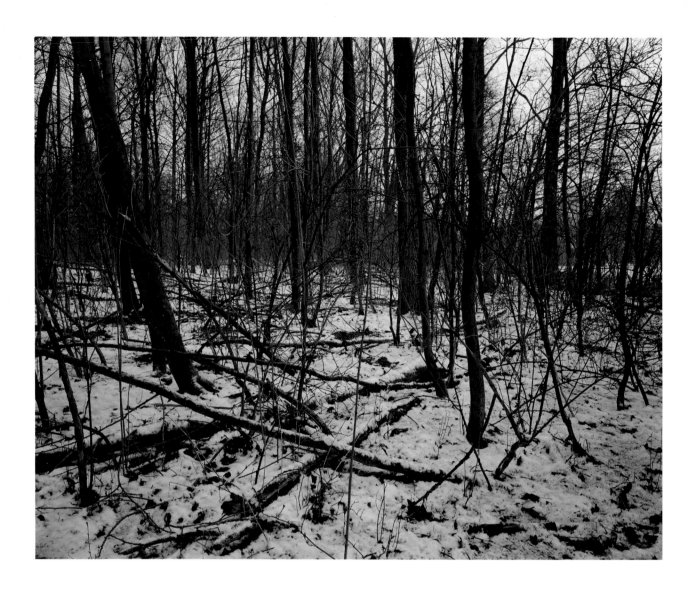

Chloe DEWE MATHEWS
Shot at Dawn
2013

In 2013, ninety-nine years after the start of the First World War, Chloe Dewe Mathews photographed the locations where British, French and Belgian soldiers were executed for cowardice and desertion on the Western Front. At the age of seventeen, Private Thomas Highgate became the first British soldier to be executed during the First World War. After fleeing northern France, unable to cope with the bloodshed he had witnessed, and probably suffering from psychiatric injury, Private Highgate was tried, convicted and shot. In the course of the war, over 300 soldiers were similarly sentenced to death for cowardice and desertion

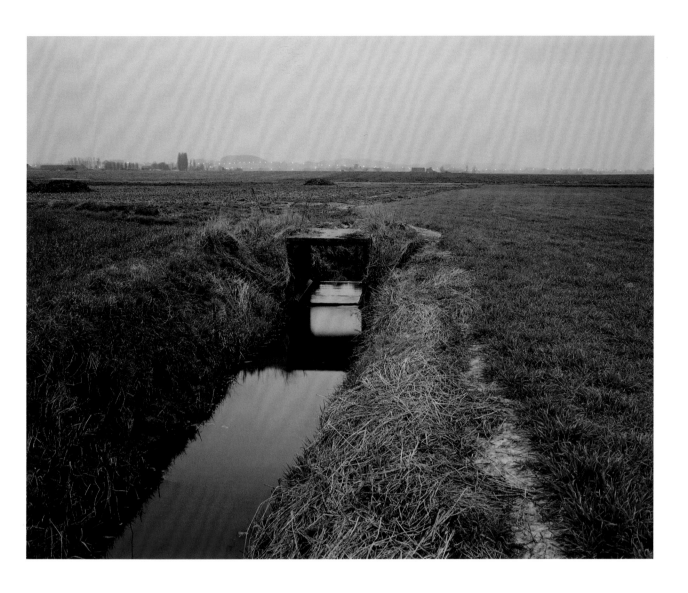

by the British army. The title *Shot at Dawn* refers to the time of day at which the sentences were usually carried out. Dewe Mathews took the images at the exact time at which the executions took place and as close as possible to the actual date.

Slaughterhouse-Five
OR
THE CHILDREN'S
≋CRUSADE ≋
A DUTY-DANCE WITH DEATH

BY

Kurt Vonnegut, Jr.

A FOURTH-GENERATION GERMAN-AMERICAN
NOW LIVING IN EASY CIRCUMSTANCES
ON CAPE COD
[AND SMOKING TOO MUCH],
WHO, AS AN AMERICAN INFANTRY SCOUT
HORS DE COMBAT,
AS A PRISONER OF WAR,
WITNESSED THE FIRE-BOMBING
OF DRESDEN, GERMANY,
"THE FLORENCE OF THE ELBE,"
A LONG TIME AGO,
AND SURVIVED TO TELL THE TALE.
THIS IS A NOVEL
SOMEWHAT IN THE TELEGRAPHIC SCHIZOPHRENIC
MANNER OF TALES
OF THE PLANET TRALFAMADORE,
WHERE THE FLYING SAUCERS
COME FROM.
PEACE.

A SEYMOUR LAWRENCE BOOK / DELACORTE PRESS

Title page, Kurt Vonnegut, Jr,
Slaughterhouse-Five,
Delacorte Press, New York
1969

People aren't supposed to look back. I'm certainly not
going to do it anymore.
I've finished my war book now. The next one I write is
going to be fun.
This one is a failure, and had to be, since it was written
by a pillar of salt. It begins like this:
Listen:
Billy Pilgrim has come unstuck in time…

Kurt Vonnegut, Jr, *Slaughterhouse-Five* (1969)[1]

Kurt Vonnegut was present during the firebombing of Dresden in February 1945 when tens of thousands of people were killed. He was locked in the underground meat locker of a slaughterhouse as a prisoner of war, and emerged the morning after the air raid to find the city destroyed. Twenty-four years later he finally published his 'war book'. For a long time, as he struggled to write it (later admitting, 'I must have written five thousand pages … and thrown them all away'); the title was going to be *Armageddon in Retrospect*.[2]

The central problem of Vonnegut's book, both for the author and reader, is that of looking backwards in time without becoming frozen and numb – a 'pillar of salt' like the biblical wife of Lot, punished for turning around to see the destruction of Sodom and Gomorrah. Vonnegut's solution, an unlikely and radical one, was to destroy time itself, and have his protagonist Billy Pilgrim come 'unstuck' in time, slipping without warning between postwar present, wartime past (including Dresden), and an alternative future in which he lived as a captive on the planet Tralfamadore 'where the flying saucers come from'.[3]

Vonnegut, however, was not unique in identifying this problem, or in taking his time with the past. After the Second World War, retrospect was a vital ingredient for many forms of literary reflection by those who had been closely involved in the action. Joseph Heller, a US Airforce bombardier, and later a pupil of Vonnegut, published *Catch-22* in 1961.[4] J.G. Ballard's masterpiece *Empire of the Sun*, about the author's experiences in a Japanese prisoner-of-war camp in Shanghai, came out in 1984.[5] And today, a century after the start of the First World War in Europe, in the absence of living survivors, the problem of looking backwards continues to deepen: events and individuals are seemingly frozen 'like bugs in amber', as Vonnegut put it, visible only with intense scrutiny though history's reversed telescope.[6]

Inspired by the fact that photographers, like writers, have made significant bodies of work about the after-effects of war (in the short, medium and long terms), *Conflict, Time, Photography* takes as its starting point the necessity and value of the time taken to consider the past, looking beyond the instantaneity of photojournalism to consider images of war and conflict made

after the fact. Both in the exhibition and in this book, the works are arranged in the same way: sequenced according to their distance from the specific events, or the ends of the conflicts, that they concern. We begin therefore with photographs made 'moments after' something has happened, and move gradually through images made days, weeks, months and years afterwards. This elastic stretching of the vantage point from which artists and photographers have looked back at the past moves onwards through years and decades (like the twenty-four years it took Vonnegut to publish *Slaughterhouse-Five*), to reach works made a hundred years after the conflicts to which they relate. The events represented include those from the nineteenth century, when photography was a new medium, such as the Crimean and American Civil Wars, and from the two World Wars (in both Europe and Asia), as well as more recent events in Africa and the Middle East.

The principal aim of this non-chronological strategy is to unstick time and see the past as Billy Pilgrim saw it, shifting perspectives constantly from contemporary conflicts to those in distant history and all points in between, across time and space: from Afghanistan to Hiroshima, the Western Front to Vietnam, Nicaragua to Iraq, Berlin to Crimea, and so on. Many of the works included necessarily share the spirit of Vonnegut's literary return to wartime Dresden in the 1960s, engaging with, rather than seeking to bridge, the impossible passage of time. In the words of one critic, writing about 1960s Japanese photography that reflected back on the Second World War, such work, 'asks us to see through the now that it is showing us, into the then that pervades the now and gives it its meaning'.[7]

As this perceptive characterisation suggests, although there are many examples of photographic projects that engage with Vonnegut's critical attitude to representing the passage of time, made about different conflicts, in different places, and after different delays, perhaps the clearest equivalent instances of this kind of time travel were made in Japan about its experience of city-wide destruction. From the late 1950s to the early 1970s, approximately fifteen to twenty-five years after the end of the Second World War, some of the most significant and original photobooks ever published took as their subjects the atomic bombings of Hiroshima and Nagasaki. Just as Vonnegut's *Slaughterhouse-Five* transcended the idea of a 'war book' to become a classic of twentieth-century literature, so Ken Domon's *Hiroshima* (1958), Kikuji Kawada's *The Map* (1965) and Shomei Tomatsu's *11:02 Nagasaki* (1966) have come to be regarded as among the most important photographic publications of the postwar period.[8]

The correlations between Vonnegut's account of Dresden and, for example, Kawada's account of Hiroshima, or Tomatsu's account of Nagasaki, run far beyond the shocking coincidence of the

ARMAGEDDON IN RETROSPECT
Simon Baker

subjects: mass civilian casualties visited upon the populations of aggressive authoritarian regimes. They point instead to something significant and different about the authors' responses to the evident disconnects between places, people and the events that had come to define them. Vonnegut, Kawada and Tomatsu, returning to these hugely symbolic cities in the 1960s, had to search for ways to describe and explain not only what had happened there, but why it was somehow still happening all those years later. Each was caught in the slowly diminishing half-lives of the original events. Vonnegut was still in thrall to his experiences in 1945 as he wrote, characteristically deadpan, about returning to Dresden in 1967: 'It looked a lot like Dayton, Ohio, more open spaces than Dayton has. There must be tons of human bone meal in the ground.'[9]

For Kawada, Tomatsu and the many Japanese photographers who sought to 'document' Hiroshima and Nagasaki from the late 1950s onwards, the radioactive nature of the original event was present everywhere on a daily basis in the lives of those who had survived the 'event' only to live (or die) in the horror of its aftermath – the so-called 'hibakusha' or atomic bomb survivors. Tomatsu put it as follows in 1961:

> Time has passed in the outside world since it stopped for Nagasaki at two minutes past eleven on August the ninth, sixteen years ago, but every victim who has died since acts as a link to join that moment with the present … What I saw in Nagasaki was not merely the scars of war, it was a place where the post-war period had never ended. I thought that the term ruins only referred to the devastated form of cities, but Nagasaki taught me that it could also be applied to human beings.[10]

Kawada, whose photobook The Map was published on 6 August 1965, precisely twenty years after the bombing of Hiroshima, fearfully recounts his first visit to the city in 1959 through a series of references to the problematic of vision. 'A veil of morning mist left me unable to see anything', he says of a postwar Hiroshima noticeably populated by many visually impaired people, with 'slightly opaque' and 'abnormal' eyes, while 'at ground zero of the blast', he continues, 'there was not one person remaining who could testify to the great scene of the vanished city'.[11] There are echoes here of the first words spoken in Alain Resnais's 1959 film Hiroshima Mon Amour: 'You saw nothing in Hiroshima. Nothing … I saw everything. Everything.'[12] Both reflect an uneasy balance between disappearance and persistence, in both physical and psychological terms, between that which is lost, and that which remains: a thread running through any such attempts to 'represent' the trauma of conflict after the fact. But in visual terms especially, the problematic tension of using photography to represent the past introduces a powerful dialectic of visible and invisible forms. The description of photographs as 'fossils of light', suggested by the Japanese photographer Daido

Moriyama, perhaps best encapsulates the sense in which the physical and the impalpable co-exist in the very essence of the photographic medium.[13] What does it mean, we might ask, to expect a photograph to reach across time and space and fulfil its obligation to represent something adequately, or even at all: like the photographs described in the peace museum in Hiroshima Mon Amour, present (only) 'in the absence of anything else'?[14]

Paul Virilio, whose important study of the remains of wartime architecture Bunker Archéologie (Bunker Archeology, 1975) includes a section entitled 'the aesthetics of disappearance', has said that 'War is not only amoral, but also experimental … experimental in the way it inverts production. The machines of war … [are] producers of accidents, disappearances, breakdowns, [designed] to make the enemy disappear.'[15] And some of the strangest and most moving photographs of conflict are those where the photographer has arrived, as so many did in the aftermath of the First World War in particular, to find merely the place where something used to be – evidence only of an absence. Pushed by a compulsion to demonstrate the terminal destructiveness of war on society to a burgeoning audience of battlefield tourists, the response was often to photograph an apparently empty landscape and add the caption 'All that remains of …' or 'The site of the village of …' (in the absence of anything else, so to speak).[16] (pp.122–3)

Such tensions are also evident everywhere in the examples of Hiroshima and Nagaski, which offer a broad scope of photographic imagery, from that made moments and hours after the bombings to work made over half a century later, where we find the subtlety and sophistication of visual reflections on the past by such artists as Kawada and Tomatsu.[17] From the very moment of the event, however, images of the unseen and the absent came to stand for what could not be shown. Toshio Fukada's sequence of photographs of The Mushroom Cloud – less than twenty minutes after the explosion at Hiroshima, is an image that cannot possibly represent what it depicts, replicating the fact that anyone who had directly witnessed the sudden massive flash of the bomb would have lost their sight, if not their life (pp.10–11). Matsumoto Eiichi's photograph Shadow of a soldier…, taken in the days after Nagasaki, likewise replaces the unimaginable horror of instantaneous incineration with the slightest suggestion of the charcoal outline of a crouching human form, burned onto the side of a wooden wall – the uncanny implication being that this most dramatic technology of war can even detach a living person from his shadow (pp.16–17).

Living Hiroshima was published in 1948 by the Hiroshima Tourist Association, just three years after the bombing, and significantly, while Japan was still occupied by the United States (pp.56–7). 'Hiroshima is still alive!' its excited author claims: 'Visiting Hiroshima for the first time a traveller would never realize that he

ARMAGEDDON IN RETROSPECT
Simon Baker

197

had come to the city of atomic bomb explosion.'[18] But despite this upbeat introduction, the overall effect of the book is to confirm visually, perhaps for the first time, the extent of the impact of the radioactive bomb. To this end, the use of the '378 photographs' boasted on the cover, by established photographers such as Ihei Kimura, is vitally important as an accumulation of different kinds of evidence. Perhaps in deference to the occupation, however, both tone and content are curiously restrained: 'The Plants Were No Exception', for example, provides oblique evidence of the blast, including a dark crescent seared onto the skin of an orange and what is described as a 'badly dishevelled' tree.[19]

Hiroshima: Scenes of A-Bomb Explosion, by contrast, was released in 1953, immediately following the official end of the occupation, and, although modest in scale, does not hold back, either in tone or the nature of its visual evidence, which begins with a still-smouldering double-page spread entitled 'The City of Death' (pp.70–1). This 1953 *Hiroshima*, however, unlike the better-known books that followed it, is an accumulated album of straightforward 'documentary' images carefully assembled and captioned: more of a guidebook than an authored account of the subject. As such, it follows the pattern of the tourist albums and guidebooks that appeared soon after the First World War in Europe; conflicted, confused publications offering, as Karl Kraus noted with horror, 'unforgettable impressions of a world in which there is not a square centimetre of soil that has not been torn up by grenades and advertisements'.[20] What horrified Kraus in 1921 about the 'Promotional Trips to Hell', as he described carefully arranged tours of the battlefields, was the uneasy persistence of the normative forms of discourses like tourism and advertising in the aftermath of an apparently apocalyptic catastrophe. 'You understand', he writes, 'that the destination has made the promotional trip worthwhile, and that the promotional trip was worth the world war.'[21] Had he lived, Kraus would no doubt have been equally horrified by the 'Atomic Tours' of Hiroshima depicted in Resnais's film.

There is an equivalent problem staged both in literature and photography in the long shadow cast by the Second World War: whether representational forms should be allowed to continue unchanged by the events they described. Which is to say that the reason why Billy Pilgrim had to come unstuck in time is the same reason why Kikuji Kawada felt compelled to photograph the stains on the ceiling of the atomic-bomb dome in Hiroshima: to turn away from the conventions of documentary photography and towards something else, something irreconcilably obtuse and impossibly abstract. As Marguerite Duras (author of the screenplay for *Hiroshima Mon Amour*) would write: 'All that can be done is to talk about the impossibility of talking about Hiroshima.'[22]

It is no accident that the most important and influential books on the atomic bombings in Japan were produced years after the events, when the culture of photography and the principles upon which documentary practice was based had shifted with the influence of avant-garde thinking. The turning point, for many reasons, is Ken Domon's *Hiroshima*, published in 1958: a compelling and highly original conflation of documentary publication and fine-art portfolio, printed in high-quality gravure and with a cover designed by the surrealist artist Joan Miró[23] (pp.80–1). Despite its luxury packaging and presentation, Domon's *Hiroshima* is nevertheless a relentlessly tough vision of the human cost and aftermath of the atomic bomb: an unflinching account of the physical impact of both the blast itself (keloid scarring and blindness), and the long-term effects of radiation poisoning, including congenital defects in the young. Looking back from a vantage point of thirteen or fourteen years after the event, Domon insists upon the presentness of suffering with a firm belief in the humanist potential of the photograph to communicate with empathy. But even as he pushed documentary photography to its very limits, Domon was still constrained by a visual language belonging to the same generation as the bombs themselves. If he asks us to look, and look harder, Tomatsu and Kawada, by contrast, suggest that looking itself is a casualty of war. While Domon believed completely in the 'direct connection between the camera and the subject', Tomastu and the so-called 'image generation' of Japanese photographers, which included Kawada, militated against the principles of photojournalism and conventional documentary practice.[24] As the philosopher and critic Koji Taki has written, summarising debates in Japanese photography in the early 1960s:

> The specific 'truth' of the photograph is not objective and not a 'universal truth'. I do not ask of the photographer an explanation of his subject. For me it is enough that the image appear, a one-time deal, irreplaceable. A one-time deal – and yet, it appears from a historical field. In this field, Tomatsu has engaged his subject in a unique relationship.[25]

Both Domon and Tomatsu provided photographs for the important publication *Hiroshima–Nagasaki Document* (1961), which, as well as being richly illustrated, was full of other forms of statistical and verbal evidence about the bombs and their aftermaths[26] (pp.98–9). This publication sits on the cusp of two potential directions for photography in Japan at the time. On the one hand it is relentlessly factual, with 'documentary images' of different kinds of scarring and medical conditions, graphs and diagrams, and carefully collected first-hand accounts of each event and the experiences of the survivors. On the other, it is deeply poetic and full of aesthetic sophistication, a seductive and visually compelling sequence of photographs. Two captions facing photographic images printed in high contrast on differently coloured papers offer evidence of these contrasting tendencies:

ARMAGEDDON IN RETROSPECT
Simon Baker

*The record of man's striving and suffering cannot but evoke
human feeling. Emotion can destroy; but it can also illuminate
thought and nourish useful action. The purpose of this book is to
arouse in its readers such emotions as will guide and encourage
them in their efforts for peaceful progress towards those goals to
which we all aspire.*

*Hiroshima: 1945, August 6th, 8:15 am
Nagasaki: 1945, August 9th, 11:02 am
Points of no return.*[27]

Hiroshima–Nagasaki Document, however, would be far from a
'point of no return' for Tomatsu, who was deeply affected by
his experience photographing in Nagasaki and could not put
the subject to rest. 'Nagasaki has two times', he would write.
'There is 11:02, August 9, 1945. And there is all the times since
then. We must not forget either of them.'[28] He not only returned
to Nagasaki to make more work, but he also returned to his
own photographs of Nakasaki to make a second, self-authored
publication. Photographs from the 1961 book *Hiroshima–Nagasaki
Document* recur in *11:02 Nagasaki* (first published in 1966),
joined by new images, carefully researched captions, and by
new forms of documentary 'evidence'[29] (pp.126–33). Despite
the connections between the two publications in terms of their
evidentiary purpose, the subjects of Tomatsu's photographs set
him apart from his co-publication with Domon, and suggest a
complex and evolving attitude to the past. Tomatsu does not
eschew images of personal suffering; he sets subtle and respectful
depictions of physical damage in a highly formalised aesthetic
context: the ruins of people among the ruins of things. Many
of his images have since become iconic: a watch stopped by the
explosion at 11:02am; a strangely corporeal melted bottle; a
helmet with bone fragment fused to the interior; the shattered
statues of angels from Nagasaki's Catholic cathedral. In each
case, these 'icons' take their places within the broader context
of a careful and deliberate sequence that connects these 'bugs
in amber' with daily life. Tomatsu's quiet radicalism, then, is to
fix Nagasaki in the present, a postwar Japan that he described
acerbically as 'characterized principally by Americanization'.[30]

There is the same ambivalence and sense of confronting an
impossible subject in Kawada's 1965 photobook *The Map*, which
was produced in Hiroshima even as Tomatsu was working in
Nagaski (pp.112–21). The young Kawada had originally gone
to Hiroshima to assist the more experienced, established Ken
Domon with his work, and recalls vividly standing in the atomic
bomb dome (or hypocentre), looking up at the strangely stained,
decayed ceiling that would become the basis of his own work,
and which he hoped Domon would not notice.[31] 'A dozen years
after the atomic bomb was dropped on Hiroshima', Kawada
remembers, 'out of nowhere a giant black "stain" appeared
above the basement ceiling of the Atomic Bomb Dome. Each

ARMAGEDDON IN RETROSPECT
Simon Baker

night the "stain" – which I had seen myself – filled my dreams with horror.'[32] Kawada's dramatic abstractions of the 'stain', which transplant Brassaï's surrealism and Aaron Siskind's formalism into the theatre of war, are both a turning away from the postwar reality of Hiroshima and a poetic re-imagining of it. For the scarred, peeled, blistered walls and ceiling cannot help their bodily associations and seem all the more explicit for the depth and scope of the gaze that Kawada levels at them. And included within this catalogue of destroyed surfaces are deeply symbolic ruins of other kinds, evidence not only of the war itself, but of the incipient Americanisation that followed it. There are rising-sun flags, Lucky Strike cigarette packets, Coca-cola bottles, tourists' graffiti, and, strangest of all perhaps, memorial shrines to Japanese zero-fighters: the Kamikaze Special Attack Force pilots whose absolute dedication to a failed state came to symbolise both pride and futility to the postwar generation.

Kawada had originally intended his photographs of these memorials, which include final letters from the pilots to their families, to constitute a separate body of work, but it is part of the complex moral equation formed by *The Map* that instead they sit within, and are surrounded by, the slowly decaying fossils of atomic Hiroshima's postwar present. 'The sudden encounters and coincidences of these images and the "stain"', Kawada writes, 'became the nucleus for *The Map*'.[33] And indeed, their embeddedness is ensured by the physical form of the book, a masterpiece designed by Kohei Sugiura, in which every page is folded as a pull-out, so that each central spread is concealed within another image. Unusually, then, *The Map* is a book about the passing of time that it is impossible to flick through, demanding instead that its readers slowly and carefully unfold and refold each page as they turn it.

Kawada's is by no means the last word on the legacy of Japan's atomic bombings from the period: there are subsequent publications, both documentary in nature (*The Testimony of Nagasaki*, 1970; pp.138–9) and avant-garde (*Hiroshima Hiroshima Hiroshima*, 1972; pp.142–3).[34] The former contains the following indictment: 'Here you will see a sublime mixture of Resignation and Furious Rage to accuse the most inadmissible criminality against human beings. These are the records of sufferers of a-bomb in Nakasaki, who have been living and struggling against death for these twenty-five years.' The latter is particularly interesting as a record of student responses to the subject under the influence of both Provoke and protest aesthetics.[35] But *The Map* can be considered the high-water mark in a history of coherently authored attempts to resolve the impossibility of talking about Hiroshima that Dumas sought to dramatise in *Hiroshima Mon Amour*.

What follow as time moves onwards are ever more archaeological and symbolic accounts of extended aftermath that rely increasingly on the gradually widening gap between the visible 'effects' of the event and those arriving to bear witness to them photographically. Since the late 1970s, for example, the photographer Hiromi Tsuchida has been making work in Hiroshima, publishing his first book on the subject, *Hiroshima 1945–1979*, in 1979.[36] Tsuchida also began a long-term collaboration with the Hiroshima Memorial Peace Museum, in which he photographed objects found in the city, and kept as artefacts of the original event (pp.152–3). Each object is described meticulously in terms of both its origin (when known) and the delay before its accession into the museum's collection: a wristwatch, for example, 'found in the water, 150 metres downstream from the Motosuya Bridge, east of the Peace Memorial Museum on April 23rd 1955, and [showing] the exact time of the bombing, 8:15.'[37] Elsewhere, more personal stories are re-attached to objects that had remained lost or hidden for years. A lunchbox found on 25 June 1970, 'by school authorities under a mud wall', for example, is identified as having belonged to Reiko Watanabe (only fifteen years old in 1945), who had been doing fire-prevention work 500 metres from the hypocentre when the bomb was dropped. Although the carbonised contents of the lunchbox remain ('boiled peas and rice'), Reiko's body itself was never found.[38] The painfully slow recuperation of these objects, still being donated to the museum in the late 1980s, is echoed by the second delay between the cataloguing of the objects and Tsuchida photographing them (many years after the original event to which they relate). These doubled passages of time not only offer a memorial counterpoint to the gradual disappearance of living survivors, but also highlight the capacity of photography to bear witness even (or especially) at removes of many decades.

In the context of this almost forensic practice, João Penalva's solarised photograms *From the Weeds of Hiroshima* 1997 offer an alternative poetics of memory through their evocation of co-existent and contradictory timescales (pp.160–1). On the one hand, there is the half century of human activity that has effaced most direct visual evidence of the event, and on the other, there is the cyclical natural time of plant-life, which forms a delicate but continuous thread backwards into the past. The 'badly dishevelled' forms, reminiscent of their postwar progenitors, are transferred directly by Penalva onto photographic paper, conforming precisely to the idea that photographs might constitute 'fossils of light'.

The reference to an alternative (natural) time in the face of human history gives the lie to the possibility of offering even an inadequate image of Hiroshima 'in the absence of anything else', confounding the logic that has insisted that 'nothing' can be seen at Hiroshima since Resnais's 1959 film. So many years after the event itself, however, and even years after the fading of its tangible aftermath, artists have continued to think, and

ARMAGEDDON IN RETROSPECT
Simon Baker

attempted somehow to picture, the persistent memory of the atomic bombings. Now, however, no longer content to render the effects of the passage of time, they imagine its collapse.

Two such works, Kirk Palmer's 2007 film *Hiroshima* and Nobuyoshi Araki's photobook *Tokyo Radiation August 6–15, 2010* (pp.166–9) are rooted firmly in the present but nevertheless function by circumventing the moments when the bombs dropped and suggesting an alternative time and place, suspended somehow, where the bombs haven't yet dropped and so never will. Araki's book, like other specifically memorial albums made throughout his career, is aimed squarely at the anniversaries from 6 August (Hiroshima) to 15 August (the official end of the war in Japan). Many aspects of Araki's own everyday life and artistic practice are covered in this ten-day period. The most striking images are the first made every day, when he goes out to his balcony and photographs the sky (as he puts it, to 'brush his eyes', as others brush their teeth).[39] To look up at the sky in Japan, deliberately, on 6 and 9 August, within a project about the continued significance of these dates, is to remember the bombs that were dropped from the same skies sixty-five years earlier, and at the same time to evoke the precious moments before either event took place. Time comes unstuck on Araki's balcony as he looks at the sky that greets him every morning and thinks at once about what has been, what might have been and what might be. To return again to words from the past, there is 'nothing' to see in these photographs, although that is not what they show.

Kirk Palmer's film *Hiroshima*, by contrast, works with and through time, and consists of a series of strangely attenuated sequences of everyday life in Hiroshima, in and around the hypocentre, complete with the muted city sounds of traffic and children playing. It is chilling because despite the anachronism of the city's appearance (in 2007 rather than 1945, unrecognisable as the original ground zero), the effect is of being forced to see the residents of Hiroshima going obliviously and imperviously about their everyday lives.[40] The film transforms them from being the inhabitants of Hiroshima sixty-two years after the bomb to representing the inhabitants of the same city just moments before the event. Looking at the present through the lens of the past, Palmer's Hiroshima seems perpetually frozen on the brink of obliteration. But although historically the bombing will always have happened, his film seems somehow to disavow this fact, and to suggest, in spite of everything, that for the on-screen Hiroshima at least, the plane will never come and the bomb will never drop.[41]

There is a similar effect described in *Slaughterhouse-Five*, when Vonnegut introduces Louis-Ferdinand Céline's obsession with time in the 1936 novel *Death on the Installment Plan*: 'Céline wants to stop the bustling of a street crowd', Vonnegut writes.

'He screams on paper, *Make them stop ... don't let them move anymore at all ... There, make them freeze ... once and for all! ... So that they won't disappear anymore!'*[42] And Vonnegut's 'war book' is likewise concerned with time, disappearance, and the impossibility of memory: its uneasy relationships with fantasy and wish-fulfilment summed up by the sentiment of Vonnegut's hugely significant line-drawn tombstone, 'Everything was beautiful, and nothing hurt'. Billy Pilgrim is an awkward amalgam of Vonnegut himself and a real-life fellow prisoner of war. As he begins the book by admitting: 'All this happened, more or less. The war parts, anyway, are pretty much true.'[43] But in offering such a disclaimer, one of a complex series that introduce the story, Vonnegut acknowledges the impossibility of accuracy when talking about the past. When Pilgrim, having come catastrophically unstuck in time, asks his alien abductors where (and more importantly when) he is, he is told: 'All time is all time. It does not change. It does not lend itself to warnings or explanations. It simply is. Take it moment by moment, and you will find that we are all, as I've said before, bugs in amber.'[44]

But perhaps Vonnegut's most radical and beautiful reflection on the war that he survived to regard from its postwar future, is the passage where Pilgrim finds himself with 'an hour to kill' before the flying saucer comes (he knew of course, that it would come, as it always had). He experiences time coming 'slightly unstuck', shifting uneasily backwards and forwards, until he finds himself watching a film about wartime bombing in reverse:

> *The formation flew backwards over a German city that was in flames. The bombers opened their bomb bay doors, exerted a miraculous magnetism which shrunk the fires, gathered them into cylindrical steel containers, and lifted the containers into the bellies of the planes. The containers were neatly stored in racks. The Germans below had miraculous devices of their own, which were long steel tubes. They used them to suck more fragments from the crewmen and planes. But there were still a few wounded Americans, though, and some of the bombers were in bad shape. Over France, though, German fighters came up and made everything and everybody as good as new.*
>
> *When the bombers got back to their base, the steel cylinders were taken from the racks and shipped back to the United States of America, where factories were operating night and day, dismantling the cylinders, separating the dangerous contents into minerals. Touchingly, it was mainly women who did this work. The minerals were then shipped to specialists in remote areas. It was their business to put them in the ground, to hide them cleverly, so they would never hurt anybody ever again.*[45]

ARMAGEDDON IN RETROSPECT
Simon Baker

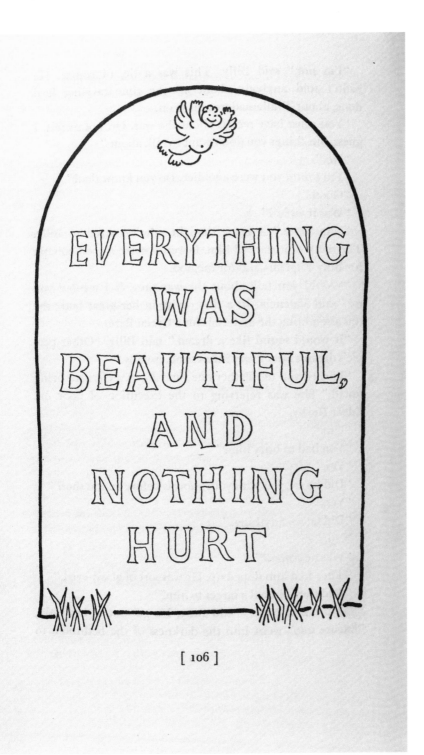

[106]

Line drawing, Kurt Vonnegut, Jr,
Slaughterhouse-Five (1969), p.106

1 Kurt Vonnegut, Jr, *Slaughterhouse-Five, or, The Children's Crusade*, Seymour Lawrence / Delacorte Press, New York 1969, p.19.

2 Ibid., p.13. The title 'Armageddon in Retrospect' would eventually be used for a posthumous collection of Vonnegut's 'new and unpublished' writings on war, including a facsimile of a letter written home to his family to tell them that he had survived, on 29 May 1945. Kurt Vonnegut, *Armageddon in Retrospect*, Jonathan Cape, London 2008.

3 See p.194 above, a reproduction of the title page of the first edition of *Slaughterhouse-Five*.

4 Joseph Heller, *Catch-22*, Simon & Schuster, New York 1961.

5 J.G. Ballard, *Empire of the Sun*, Gollancz, London 1984.

6 *Slaughterhouse-Five*, p.66.

7 Leo Rubinfien, 'Echoes of War', in Leo Rubinfien and John Junkerman (eds.), *Chewing Gum and Chocolate: Photographs by Shomei Tomatsu*, Aperture, New York 2014, p.186.

8 See Martin Parr and Gerry Badger, *The Photobook: A History*, vol.1, Phaidon, London 2004; see also Ryuichi Kaneko and Ivan Vartanian, *Japanese Photobooks of the 1960s and '70s*, Aperture, New York 2009.

9 *Slaughterhouse-Five*, p.1.

10 Shomei Tomatsu, 'The Original Scene' (1986, trans. Gavin Frew), in *Traces: 50 Years of Tomatsu's Works*, exh. cat., Tokyo Metropolitan Museum of Photography, Tokyo 1999, p.185.

11 Kikuji Kawada, 'The Illusion of the Stain' (1965), in *The Map*, facsimile edition, Getsuyosha, Tokyo 2005.

12 Alain Resnais, *Hiroshima Mon Amour*, 1959, based on an original screenplay by Marguerite Duras, and starring Emmanuelle Riva and Eiji Okada.

13 Daido Moriyama, 'Fossils of Time', in *Memories of a Dog*, trans. John Junkerman, Nazraeli Press, Tucson AZ 2004.

14 After the dispute around whether Emmanuelle Riva's characters had seen 'everything' or 'nothing' in Hiroshima, she recounts her visit to the museum, which contains photographs and 'reconstructions' – Resnais visualises the latter as part of his film.

15 Quotes from Paul Virilio are from his participation in the film *Warum Wir Männer Die Technik So Lieben* (Why We Men Love Technology So Much), directed by Chris Dercon and Stefaan Decostere, BRT, 1985.

16 See particularly the Michelin battlefield guides, pp.22–3 above. For more on this material see Simon Baker, 'Ruins: The Ruins of Ruins. Photography in the Red Zone and the Aftermath of the Great War', in Elena V. Barbaran, Stephan Jaegar and Adam Muller (eds.), *Fighting Words and Images: Representing War across the Disciplines*, University of Toronto Press, Toronto, Buffalo, and London 2012.

17 For a recent and comprehensive account of the immediate postwar imagery of Hiroshima, see John W. Dower, Adam Harrison Levy, David Monteyne et al., *Hiroshima: Ground Zero 1945*, ICP, New York 2011.

ARMAGEDDON IN RETROSPECT
Simon Baker

18 Kenzo Nakajima, 'Foreward', in *Living Hiroshima*, Hiroshima Tourist Association, Hiroshima 1948.

19 Ibid., pp.22–3.

20 Karl Kraus, 'Promotional Trips to Hell' (1921), *In These Great Times: A Karl Kraus Reader*, trans. Joseph Fabry, Max Knight, Karl F. Ross and Harry Zohn, Carcanet, Manchester 1984, p.93.

21 Ibid., p.92. For more on this material see Simon Baker, 'Promotional Trip to Hell', in Jake and Dinos Chapman, *Fucking Hell*, White Cube / FUEL, London 2008.

22 Marguerite Duras, *Hiroshima Mon Amour*, Editions Gallimard, Paris 1960 / trans. Richard Seaver, Grove Press, New York 1961, cited in Eikoh Hosoe, *Deadly Ashes: Pompeii, Auschwitz, Trinity Site, Hiroshima*, Mado-sha Publishing Co., Tokyo 2007, p.85.

23 Ken Domon, *Hiroshima*, Kenko-sha, Tokyo 1958.

24 See Kitaro Lizawa, 'The Evolution of Postwar Photography', in Anne Wilkes Tucker, *The History of Japanese Photography*, Yale University Press, New Haven and London 2003, pp.208–59.

25 Koji Taki, 'Traces of Traces', in *Traces* 1999, p.178.

26 Ken Domon and Shomei Tomatsu, *Hiroshima–Nagasaki Document*, The Japan Council Against the A and H Bombs, Tokyo 1961.

27 Ibid., unpaginated pages opposite Tomatsu's photographs.

28 Shomei Tomatsu, *11:02 Nagasaki*, quoted in Nakahara Atsuyuki, 'Tomatsu Shomei: Fifty Years of Innovation', in *Traces* 1999, p.192.

29 Shomei Tomatsu, *11:02 Nagasaki* – the usual anglicised title of *Nagasaki 11:02, August 9, 1945*, Shashindojin-sha, Tokyo 1966.

30 Shomei Tomatsu, 'The Original Scene', in *Traces* 1999, p.184. See also Shomei Tomatsu, *Ruinous Gardens*, with composition and texts by Toshiharu Ito, PARCO, Tokyo 1987.

31 Kikuji Kawada, in conversation with the author, Tokyo, April 2014. See also Kikuji Kawada, *Theatrum Mundi*, exh. cat., Tokyo Metropolitan Museum of Photography, Tokyo 2003.

32 Kikuji Kawada, 'The Illusion of the Stain', *The Map* (2005 facsimile).

33 Ibid.

34 *The Testimony of Nagasaki*, JRP, Tokyo 1970: *Hiroshima Hiroshima Hiroshima*, publication by the Association of Student Photographers of Japan (Nihon Realism Shashinshudan Shibu), published by Nagasaki Genbeku Hiensha Kyogikai, Nagasaki 1972.

35 Both the student protest movement in Japan in the late 1960s, which resulted in a proliferation of self-published and underground photographic books, and the avant-garde magazine *Provoke* influenced the authors of *Hiroshima Hiroshima Hiroshima*. *Provoke* included the work of such photographers as Takuma Nakahira and Daido Moriyama who espoused a highly subjective, immediate practice, characterised by grainy, blurry images of everyday urban life.

36 Hiromi Tsuchida, *Hiroshima 1945–1979*, Asahi Sonorama Ltd, Tokyo 1979; *Hiroshima*, Kosei Publishing Co., Tokyo 1985; Hiromi Tsuchida, *Hiroshima Collection*, NHK, Tokyo 1995; Hiromi Tsuchida, *Hiroshima Monument II*, NHK, Tokyo 1995.

37 *Hiroshima Collection*, p.110.

38 Ibid., p.8.

39 In conversation with the author, Tokyo 2012.

40 Kirk Palmer, *Hiroshima* 2007.

41 While accepting this reading of the work, Palmer, it is important to note, sees the human, moral and ethical dimensions of the atomic bombings as having been of paramount importance in the conception and production of the work.

42 *Slaughterhouse-Five*, p.19.

43 Ibid., p.1.

44 Ibid., p.74.

45 Ibid., p.64.

ARMAGEDDON IN RETROSPECT
Simon Baker

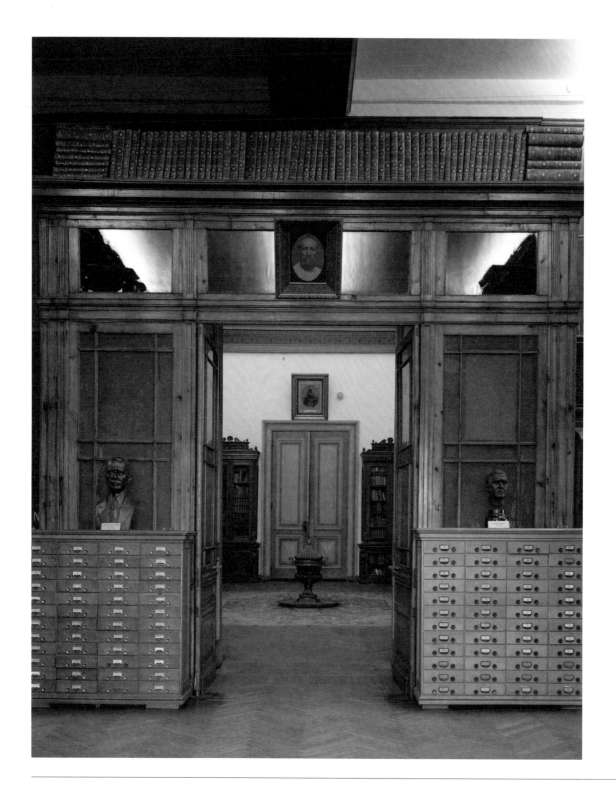

Hrair Sarkissian
istory
2011
Photograph, archival inkjet print
on paper
190 × 150
Courtesy the artist and Kalfayan
Galleries, Athens – Thessaloniki

Photography and the archive are both children of the nineteenth century and its relentless appetite for recording, measuring and categorising. Their histories are closely linked and both share the drive to preserve the past, in the present, for the future. However, not limited to material traces, the archive can also be a mental construction, an abstract entity and a framework for discourse. A creation to which Michel Foucault refers as a 'system of discursivity',[1] the abstract archive does not bear 'the weight of tradition', but existing 'between tradition and oblivion, it reveals the rules of a practice that enables statements both to survive and to undergo regular modification'.[2] Recent contemporary cross-disciplinary research has shifted and expanded the meaning of the archive beyond the stagnant, authoritative, self-contained repository, deepening its ambiguity. What Jacques Derrida suggested in the mid-1990s still rings true today: 'nothing is less clear today than the word "archive"'.[3] The archive, therefore, is nondescript, ambiguous and adaptive; it is this fluid 'general system of the formation and transformation of statements'[4] that has placed it at the centre of much theoretical discourse and debate.[5] This recent expansion in practice pushes the archive beyond its literal meaning, which is simultaneously complicated and strengthened by its multiple meanings and uses, and by the integration of perspectives from a wide range of disciplines. It is what sociologist Thomas Osborne refers to as its elasticity which serves as an invitation for exploration, explaining its widespread use in contemporary art practice, which often leaves behind these 'two extremes of literalism and abstraction'.[6]

Photography, since its invention, has played an important role in contributing to and shaping archives, first due to the inherent traits of the medium, notably its ability to document, reproduce and distribute imagery, and secondly due to the apparent authority that it holds as evidence or historical information. This relationship between the archive and photography has over time, however, become more and more complex, from the vast accumulations of photographic 'documents' in the nineteenth century to the early twentieth century, when photographs from studio archives began to be reinterpreted and collected by museums as art objects, blurring the relationship between photography, art and the archive. In the 1960s, photography emerged as one of the central mediums in archival-based practices through the use of found imagery, first in pop art, which took images from the mass media, followed by a more radical use of photography and the archive in the conceptual practices of the 1970s, which were central to this genre due to their shared links with bureaucratic forms, seriality and the everyday. As writer David Campany explains, conceptual practices sought to highlight ideas and investigations engaging with photography and the archive in many different ways: using the archive as a source of research, gathering and reinterpreting images; recreating or staging archival images; and investigating the relationships between history and memory in the archive.

These conceptual practices opened up a more self-reflective investigation of the meanings and implications inherent in the archive itself, rather than simply using it as a source of imagery.[7]

Although this long history of archival practice is present in *Conflict, Time, Photography*, the majority of the artists have engaged with the archive not because of an interest in traditional archival practices, but out of their personal or political interest in particular conflicts. The conflicts referenced all share complex and contested histories, not only in relation to what occurred at the time, but also in relation to the official narratives and histories that followed – histories that are often hidden or forgotten. Ranging from the Troubles in Northern Ireland to the Armenian Genocide, the Soviet occupation of Lithuania and the Lebanese Civil War, these conflicts, although some occurred almost a hundred years ago, still provoke controversy and therefore renewed engagement and investigation. The examination of these contested, hidden and unknown histories demands a research-based practice, which inevitably leads to and begins with the archive. In an attempt to uncover hidden or forgotten histories, these archives provide a junction between the past and the present, a source of information that activates a conflict that only exists in the distant past as a memory, historical event or both. In the absence of an official narrative, the archive is accessed by the artist seeking information, to fill in the missing gaps amongst these contested histories, to build a more solid understanding by seeing each piece of information as a fragment in the larger story.

Archives are central to *Conflict, Time, Photography* because of their specific relationship with the concepts of *conflict, memory* and *time*. Archives themselves have complicated relationships to conflict since some, such as the Belfast Exposed Archive and the Museum of Genocide Victims of Lithuania, were born out of the direct results of conflict. These archives were set up with the intention to capture certain histories as a form of remembrance or as a result of the loss and destruction caused by the conflict. In this way, archives relating to conflict help to create collective memory, using information to reconstruct the past and give memory its texture.[8] Archives are also linked to notions of time, because they rupture the idea of linear time and provide a vision into the past, bridging the gap between past and present, and allowing artists to activate moments from the past in the present.

In its broadest sense, the archive surfaces repeatedly throughout *Conflict, Time, Photography* and is referenced and engaged with in many different ways. Adam Broomberg and Oliver Chanarin physically delve into the content of the Belfast Exposed archive, using it as a material source; Hrair Sarkissian attempts to engage with the Ottoman archives but is limited by bureaucracy; Chloe Dewe Mathews engages the expertise of scholars and local historians to piece together the locations in which soldiers were

THE MODERN ARCHIVE OF CONFLICT
Shoair Mavlian

shot for cowardice and desertion during the First World War, and Indrė Šerpytytė uses found photographs to expand research into houses used for torture by the KGB during Soviet Lithuania. Adopting the structure and form of the archive in a more direct way, Walid Raad and The Atlas Group create their own archive to imagine histories relating to the Lebanese Civil War, while Susan Meiselas looks back and engages with her own archive of images.

The artist Allan Sekula framed the archive as a 'toolshed'[9] of potential possibilities that can be approached by an artist from two perspectives, firstly as 'historical documents' in order to convey historical knowledge, and secondly as 'aesthetic objects' with purely ornamental value.[10] In their work *People in Trouble Laughing Pushed to the Ground* 2011 (pp.76–9), Broomberg and Chanarin approach the archive as a set of 'aesthetic found objects' to be activated and ruptured, and they incorporate as their conceptual guiding principle one of the technical processes used in 'archivisation':[11] the coloured dots employed by photographers, archivists and editors to identify their selections for publication or the images they have rejected. The artists' 'toolshed', the Belfast Exposed archive, was founded during the height of the Troubles by a group of local professional and amateur photographers from across the sectarian divide with the intention of documenting everyday life from the inside, as a way to counteract images of the conflict portrayed in the international media.[12] A communal public record and important source of visual history, the archive bears the physical traces of time, and interaction with the public over the course of the years has led to marks, wear and tear, and perhaps intentional vandalism. As a result, the contact sheets are filled with markings – mostly the small coloured stickers mentioned above. Within the archive, these dots form a code, which Broomberg and Chanarin use to form and inform the conceptual framework and structure of the project. Thus the code (and therefore the selection) was not made by the artists, but by the archive itself. With the parameters predetermined, the pair then begin the archaeological process of removing the stickers and reprinting the circular section of the image that was previously hidden. This conceptual mode of working offers a perspective on moments in time that have been hidden by the archival processes, sometimes for decades, providing an evocative series of abstract glimpses into the past.

Far from being a stagnant collection, the archive activated and reinterpreted by Broomberg and Chanarin is a functional one. Adding another layer and recontextualising the photographs (now crossing over into the realm of the museum), their work exists simultaneously in the past and present, in the moments when the images were taken, the various moments of interaction over time and the moment when it is retrieved, perhaps belonging to neither past nor present, producing a transcendence of time. By taking this conceptual approach rather than focusing on a subject or theme, Broomberg and Chanarin reveal the 'mix of the mundane and the extreme' often present on a single contact strip.[13] Highlighting the juxtaposition between scenes of police in riot gear with adolescents on the streets, and familiar domestic scenes, the work reveals an unbiased cross section of the archive documenting a community in times of conflict. Everyday activities are intertwined with images of aggression or violence, both playing an equally important role and collapsing the usual hierarchy of images. These mirrored images of conflict and the everyday adopt a shattered and disordered incongruity when viewed against the work's sequential structure. The work is, however, determined by previous selections or rejections, relating to the idea that the archive is never neutral, never just a 'collection' but a 'selection'.[14] Approaching the found material as aesthetic objects and not historic documents sits at odds with the socially engaged nature of the archive, but highlights the importance of contemporary artists' ability to activate and rupture certain accepted narratives of history.

Hrair Sarkissians's work *istory* 2011 (pp.188–9, 206) does not record an event, but instead references events that have occurred in the past, in this case ninety-six years ago. Engaging with the archive on the most rudimentary level, *istory* questions the relationship between access to historical documents and the construction of official historical narratives. Conceived while the artist was on a residency in Istanbul, the work was triggered by a public educational display – a timeline listing each year, accompanied by significant historical events, apart from the year 1915, which was absent. Sarkissian explains how the work stages a confrontation between two contradictory narratives: 'Turkey's official historical account of the Armenian Genocide, which does not acknowledge it as history, and that of my grandparents, who were forced to flee Eastern Anatolia for Syria in 1915.'[15]

Sarkissian, who sought access to various public and semi-private libraries and archives in and around Istanbul,[16] was denied access to several institutions, but granted entry to others. Both Sarkissian and the authorities were acutely aware of the shared histories of Turkey and Armenia. Since he was often accompanied by security guards on these site visits, the conceptual limitations of his project were set by the authorities rather than by himself, and, although access was granted to several spaces, Sarkissian was not able to touch, open or explore any of the material contained within these archive spaces. As he explains: 'on one occasion I was not allowed into the rooms where the books and documents were kept; instead the security guards (the director of the National Archives centre) said I could photograph the reading room, which was full of empty glass cabinets.'[17] Thus the main subject, the archive itself, was neither explored nor interacted with. Instead, the camera merely recorded the space; shot with only the limited available light, the images look stale, claustrophobic and inaccessible.

Here, the 'objective' nature of the archive is brought into question. Recent theoretical debate has acknowledged that the archive, once perceived as a neutral historical repository, is far from being so, and is instead a predetermined collection made by those in a position of power. Despite this understanding, however, archives still wield an enormous amount of authority. Far from being an untouched 'time capsule', the Ottoman archives are said to have been looted several times throughout the twentieth century, putting into question the notion of an archival 'objective truth'. Referring to this purging of the Ottoman archives, historian Taner Akçam notes that a 'systematic cleansing' of an archive can never be fully achieved, since for every document that is destroyed there could be, and often is, another document that speaks of it having existed.[18] In this example of the reinterpretation of classified archives, or archives that intentionally create bureaucratic obstacles to their access, time and conflict work simultaneously to mould the perception of the subject. The changing, arbitrary nature of the archive's content over conflicting time-frames, where content is tailored or manipulated, causes the archive to evolve, while the restrictions placed upon access to the archive limits the interpretation and, therefore, the presentation of the material. All of this brings into question the accuracy and veracity of the archive's ability to represent a moment in history.

In his projects, often the culmination of long periods of thought, Sarkissian addresses the process of facing history through his camera. As historian Steven Hoelscher states, no 'medium is more associated with memory than that of photography'.[19] Thus in Sarkissian's photographs, personal history and public memory are linked and, while acknowledging the presence of what Marianne Hirsch describes as 'postmemory' – a second-hand, delayed and indirect form of memory that is 'distinguished from memory by generational distance and from history by deep personal connection'[20] – his work is also relevant to the present. Although the quest for answers is implied, the work is equally concerned with the idea of looking, inviting the viewer to ask questions and perhaps rethink the expected narratives.

Addressing 'closed' or 'classified' archives, Sarkissian highlights the inherent power relation between archive and information, state and citizen. As Derrida highlights, 'there is no political power without control of the archive … Effective democratisation can always be measured by this essential criterion: the participation in and access to the archive, its constitution and its interpretation.'[21] The opposite of this authoritarian approach is the open archive, what historian Patrick Joyce describes as 'Liberal Archives', claiming that these open archives form the foundation of a free and informed society.[22] The intention of the 'classified' status is to safeguard information, keeping things confidential until sufficient time has passed for the contents to have become less relevant or controversial. In its physical

THE MODERN ARCHIVE OF CONFLICT
Shoair Mavlian

sense, the archive exists, but once closed it is destined to remain a time capsule inside a void, in turn limiting and affecting the construction of history and collective memory. As Walter Benjamin acknowledged, not even the dead are safe when the victors tell the story,[23] which parallels the belief that the archive has the power to marginalise certain histories, particularly in relation to historic conflicts.[24]

Chloe Dewe Mathews, in her work *Shot at Dawn* 2013 (pp.190–1) addresses a subject that was concealed in the British National Archives, until several historians gained access to the classified archives in the 1980s and the records became available to the general public during the early 1990s. The work documents the locations where soldiers were executed for cowardice or desertion during the First World War.[25] Aware of this weighted history and the extended passing of time, Dewe Mathews saw an 'opportunity to re-appraise the knowledge I assumed I had of the war, and a way to shine a light on the under-discussed subplot within it'.[26] Courts-martial documents contained the names, dates and times of the executions, but the locations were far more ambiguous; almost no visual record existed. In a bid to find out more, Dewe Mathews engaged with different academic specialists and local historians in order to piece together information about the exact locality of the executions, entering not into the physical archives, but instead engaging with the archive of personal memory. For the historian, the main interest lies in the documentation of the past; Dewe Mathews, however, 'was interested in looking back from the present. When you stand in the landscape with the execution in mind, you're pushing that event back onto the space. It's a way of stamping that presence back into the landscape and recording it in that particular context.'[27] Although the project draws heavily on academic archival research, text and the document are not present in the finished work; instead, Dewe Mathews simply displays the photographs alongside the name, title, date and location of the shooting. The academic document brings with it, as Sekula suggests, 'a notion of legal or official truth, as well as a notion of proximity to, and verification of, an original event'.[28] The lack of archival documentation in *Shot at Dawn* separates the work from this official weight and authority in order to allow the viewer to think about the moment from the point of view of the present. Thus *Shot at Dawn* sits between two worlds, on the one hand contributing the first systematic photographic documentation to this text-based history, and on the other hand existing outside the realm of the academic archive as a conceptual photographic project.

Shot at Dawn is the visual culmination of research into wartime events and therefore, an archive born out of the memory of conflict. The absence of people within the work mirrors not only the disarray and destruction that a war generates, but also the fragmentation of memory following a period of trauma. It is the absence of those involved in the conflict that generates an

impact, since it leaves gaps for memory to be interpreted. Conflict therefore, is not only the subject that is missing in Mathew's work, but the matter that replaces it, or as theorist Roland Barthes would suggest, the noeme – the thing 'that-has-been'.[29] Photography and the archive in this sense offer an 'abrupt dive into literal death'.[30]

Shot at Dawn alludes to the way in which the archive of official material related to the First World War simultaneously conserves and buries material, and in relation to such a vast conflict, referring back to the individual was key for Dewe Mathews, whose work is about the relationship of people to the landscape. 'It really doesn't matter that the people aren't depicted', she says, 'since by presenting the landscapes, the viewer is given space to think about the individual'.[31]

This desire to reinsert the individual into the present is in tune with works by artists who seek to make physically present historical information that has been lost or displaced.[32] Like Dewe Mathews, Indrė Šerpytytė is interested in highlighting buried or unknown histories by investigating the spaces where past atrocities took place. Her work *(1944–1991) Former NKVD – MVD – MGB – KGB Buildings* 2009 (pp.164–5) investigates the domestic dwellings used by KGB officers as control centres and spaces for interrogation, imprisonment and torture in Lithuania between 1944 and 1991. Šerpytytė explains: 'By bringing attention to the space it makes something invisible partially visible again.' Much of her practice comes from a desire to investigate lost or unknown histories as a way to understand the past, while simultaneously allowing the past to reclaim a place in the present: 'by revisiting the horrors of the past and by showing the work within a contemporary framework I ask for the history not to be forgotten'.[33] Using fragments of information and archival photographs discovered online[34] as the source to investigate this relatively unknown subject, Šerpytytė gave a multi-layered structure to her project, which exists in many forms. She explains: 'What interested me was this idea of this structure that was used by the KGB, the structure of the home, a domestic setting, which is supposed to be a place of refuge and safety, becoming a place of torture, and then becoming a home again.'[35] The format of the work mimics this structure of regeneration, the original photographs becoming objects, and then becoming photographs again. The structure of the project also mimics that of the way in which oral histories are communicated: 'I take the photographs of the houses and then I pass them on to someone else, the craftsman who reinterprets the images by hand and then passes them back to me, which I again reinterpret through photography.'[36] This approach ensures that different perspectives contribute to the narrative, making the work not objective but subjective. The personal and immediate aspect of conflict within the domestic environment is emphasised in Šerpytytė's work: the repetitive nature of her documentation replicates the flashback

attributes of trauma, whilst juxtaposing this with the diffusion of clarity in memory.

As in both Sarkissian's and Dewe Mathews's work, here architecture and physical space play a crucial role as the container in which history and memory resides. Šerpytytė sees 'architecture as an object of memory'.[37] Stemming from her own displacement is an attempt to reclaim this lost or unknown past through photography, where the reconstruction of history plays a major role: 'by rebuilding the inherent history I try to reclaim it', she says. Here, as in many similar works, the boundary between history and memory is blurred and the terms are interchangeable. Such a relationship between history and memory is set up in historian Pierre Nora's seven-volume *Les Lieux de Mémoire* (Sites of Memory), where he discusses how 'modern memory depends entirely on the materiality of trace, the immediacy of the recording, the visibility of the image',[38] directly linking photography or the image to the process of memory. '[W]ith the appearance of the trace, of meditation, of distance', he adds, 'we are not in the realm of true memory but of history'.[39]

These visual investigations into personal histories also contribute to collective memory, and by entering the narrative of contemporary art practice, open out this field of thought into realms outside of its local context. The investigations become an integral part of the final piece, suggesting that this research-based practice is as much pre-production as post-production.[40] Over the course or six years, Šerpytytė has documented over a hundred houses, saying that for this type of methodical research, 'you have to become an archivist yourself'.[41] This view of the artist as archivist is a concept that emerges throughout this exhibition and, as the collated material of the artists is presented, an archive of conflict, rather than a conflicting archive, develops. The archive becomes a linking aspect between the 'operator', curator and spectator,[42] as each generates and engages with the material.

Walid Raad often presents his work under the rubric of The Atlas Group, itself an archival enterprise, which seeks to locate, preserve, study and produce audio, visual and literary documentation that sheds light on Lebanon's recent history.[43] Blurring the line between sites of 'excavation' and sites of 'construction',[44] Raad set up an archival structure for The Atlas Group that organises and creates material in three categories: Type A (authored files that contain documents produced by the group and attributed to named or imaginary individuals or organisations), Type FD (found documents attributed to named individuals or organisations), and Type AGP (Atlas Group Productions). Ambiguity between truth and fiction surrounds much of the work, which, in the absence of an official historical narrative, attempts to navigate the events and experiences surrounding the Lebanese Civil War, whilst at the same time instigating scepticism, questioning notions of truth, authenticity and the telling of history.

Here again, Nora's suggestion that memory demands traces – photographs, film, documents – which enable us to construct modern memory is relevant; without this, collective memory cannot be formed.[45] This is particularly pertinent in relation to Lebanon, since although the civil war officially ended with the Taif Agreement more than twenty years ago, and it was widely acknowledged that a universal text of Lebanon's recent history would be crucial to shaping postwar society, this history is yet to be agreed, and the Civil War remains absent from the official educational curriculum. The absence of this official history leaves events open to interpretation. Possibly stemming from this lack of official cultural documentation or perhaps as a reaction to loss, documentary and archival practice in both theme and form are heavily present in the work of contemporary Lebanese artists from the postwar generation, and many artists have also assisted in setting up real archives to preserve cultural history in the region.[46] This absence of an official history also ruptures the linear notion of time in relation to memory and history, an idea on which Raad plays, often disregarding chronologies and dating his work ambiguously. This deliberate confusion around official dates is a strategy Raad adopts in order to avoid declaring an event or document as closed but rather still open for discussion or reinterpretation. The detailed information provided in much of his work gives the illusion of clarity; however, when viewed closer it is not known what this information amounts to, and we learn nothing of the outcomes of either the perpetrator or the victim, a critical point in an age where images are so often used to put across a particular side of the story.

The archival form and the fluidity and elasticity that it presents are the most logical format for this complex and multi-layered work which, as Raad puts it, attempts to 'examine multiple dimensions of war, social, political, economic, military, technological, psychological and epistemic'.[47] Combining found images from various newspaper archives with text and installation, *My Neck is Thinner than a Hair: Engines* 2000–3 (pp.74–5) looks specifically at the use of car bombs in Beirut during the Civil War in Lebanon, where between the years of 1975 and 1991, 245 car bombs exploded, mainly in the major cities, terrorising daily life. Borrowing the grid structure common in serial photographic practice, the presentation can be seen as a commentary on the banality of violence during war, while at the same time the repetition of images refers to the constant resurfacing of trauma. The grid and repetition also mirrors the psychic tension created by the bombs. In a relentlessly urban city such as Beirut, any one of the endless parked cars could actually be a deadly weapon and explode at any moment, which means that damage is caused not simply by an explosion but also by the creation of a constant anxiety about the next explosion. Perhaps

in an acknowledgment of the elastic nature of the archive, The Atlas Group alternates different modes of presentation and the works exist in several different forms, an expansive approach that relates to how they interpret history in general as part of an ongoing series of research, creation, documentation and archive. Raad explains:

> The project is not an attempt to place blame or generalize suffering … What our work demonstrates is that the detonation of a car bomb is not only an act of violence, but also produces a discourse that directly and indirectly affects individuals, families, and communities … [T]he car bomb is both a cause and a consequence of the ongoing political, military, economic, and criminal conflicts that have defined most aspects of life in Lebanon for the past thirty years. The history of these car bomb explosions doubles as a history of how the wars were physically and psychically experienced, and how those who lived through such events speak about and assimilate their experiences.[48]

Here Raad is highlighting the ramifications of conflict on everyday life, drawing attention not only to the physical impact of the car bomb, but also to the ongoing impact of the event on society, affecting the present and future. The photojournalistic images testify to the car bomb itself, while the grid and repetition highlight the relentless frequency and duration of conflict over time. The gathering of this material more than ten years later accentuates that the conflict is still provoking controversy that needs to be discussed, questioned and investigated.

In this complex setting, the work not only 'draws on informal archives, but produces them as well', and 'does so in a way in that underscores the nature of all archival materials, as found yet constructed, factual yet fictive, public yet private'.[49] *My Neck is Thinner than a Hair: Engines* is an archival collection that doesn't attempt to evade the violence of conflict, but engages with it: the images, taken from the Lebanese press, assume a brutality in their structured display, highlighting the repetitiousness and inexorability of conflict, its impact and how it transcends generations and cultures. Repetition and the use of text, combined with the structural form of the archive, means that the work assumes historical weight; the car bombs definitely exploded – it is just a question of whose history is being represented.

Acting as a mediator, the archive exhumes, bridging past events with the present. Often activated by those whose knowledge is imagined rather than experienced, these secondary accounts are told with the freedom of people not burdened by bearing witness to the conflict. Susan Meiselas, however, needs no mediator, since her own images, taken in Nicaragua over a year-long period during 1978 to 1979, formed much of the photographic basis through which the revolution has come to be imagined. This

personal investment brings out a much more radical space for questioning – a questioning with which Meiselas has actively engaged, revisiting the work, the country and the people, ten, twenty and twenty-five years later. In *Nicaragua: June 1978 – July 1979* (1981), Meiselas states that 'this book was made so that we remember',[50] but it is how and what we remember that has become key over time, since time, along with nostalgia, shapes memory, particularly in this fraught political landscape, where hope and change quickly turn to despair, regret and loss.

Looking back is a common trait among photographers, whose years of work has resulted in large archives of images, but Meiselas is not revisiting an archive of unknown images, but an archive of iconic images. This implies a more direct interest in the nature of time as a key part of the photographic medium and the photographer's responsibility to contextualise and recontextualise the image. Meiselas states, 'It's true that photographs stop time. But for people, time doesn't stop. Maybe photographs tell a kind of truth about the moments they fix. But is it enough of the truth? … [I]s that truth of any consequence?'[51] By engaging with her own archive Meiselas is re-presenting her active intentions to discover, document and collect over time as well as to visually articulate the transformation process and life of an image over time.

Explaining this complicated relationship with time, in which past and present merge and memory is a central concern, she comments, 'I'm still fascinated by, curious about, and almost desperate to understand the impact of time.'[52] Ten years after the revolution, in an acknowledgment of how little she knew about her subjects, Meiselas returned to Nicaragua to find the people in the photographs, and made the film *Pictures from a Revolution* (1991).[53] Here, she travels around Nicaragua with her photobook of images, finding the individuals pictured and asking them about their memory of that frozen moment, curious to reveal their perspective on the revolution ten years later. As the film unfolds, the unreliability of memory and the inability of an image to convey truth become apparent, revealing many complicated and conflicting perspectives. This understanding of the images as 'fragments of an experience'[54] explains why Meiselas returned to Nicaragua as a way to reconsider the work in a multi-dimensional way.

Completed on the twenty-fifth anniversary of the revolution, *Reframing History: Nicaragua 25th Anniversary Mural Project* 2004 was an installation of nineteen mural-sized prints in the locations in which they were shot (pp.136–7). Collaborating with local communities, Meiselas created sites of collective memory, provoking and inviting an interrogation of recent history. Both later projects are about the layering of time, history and people. Whilst acknowledging that each image exists and belongs to a certain time and space, by returning to Nicaragua Meiselas

acknowledges the limits of her photographs (the documents) to tell the story of the revolution, and the fact that images, documents and history need constant recontextualising. The original selection of images published in 1981 are fixed and constitute a kind of time capsule, but by revisiting the work Meiselas ruptures time, reinserting these moments into the present. This rupture of time diminishes the heroic nature of the image, honestly unveiling the reality of Nicaragua in the aftermath of the revolution and questioning what the revolution means in real terms, what it means to be revisited, revealing an ongoing contested reality of the memory.

Referring back to the archive in a more traditional sense Meiselas, in the work *The Life of an Image: 'Molotov Man'*, comments on how the image 'has a life of its own afterwards',[55] beyond the control of the artist. Shot on 16 July, the day before Anastasio Somoza fled Nicaragua forever, her now iconic image (depicting the Sandinista Pablo 'Bareta' Arauz throwing a Molotov cocktail at one of the last National Guard regiments remaining under the dictator's control) captured a defining moment of the revolution. Almost immediately, the image evolved to become a symbol of the revolution, representing that moment in history, the final struggle. As Meiselas explains: 'what began as a document became an illustration and then a symbol'.[56] Used on matchbox covers celebrating the first anniversary of the revolution, employed by the Catholic Church, by the Sandinistas and also by the Contras, on murals, t-shirts and finally as the emblem of the twenty-fifth anniversary, the image came to symbolise many often contradictory things. Just as the conflict has different connotations for separate people, so too does the image. Now presented by Meiselas as an installation of archival material that shows the life of the picture in all its subsequent forms, it demonstrates the uncontrollable potential of an image, as well as how we remember, again harking back to the idea that memory needs an image.[57]

In a way, *Molotov Man* represents the opposite of what Meiselas was trying to achieve by contextualising and recontextualising the past. Unlike a single image, which displays a limited, framed vision of an event, an archive of images or documents has the possibility, with its accumulation of objects, to build a more versatile picture, each object shedding light on the next. The archive and conflict are linked by the unfortunate reality of violence and the tragedy that this violence brings, the need to remember the victims and their suffering. The archive attempts to hold this information but requires interpretation as subsequent societies deal with trauma as time goes on. In essence, conflict and the archive work simultaneously, both on an aesthetic and abstract level: conflict generates archival material due to the inherent need to remember the war, loss and trauma of a particular time. The material produced is often fragmented and fractured, mimicking the chaos of conflict itself.

THE MODERN ARCHIVE OF CONFLICT
Shoair Mavlian

As time progresses, the archive helps form collective memory, establishing accepted narratives and official histories. However, these histories are often contested, and over time the history of conflict is questioned as perceptions alter and archival material is activated, clarified and recontextualised. The fluidity and elasticity of the archive, therefore, is anchored and tethered by conflict, while conflict relies on the archive for remembrance. As Foucault has written, the archive 'emerges in fragments, regions and levels, more fully, no doubt, and with greater sharpness the greater the time that separates us from it: at most, were it not for the rarity of the documents, the greater chronological distance would be necessary to analyse it'.[58]

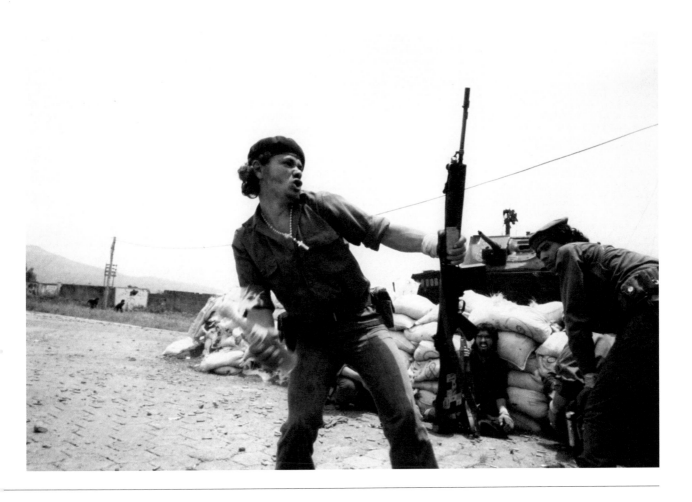

Susan Meiselas
Sandinistas at the Wall of the
National Guard Headquarters:
'Molotov Man', Estelí, Nicaragua,
July 16th 1979
1979
Photograph, C-print on paper
50.8 × 61
Collection of the artist

1 Michel Foucault, *L'Archologie du Savoir*, Edition Gallimard, Paris 1969, trans. Alan Sheridan Smith, *The Archaeology of Knowledge*, Travistock Publications, London/Panthenon Books, New York 1972, pp.126–31, p.129.

2 Foucault 1972, p.130.

3 Jacques Derrida, *Archive Fever: A Freudian Impression*, trans. Eric Prenowitz, The University of Chicago Press, Chicago and London 1995, p.90.

4 Foucault 1972, p.130.

5 Seminal texts include Derrida 1995 and Foucault 1969.

6 Thomas Osborne, 'The Ordinariness of the Archive', *History of the Human Sciences*, vol.12, no.2, May 1999, pp.51–64, p.53.

7 For a survey on conceptual and archival practice in photography see David Campany, *Art and Photography*, Phaidon, London 2003, pp.16–22.

8 Steven Hoelscher, 'Dresden: A Camera Accuses. Rubble Photography and the Politics of Memory in Divided Germany', *History of Photography*, vol.36, no.3, 2012, pp.288–305, p.291.

9 Allan Sekula, 'Reading an Archive: Photography between Labour and Capital', in Patricia Holland, Jo Spence and Simon Watney (eds.), *Photography/Politics: Two*, Comedia, London 1986, pp.152–61, p.155.

10 Ibid., p.157.

11 Derrida uses the word 'archivization' to describe how the technical methods used in an archive effect what is recorded, emphasising how the structure and processes of the archive determine what can and is archived. Derrida 1995, p.17.

12 http://www.belfastexposed.org/

13 Adam Broomberg and Oliver Chanarin, conversation with the author, 22 May 2014.

14 Sekula in Holland, Spence and Watney 1986, p.155.

15 Hrair Sarkissian in conversation with Murtaza Vali, in *Extra/Ordinary*, exh. cat., The Abraaj Group Art Prize 2013, p.99.

16 Sites photographed included Ataturk Library in Taksim, the Ottoman Archives of the Prime Minister General Directorate of Sate, and the Ottoman Bank Archives and Research Centre. These institutions house historical texts, primary sources, documents, manuscripts and multimedia resources.

17 Hrair Sarkissian, in conversation with Sheena Wagstaff, Arts Club, London, 12 February 2013, for *Bidoun Magazine*.

18 Basak Ertür, 'Plenty of History', *Manifesta Journal*, no.15, *I Forgot to Remember to Forget*, 29 July 2013. http://www.manifestajournal.org/sites/default/files/issues-pdf/mj15-i-forgot-remember-forget/120703_MJ-15.pdf

19 Hoelscher 2012, p.291.

THE MODERN ARCHIVE OF CONFLICT
Shoair Mavlian

20 Early concepts of postmemory were developed based on case studies of the Holocaust. Postmemory refers to the relationship that the generation after has to the personal, collective and cultural trauma of their ancestors; experiences which they 'remember' only through the stories, images and behaviours around which they grew up. See Marianne Hirsch, *Family Frames: Photography, Narrative and Postmemory*, Harvard University Press, Cambridge MA 1997, p.8 and *The Generation of Postmemory: Writing and Visual Culture after the Holocaust*, Columbia University Press, New York 2012.

21 Derrida 1995, p.4, note 1.

22 Patrick Joyce, 'The Politics of the Liberal Archive', *History of the Human Sciences*, vol.12, no.2, May 1999, pp.35–49.

23 Walter Benjamin, 'Thesis on the Philosophy of History', in *Illuminations*, ed. Hannah Arendt, trans. Harry Zohn, Fontana Press, Glasgow 1973, p.257.

24 This is the case particularly in relation to the First World War; see Joan M. Schwarts and Terry Cook, 'Archives, Records and Power: The Making of Modern Memory', *Archival Science*, vol.2, nos.1–2, 2002, pp.1–19, p.7.

25 This archival material has been the subject of much academic research. John Hipkin led the 'shot at dawn' campaign along with Julian Putkowski. Several leading historians along with relatives of the deceased led a twenty-year campaign for the men to be granted a posthumous pardon. A conditional pardon was granted in 2007.

26 Chloe Dewe Mathews, conversation with the author, 23 May 2014.

27 Ibid.

28 Sekula 1986, p.157.

29 Roland Barthes, *Camera Lucida: Reflections on Photography*, Vintage Books, London 2000, p.96.

30 Ibid., p.92.

31 Dewe Mathews, conversation with the author.

32 Hal Foster, 'An Archival Impulse', *October*, no.110, Fall 2004, pp.3–22, p.4.

33 Indrė Šerpytytė, interview with Martin Barns, Senior Curator of Photography at the Victoria and Albert Museum, London, 2009.

34 See http://www.genocid.lt/muziejus/en.

35 Indrė Šerpytytė, conversation with the author, 13 June 2014.

36 Ibid.

37 Šerpytytė, interview with Martin Barns.

38 Pierre Nora, 'Between Memory and History: Les Lieux de Mémoire', *Representations*, no.26, *Special Issue: Memory and Counter-Memory*, Spring 1989, pp.7–24, p.13.

39 Ibid., p.8.

40 Foster 2004, p.5.

41 Šerpytytė, conversation with the author.

42 Barthes 2000, p.9.

43 www.theatlasgroup.org/.

44 Foster 2004, p.22.

45 Nora 1989, p.13.

46 For example, in the work of postwar generation artists such as Khalil Joreige and Lamia Joreige. The photographic archive The Arab Image Foundation was established in Beirut in 1997 dedicated to the collection, preservation and study of photography and visual material from the Middle East, North Africa and the Arab diaspora. Founding members include Akram Zaatari, Fouad Elkoury and Samer Mohdad. Walid Raad and Yto Barrada have also been involved.

47 Walid Raad, *Scratching on Things I Could Disavow: Some Essays from the Atlas Group Project*, Walther König, Cologne and Culturgest, Lisbon 2007, p.91.

48 Ibid.

49 Foster 2004, p.5.

50 Susan Meiselas, *Nicaragua*, Pantheon, New York 1981.

51 Susan Meiselas, *Pictures from a Revolution*, produced, directed and edited by Susan Meiselas, Richard P. Rogers and Alfred Guzzetti, 1991, colour, 93 minutes, distributor Kino International.

52 Susan Meiselas, in Drake Stutesman, 'Connectivity: An Interview with Susan Meiselas', *Framework*, vol.51, no.1, Spring 2010, pp.66–78, p.67.

53 Meiselas's images were also used in the film *Voyages*, directed by Marc Karlin 1985, followed by *Pictures from a Revolution* in 1991.

54 Meiselas in Stutesman 2010, p.64.

55 Ibid., p.67.

56 Meiselas, *Pictures from a Revolution*.

57 Bertrand Russell, *The Analysis of Mind*, Allen and Irwin, London 1921, p.26.

58 Foucault 1969, p.130.

Unknown photographer
USAAF camera-men gathered
before 'Suella B', Super Fortress
44-61577, preparing for Operation
Crossroads, July 1946
1946
Archive of Modern Conflict, London

Lenses and the Mouths of Rifles

Since its inception, the making of photographs has been involved with the making of war itself. As the artists Adam Broomberg and Oliver Charnarin have observed: 'the act of war coincides with its representation, with the act of image making'.[1] Nowhere, perhaps, is this convergence between the absolute violence of war and the production of photographs more startlingly demonstrated than in Matsumoto Eiichi's photograph *Shadow of a soldier remaining on the wooden wall of the Nagasaki military headquarters (Minami-Yamate machi, 4.5km from Ground Zero)* 1945 (pp.16–17). Here, a silhouetted human figure is 'photographed' by the blinding light of the atomic bomb on the city of Nagasaki, fixed upon a rough screen. As demonstrated by contemporary UAV (Unmanned Aerial Vehicle) drones, which are platforms for remote visual surveillance as well as weapons, 'there is very little difference between the technologies used to wage war and those used to view it'.[2]

The significance of this conjunction of guns and cameras was underlined by the German author and ex-Shock Trooper soldier Ernst Jünger in his 1930 essay 'Krieg und Lichtbild' (War and Photography):

> It is that same intelligence, whose weapons of annihilation can locate an enemy to the exact second and metre, that labours to preserve the great historical event in fine detail … Included among the documents of particular precision … are photographs, of which a large supply accumulated during the war. Day in and day out, optical lenses were pointed at combat zones alongside the mouths of rifles and cannons.[3]

There was a closeness between the extreme existential experience of combat, and combat photography itself – for example, in the life and work of Don McCullin and Robert Capa – but Jünger also drew attention to more banal ways in

Unknown photographer
Paper Target c.1918
Archive of Modern Conflict,
London

which the cultural memories of war might be assembled through photographs: 'the types of weaponry, the look of destruction they inflict on human beings and on the fruits of their labour, on their dwellings and on nature; the face of the battlefield at rest'.[4] He cited a vast 'trove' of images that had been generated by photography during the First World War and which were now being turned into memorialising photobooks. This process of itemising the evidence of war stemmed from the commercial publication of endless recombinations of images during and in the aftermath of war. In photobooks such as *Les Vandales en France* (The Vandals in France, 1915; pp.20–1) it was a tactic in the patriotic recovery of national identity by the French, while in books such as *Krieg dem Kriege* (War against War, 1924; pp.68–9) it was to convey the disgust with war felt by radical Germans.

Photographs of debris from German bombardment piled in the chancel of Reims Cathedral were widely reproduced and circulated, as in Pierre Antony-Thouret's folio *Reims au Lendemain de la Guerre* (Reims after the War, 1927; pp.26–32). His photogravures signified the larger desecration of the fabric of embodied France. In this, they followed the example of photographing the wrecks of national symbols that had begun in France with documentation of the buildings destroyed by The Commune in 1871, particularly in the two-volume work by Alfred D'Aunay, *Les Ruines de Paris* (Ruins of Paris, 1871). A double process was at work: the careful marking of the de-sacralised, ruined buildings and then their re-sacralisation[5] as mutilated parts of France. According to D'Aunay, The Commune's act of destruction of the Vendôme Column honouring the victories of Napoleon I was a 'sacrilege' within the bigger trauma of French defeat and Communist insurgency.

In Chris Marker's photo-roman film *La Jetée* (The Jetty, 1962), a photograph of the ruined interior of Reims Cathedral sits in a montage sequence alongside the skeletal north side of the Frauenkirche in Dresden and a shocking mocked-up image of a smashed Arc du Triomphe. In this movie, not just the unnamed time-travelling anti-hero, but also the film itself, suffers from shock and damaged memory in relation to a projected future trauma – World War Three. These discontinuities of history – this sense of the broken-off that war brings – are graphically emblematised by actual and simulated photographs of ruin. They point towards catastrophes of war as the motor of history, with the ultimate catastrophe of nuclear war waiting in the wings.[6]

Trauma Time
Photographers such as D'Aunay and Antony-Thouret forensically showed traumatic injuries sustained by the metaphoric body of France, while Don McCullin, in his 1968 photograph *Shell-shocked US Marine, Vietnam, Huế* (pp.8–9), pictured 'the shrapnel of traumatic time' lodged in an American soldier's body.[7] The marine's unearthly martyr's gaze is both pained and elsewhere,

ON OMAHA BEACH
David Alan Mellor

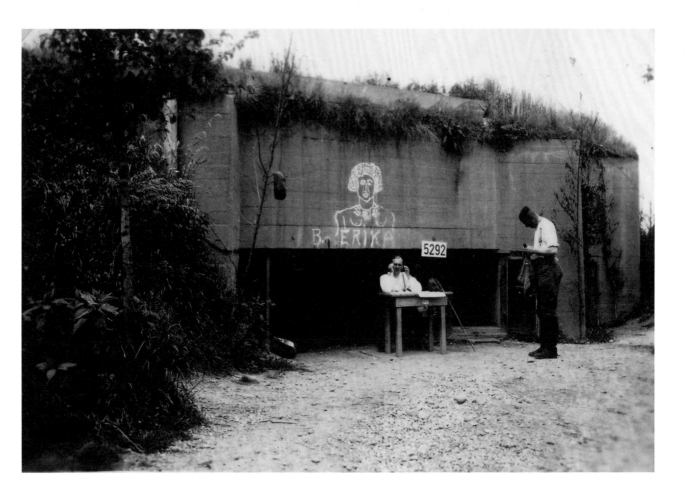

separated from the continuities of ordinary time in a dark pocket of combat-time. McCullin, during the siege of Huế in February 1968, came to view the battle in terms of bodies under extraordinary stress. The context for this was the cyclonic violence and scrambled time of the Tet Offensive by the Viet Cong, which went on to reframe the narrative of the Vietnam war itself. McCullin recognised his own symptoms of what would now be called Post Traumatic Stress Disorder in the aftermath of the siege, when he had been helicopter-evacuated to the US base at Da Nang: 'My body was somebody else's body. My face was somebody else's. I think this was combat fatigue. It went way beyond madness. I threw all my clothes in a waste bin.'[8] His account – what amounted to the testimony of a temporarily dissociated identity – closed with an incident drawn from the narrative of a film in which his still photographs had featured during the previous year – Michelangelo Antonioni's *Blow-Up* (1967).

Perhaps the photographic shocks of war are rehearsed early on in life, as is implied at the start of *La Jetée*, when we hear on the soundtrack: 'This is the story of a man marked by an image from his childhood.' Paul Virilio traced back to his childhood his obsession with abandoned and ruined Nazi military bunkers in coastal Northern France – the Atlantikwall – which he photographed between the mid-1950s and the 1970s, leading to his publication *Bunker Archéologie (Bunker Archeology*, 1975; pp.122–3): 'A lot of people of my generation, whether in Germany, France or England, went through this trauma of war … A kid is a war voyeur. He watches atrocities through a keyhole. That explains *Bunker Archeology*.'[9] For Virilio, it was his moment of encounter with the overwhelming Nazi attack on France – the *Blitzkrieg* – that marked him, with its speed and unprecedentedly aggressive advance:

We switched on the radio and heard that the Germans were in Orleans. There are 400 kilometers between Orleans and Nantes.

Unknown photographer
*German Soldiers relaxing outside
an Atlantikwall Bunker* c.1943
Archive of Modern Conflict,
London

We thought, 'They are still in Orleans. We have got time to pack.' After the meal we heard a weird noise out in the street. I rushed out (I was only 8) and I saw the enemy already there. This was the Blitzkrieg. Thus I experienced this conjunction of speed and war.[10]

Photographers who were the agents of the new sensibilities of the 1960s were often marked by their childhood experiences during the Second World War, and arguably Don McCullin followed this pattern. He has recounted a childhood formed by the Blitz and peacetime murder and death: coming home to his north London district of Finsbury Park after an initially idyllic evacuation to Somerset, 'the bombing was intense and frightening';[11] when he was evacuated to a Lancashire farm for more than four months during the V1 and V2 attacks on London, he was physically abused; then when his career as a cameraman took off in 1959, it was enabled by reporting on the aftermath of a murder in Finsbury Park: 'The jumping off point for my whole life was based on a terrible act of violence and its consequences.'[12] Violence was also a prompt later, with the terrifying narrative of the Cold War and, by early August 1961, the likelihood of fighting between US and East German troops in Berlin. It was the time of McCullin's honeymoon in Paris, and the end of the world – through an escalation of tension in Berlin descending into thermonuclear war – seemed close. The Berlin Wall was being built, and it was a photograph of an East German soldier fleeing the eastern sector by leaping over the barbed-wire border that caught McCullin's attention.[13] At Checkpoint Charlie on Freidrichstrasse, he loitered on the sultry August days, peering at the no-man's land of the zone that divided East from West. Behind and around him, on the western side of Freidrichstrasse, was a weird urban panorama, with immobilised US troops taking up defensive positions on the ruined pavements and doorways of West Berlin, intermingled with women shopping. Most striking of all these images is *Near Checkpoint Charlie, Berlin 1961* (p.91), taken at ground level, with a heavy machine gun pointing east along the pavement, a heavy boot in the extreme foreground. Meanwhile, a middle-aged woman with a handbag walks with seeming unconcern towards the camera. Waiting for an unimaginable war, vacant gazes cross the most dangerous street in the world in these images, recalling those lost looks that McCullin would photograph among a similarly distracted crowd gathered outside Bedford Gaol, when James Hanratty was hanged for his part in the 'A6 Murder' on the cold morning of 4 April 1962. Vacant and lethal, Berlin's no-man's land, was the buffer between East and West, as significant as the space between the Western Front armies in the First World War, featuring as the abandoned dead zone at the climax of John le Carré's novel *The Spy who Came in from the Cold* (1963): 'East and west of The Wall lay the unrestored part of Berlin; a half-world of ruin.'[14]

The great photographic monument to Berlin's dead zone was made by Harry Shunk and János Kender, recorders and contributors to the Parisian Nouveaux Realiste group of artists in the early to mid 1960s. They gave their bleak photographs of the Wall's segments, the strictly limited, walled-in space between East and West, an ironic title: *World Tour* (pp.104–11). In Shunk and Kender's series, the implacable surfaces of The Wall break down into localised spaces: bricked-up and roughly sealed openings of faceless windows and blocked doorways. The photographs depict the planar, shuttered, striated walls and surfaces of divided Berlin, cropped or in close up, replete with graffitied reminders of totalitarianism; for example, the letters 'KZ' (*Konzentration Lager* – concentration camp) painted in white on brick walls. Here was a manifestation of an Iron Curtain made up of squalid breeze-blocks. In June 1962, Shunk and Kender photographed another Iron Curtain, a Nouveaux Réaliste sculpture and urban provocation: eighty-nine piled-up oil drums blocking the rue Visconti in Paris, constructed by the artist Christo. In his typewritten documentation for the project, Christo referred to this barricade as a *rideau de fer* – an iron curtain. McCullin's reportages of paralysed moments during the August 1961 Checkpoint Charlie confrontation, and Shunk and Kender's intimate notation of mute scenes along the Wall, appear to the spectator as a world in stasis – fragments of history composed of stunned images that in their dream-like state appear to be already stuck in a larger traumatised memory. Virilio's strategy, when gathering his photographs of the bunkers of the Atlantikwall, was to slow down that apocalyptically fast history of the *Blitzkrieg* to the point of eternalising it as a vast, monumental and melancholy spectacle.

The nullifying conquest of an oppressive time, in relation to the terror of Nazism, can also be seen in Stephen Shore's memorialising of surviving Jewish communities in his recent series *Ukraine* 2012–13 (pp.172–9). His reportage tour has associations with Jonathan Safran Foer's novel *Everything Is Illuminated* (2001); that is, the picaresque trope of an American exploring Ukraine, searching for memories of annihilation and survival among Jews in the face of Nazi extermination. In these serene, coloured fragments realms of rest for both the old and the young are depicted. One elderly lady – *Galina Karpenko, of Tomashpol, Ukraine – 25th July 2012*, was one of those spared from Nazi persecution after the invasion of Ukraine in June 1941. In one cluster of photographs, Karpenko resembles – in her poses and the picture's composition – Lucian Freud's portraits of his refugee Berlin mother lying back on a pillow. The theme is that of ark-like survival after a close brush with annihilation. What Shore has done is to present a cluster of portraits of sleep, a benign reflective solitude and the calm of deliverance. By accomplishing this, Shore shares a vital aspect of Foer's novel, bringing about, in the words of Francisco Collado-Rodríguez, a slow 'release of repressed trauma'.[15]

ON OMAHA BEACH
David Alan Mellor

That decompressive effect of the unearthing, retrieval and release of traumatic memory is at the heart of Susan Meiselas's 2004 revisitation of her photographs of Nicaragua, which she had made during her reportage on the civil war in that country in the late 1970s. Her *Reframing History: Nicaragua 25th Anniversary Mural Project* 2004 (pp.136–7) is about the establishment of monuments – photographic monuments like billboards – sited at the location of incidents that she had photographed twenty-five years before for her book *Nicaragua: June 1978 – July 1979* (1981). These billboards – integrating contemporary place and a previous photographic image – prompt the recollection of traumatic moments that happened and were photographed by Meiselas during the 'dirty war' and the Sandanista's liberation of their country. Some of these recollections, spoken by witnesses whose memories reverberated with the original incidents, form the soundtrack to Alfred Guzzetti's video *Reframing History: Bareta*,[16] which begins with over-size shovels digging down into soil, an excavation that could also be a disinterment but turns out to be preparatory work to sink frame posts for the billboard hoardings that will carry Meiselas's photographs. The short film then moves to the erection of a blow-up of her photograph of the military searching a bus queue, and the spoken words of a male recalling: 'It's what I have fixed in my mind from that time', while another voice says: 'That's why I keep remembering those terrible moments … [of] anguish and desperation.'

The Funereal
Meiselas's blow-ups, set into the landscape, accost passers-by and function as memorial stelae of a 'dirty war', like the Jewish gravestones at the centre of Jerzy Lewczyński's *Pessimistic Triptych* 1960 (pp.82–3). This cluster of stones is laterally bordered by brute manufactured objects – bedframes, shoes from Auschwitz – rather than figurative artifacts, as if the customary funerary markers of the gravestones were rendered inadequate by the raw things that carry their own memory as jetsam thrown up in the disaster of the Shoah and the systematic Nazi massacres that took place in Lewczyński's Polish vicinity. These relics are memorial markers for Lewczyński, which he had photographed at Auschwitz fifteen years after its liberation. Despite the title of the triptych, Lewczyński photographically rescued these abject souvenirs so that they would not be 'doomed to oblivion or … at the mercy of fortune'.[17]

Like Virilio, Lewczyński was drawn to photograph the monstrous concrete bunkers built by the Nazi engineering group Organisation Todt and imposed deep in occupied Poland. Slave labour was used to build them: they were, in all senses, totalitarian sites. Lewczyński had been a resistance fighter with the Armia Krajowa, the Polish Home Army, and he photographed the extermination camps at Majdanek and Auschwitz in all the dilapidated spiky horror of their decaying ferro-concrete construction. At the same time, he turned his attention to

ON OMAHA BEACH
David Alan Mellor

another ruined Polish site that resonated with a baleful history of European fascism: the blown-up remains of the Wolfsschanze (The Wolf's Lair), which had been Hitler's eastern command post (pp.84–5). As in Anselm Kiefer's paintings of Hitler's Chancellery made nearly twenty years later, their monumental surfaces are broken into agitated forms. A pictorial haunting takes place, which Lewczyński calls 'an authentic witness of past events'.[18] In his photographs of the Wolfsschanze, unquiet flying fingers of rusted steel rods, which had reinforced the concrete itself, probe and pierce the bright sunlit air, fretful abstract elements that were themselves refugees from Polish constructivism. They stand as dynamic elements against the inert density of myth and terror in the sinister location, after its destruction by the retreating SS.

In February 1968, it had been a sensitivity to arenas of past history, to places haunted by histories of violence, that brought McCullin to the old Imperial capital of Huế in South Vietnam. As he flew into Saigon he reflected on his motive in travelling there in relation to his recent part in the Six Days War: 'As with Jerusalem, I was drawn to the idea of covering a battle in an ancient city.'[19] Another instance of being caught up by echoes of former martial tumults and ruin, but in the light of contemporary geo-political faultlines, is evident in Ursula Schulz-Dornburg's photographic project Train Stations of the Hejaz Railway 2003 (pp.184–5). This takes the shape of a faux-topographical survey of a vanished European Imperial scheme – the Hejaz Railway, designed and built by the German engineer Heinrich Meissner between 1900 and 1908 as part of the infrastructure of the Ottoman Empire, linking Damascus and Medina. In 2003, Schulz-Dornburg managed to photograph at regular intervals along the site of this track, picturing deserted railway stations and remains of track bed, across grand wastelands, like the desert ground in Sophie Ristelhueber's Fait 1992, which also recorded another tragic aftermath of Empire, in this case Saddam Hussein's hubristic attempt at mastery in Iraq and its region (pp.36–45).

Schulz-Dornburg's sites contain places haunted by mayhem and death that are caught up in the geometry of the converging lines of the railroad. This stretch of desert is pervaded by the mythos of Colonel T.E. Lawrence, the English archaeologist and army officer who led Bedouin guerrillas to raid and destroy portions of the railway repeatedly between 1915 and 1917. Her desert landscapes are full of absence – the vacancy of western imperial heroics; the absence, even, of the very metal rails that ran over the ballasted track bed laid down in Meissner's German epic of building. Lawrence would later call his campaign of guerilla warfare 'railway cutting'. He was aware of the immensity of the desert and the need for an entirely different model of military strategy, contrasting the waste of pitting huge numbers of soldiers against one another – the 'absolute war' on the Western Front – with his gadfly guerilla tactics. 'The Arab War', he wrote, 'should be a war of detachment to contain the enemy by the silent threat

of a vast unknown desert, not disclosing themselves until the moment of attack … this attack need be only nominal, directed not against his men, but against his materials … In railway cutting this would usually be an empty stretch of rail.' Lawrence imagined the irregular Arab insurgent force against the Turks as a dematerialised entity: 'an influence, a thing invulnerable, intangible, without front or back, drifting about like gas. Armies were like plants, immobile as a whole, firm-rooted and nourished through long stems to the head. The Arabs might be like a vapour, blowing where they listed.'[20] Lawrence's metaphor of the 'intangible' nature of the Arab revolt is the prototype of twentieth-century guerilla warfare, and it is precisely this ghostly, disembodied image that blows around the desert places of Schulz-Dornburg's photographs of the Hejaz railtrack bed.

Seen singly or in succession, Schulz-Dornburg's photographs plunge along the axis of the railway, along the track bed, into a deep space like the surface of Mars. This disenchanted point of view from the front of a ghost train is reminiscent of an entire genre in early cinematography: the 'phantom ride' film.[21] The game of Empires – Ottoman, British, French – overlays traces of earlier empires and comes forward to meet us in our phantom ride into the interior desertscapes of Saudi Arabia; a past that is eroded, while still bearing traces of its earlier function, almost a century after its destruction. This sequencing of the past through Schulz-Dornburg's succession of photographs is unsettling for the viewer, observed as if from the position of a phantom train driver. These are unanimated still photographs, but as we pass over them, a sort of kinesis and subjectivised temporality enters in: 'By waiting for movement we also experience duration.'[22] That future that is rising before us is a past in ruination, which also lies ahead of us after twenty-first century invasions and wars in Iraq and Afghanistan. A temporal pessimism hovers over the photographs, perhaps corresponding to an experience of time and duration which Henri Bergson characterised as 'predatory' in his study Matter and Memory: 'the present is the invisible progress of the past gnawing into the future'.[23]

The photographic reanimation of the past occasionally bears down upon and haunts the present when it is excavated or exhumed. Luc Delahaye's Patio Civil, cementero San Raphael, Malága 2009 (pp.180–1) shows a monumental grave dating from the Spanish Civil War, seen from above, with exposed skeletons flattened and suffused by dark light as they lie in the earth. These are the phantom traces of multiple bodies-in-pieces. In photographs such as Ambush, Ramadi 2006 Delahaye adopts a rarified photographic stare (pp.4–5). Time hangs in the air in the aftermath of an insurgent attack, where colour is washed out until it reaches the limit of Lawrence's metaphor for guerilla action – becoming a 'vapour'. No such ineffable dematerialised suspension operates in Patio, where we are gripped by the all-too substantial skeletal remains. The photograph represents a

ON OMAHA BEACH
David Alan Mellor

baroque eschatological moment, with scarifying flying skeletons 'rising' from the bottom of the picture frame. It is a perfect example of a photographic haunting by war, the return of a previously repressed history in the form of the mortal remains of those murdered by General Franco's fascists.

The contemplation of 'last things', of eschatologies, rises again in J.G. Ballard's apocalyptic narratives, where he repeatedly refers to intense subjectivisation precipitated by extreme modern events. The pathos of devastation found at abandoned test sites of nuclear weaponry holds a particularly prominent position in his imagination of pulverised versions of space and time. In his short story 'The Terminal Beach' he cites the blasted Pacific island of Eniwetok, where the US tested the first hydrogen bomb in 1954. Here the bunkers and paraphernalia of the bomb tests resolve themselves into cryptic distressed monuments of the nuclear era.[24] In 2012, Schulz-Dornburg travelled to photograph one of these 'dark sites' in post-Soviet Asia, where the ground is left contaminated by radioactive after-traces. The displaced concrete bunkers she photographed at the former Soviet nuclear-weapons testing site, Opytnoe Pole in Semipalatinsk, Kazakhstan (pp.134–5), are at one with the toppled concrete bunkers in Virilio's Atlantikwall and Lewczyński's Wolfsschanze: that is, they are set at an unsteadying slant, which for Virilio was a signifier of extreme stress on the human body. Schulz-Dornburg's ruined diagonal fragments have survived from the epoch of mutual assured destruction, and stand sombrely, if unsteadily, like tilted moai monoliths – the Easter Island sculptural heads. The diagonal produced by tilted giant-scale concrete dice-forms found in the compositional presentation of the wrecks of Nazi and Soviet monuments by Schulz-Dornburg, Lewczynzski and Virilio, was repeated again in Jane and Louise Wilson's Atlantikwall homages to Virilio, such as *Urville* and *Biville*, made in 2006 (pp.162–3). Encountered in some spatial and temporal limbo – beaches, wastelands – the aura of some deathly ceremonial had struck Virilio as early as 1958. In his first text on the Atlantikwall's ruined remains he wrote: 'this piece of artillery fortification could be identified as a funeral ceremony, as if the Todt Organisation could manage only the organisation of a religious space'.[25] The eschatological funerality attached to cyclopean fragments of destroyed concrete from Hitler's *Götterdämerung* (the last days in his bunker) lived on both in the affective fantasies of the nuclear Cold War and those of post-9/11 devastation.

Combat Traces at Easy Red

Rapidity of response began early on in the history of war photography. Alan Trachtenberg has suggested that the publication in 1866 of George N. Barnard's American Civil War documentary, *Photographic Views of Sherman's Campaign* (pp.54–5), was 'virtually simultaneous with the event, sealing the final stamp of modernity on the war'.[26] D'Aunay advised the readers of *Les Ruines de Paris* to look at his photographs urgently: '*Pressez-*

ON OMAHA BEACH
David Alan Mellor

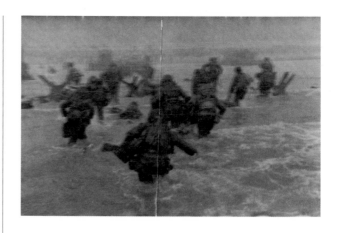

vous … because the monuments are being lost.'[27] Here was a peculiar subjective temporality of 'battle-time' over orthodox 'clock-time' which recapitulated that of the American Civil War.

Adam Broomberg and Oliver Chanarin decided in 2008 to travel as embedded photographers with the British Army to Helmand Province in Afghanistan. There, mindful of established spectacular mythologies surrounding the photography of war, they side-stepped any narrative content of bravery and heroic suffering by picturing nothing. Instead of imprinting their photographic paper with conventional figurative images from the fighting – the suicide bombings, the IED attacks – they de-sensationalised the context by making a single gesture of negation. Just as Marcel Duchamp established an arbitrary, time-based criterion for choosing 'readymade' consumer goods from hardware merchants, without preconceptions of taste or content, so in Helmand, Broomberg and Chanarin decided to expose seven metres of photographic paper to sunlight for twenty seconds, once a day, over a five-day period. Each of those days saw devastating insurgency mayhem, except for the fifth – *The Day Nobody Died* 2008 (pp.6–7). The unfurling of light-sensitive paper created an abstract scroll, with no bodies, no landscape, no action, no scene, no picture, just spectral, jagged colour contours, like the traces of a unknown scientific experiment, beautifully coloured but eternally remote. In doing this they had excavated back to a primal form of photography: the photogram, which registered only light and the time of its own making. They cite Ulrich Baer's simple analysis: 'the single, indisputable truth about any photograph … is not its meaning but its register of time'.[28] This ultra-formalist definition apparently stood in opposition to the intention and meaning of Capa's combat photographs, which he made amid the foreshore surf and pebbles of the Easy Red sector of Omaha Beach in Normandy at the dawn of 6 June 1944, the day of the Allied invasion of Hitler's Fortress Europe. Capa's insistence on being present as a participant-observer in this event in the struggle to overthrow Nazism stemmed from a precise

Robert Capa
Beachheads of Normandy, 6 June 1944
Archive of Modern Conflict, London

project – a total existential commitment: 'The war correspondent has his stake – his life – in his own hands … I am a gambler. I decided to go in with E Company in the first wave.'[29]

That 'first wave' of GIs was decimated by withering machine-gun and shellfire by German troops, entrenched – noted a caption to one of Capa's barely legible photos in *Life* magazine – in 'concrete pill boxes'[30] in the Atlantikwall. These were the same melancholy crypts to which Virilio and Wilson would return to photograph in their postwar afterlife. Capa's pictures in that grey dawn moment became talismanic. So to simulate the chaotic arrival of invading GIs on Omaha Beach for the film *Saving Private Ryan* (1998), the director Steven Spielberg referred to Capa's roughly hewn, kinetic pictures: 'I did everything I could to my camera to get June 6th '44 to look like Bob Capa's photographs.'[31] The experience of being under lethal fire was viscerally transmitted from Capa's shaking body into his pictures; they became testaments of that fraught, supremely dangerous set of affects that Jünger had nominated as components of *Fronterlebnis* – the body's own exhilarated but stressed nervous experience during combat. *Life* magazine excused the illegibility of these photographs on account of 'immense excitement … [which] made photographer Capa move his camera and blur his picture'.[32] Capa's experience on Omaha Beach was a series of shocks to his body and nervous system. A soldier, misinterpreting his hesitation before leaving the landing craft for cowardice, kicked him off the ship. It must have been immediately following this booted jolt, alongside the many shocks of coming under Nazi fire, that Capa pictured the ragged 'V' formation of troops just ahead of him in the surf, their shaking body contours signifying dangerous contingencies and dangerous chances.

It was not only his own shaking body that marred the outline of the soldiers. Another kind of contingency had intervened before the photographs were published. The emulsion on the developed

rolls of film, which had been rushed to London, melted in a drying cabinet in *Life*'s photo-lab. Almost all of his pictures had, effectively, been destroyed, or 'heat-blurred',[33] by an accident far away from the site of combat. Those that survived were muddily distorted. Broomberg and Charnarin have alluded to the virtues of an exposed film in a stressed situation that 'bears the scratches, the effects of light, the environment on its surfaces'.[34] Capa's Omaha Beach photographs bore indexical traces of the process that brought them to *Life*'s readers. The US Signal Corps 'wired' Capa's pictures for free distribution to the Allied press. The prewar technique of sending photographs across continents by wireless and 'radiotelephone' had now become commonplace. Tolerance over the visual 'noise' that accompanied them was factored in. Up to this juncture, *Life* rarely used wire photos, yet such was the premium on immediately bringing records of the violent landings in northern France to readers on both sides of the Atlantic that it made a virtue of their being 'slightly out of focus':[35] this was their guarantee of authenticity. In a comic and ironic twist, Capa would seize upon *Life*'s exculpatory phrase, 'slightly out of focus', to serve as the title of his autobiography in 1947. In the same year, Cecil Beaton went out of his way to praise the high emotional colouring of radioed combat photographs which the British Army Film and Photographic Unit (AFPU), in the run-up to the Battle of El Alemein in 1942, had sent back from the Western Desert to the UK. Beaton was convinced that it was the blurs, the loss of middle tones and the jagged 'noise' of their process that gave them value. Concluding his book *British Photographers* (1944) with reproductions of two of Sgt Len Chetwyn's photos of bayonet charges, he defended them as romantic documents of combat time: 'as pictures they have a real aesthetic interest. When transmitted by radio, the dots and dashes add to, rather than detract from their dramatic effect.'[36]

Trauma was embodied in Capa's beach photographs, supplemented by the transferred indexical traces of his muscle spasms and concussions. He had survived in Easy Red sector on Omaha Beach for a relatively short space of time before experiencing extreme terror: 'I had it bad. The empty camera trembled in my hands. It was a new kind of fear shaking my body from toe to hair, and twisting my face.'[37] After what may have been an hour and a half or just a few minutes, on his own admission he ran away and was then evacuated back to England by boat. By the later stages of the Second World War the phrase 'combat exhaustion' was being used by US and Canadian army medics as a term to denote the stress of war, a precursor to our current diagnosis of Post Traumatic Stress Disorder. On board the boat back to England he was one among many grievous casualties, examined and triage-categorised. A paper label was tied on him as he lay on a stretcher: 'On my neck a piece of paper read "Exhaustion Case: No Dog Tags".'[38] The combat photographer's traumatised body was now a trace of war in itself, just as on Omaha Beach, photograph and trauma were one.

Cecil Beaton
British Photographers, Collins,
London 1944, pp.44–5

NOTES

1 Text from Barbican Art Gallery presentation by Adam Broomberg and Oliver Chanarin, 4 December 2008.

2 Debjani Ganguly, abstract from 'The World Novel, Mediated War and Exorbitant Witnessing', in Ato Quayson (ed.), 'New Topographies of the Post-Colonial', *Cambridge Journal of Postcolonial Literary Inquiry*, no.1. http://geographicalimaginations.com/2014/04/01/exorbitant-witnessing/, accessed 5 June 2014.

3 Ernst Jünger, 'War and Photography', trans. Anthony Nassar, *New German Critique*, no.59, Spring/Summer 1993, pp.24–6, originally published as Ernst Jünger, 'Krieg und Lichtbild', in *Das Antlitz des Weltkrieges: Fronterlebnisse deutscher Soldaten, Mit etwa 200 photo-graphischen Aufnahmen auf Talfeln, Kartenanhang sowie einer chronologischen Kriegeshchicte in Tabelle*, Neufeld & Henius Verlag, Berlin 1930, p.25.

4 Ibid., p.26.

5 See Max Saunders, 'War Literature Bearing Witness and the Problem of Sacralisation: Trauma and Desire in the Writing of Mary Borden and Others', in Elena Lamberti and Vita Fortunato (eds.), *Memories and Representations of War: The Case of World War I and World War II*, Textxet, Amsterdam and New York 2009.

6 'history continues to be determined by catastrophe. History is constantly being broken off'. Dieter Kemper, 'Between Simulation and Negentropy', in Dieter Kemper and Christoph Wulf (eds.), *Looking Back on the End of the World*, Semiotexte, New York 1989, pp.96–105, p.97.

7 Ulrich Baer, *Spectral Evidence: The Photography of Trauma*, MIT, Cambridge MA 2002, p.7.

8 Don McCullin, *Shaped by War*, Jonathan Cape, London 2010, pp.81–2.

9 Enrique Limon, interview with Paul Virilio, in S. Allen and K. Park (eds.), 'Sites and Stations: Provisional Utopias: Architecture and Utopia in the Contemporary City', Lusitania Press, New York 1996, p.51.

10 Ibid.

11 McCullin 2010, p.13.

12 Ibid., p.37.

13 Ibid.

14 John le Carré, *The Spy who Came in from the Cold*, Gollancz, London 1963, p.70.

15 http://www.academia.edu/395857/Trauma_and_Dual_Narratives_in_Jonathan_Safran_Foer_s_Everything_is_Illuminated_2008, accessed 4 April 2014.

16 http://vimeo.com/50164713, accessed 2 March 2014.

17 http://www.galeriaff.infocentrum.com/lewcgb.html, accessed 15 May 2014.

18 Ibid.

19 McCullin 2010, p.96.

20 T.E. Lawrence, 'Guerilla Warfare', in *Encyclopaedia Britannica*, 14th edn, 1929.

ON OMAHA BEACH
David Alan Mellor

21 See Patrick Keillor, *The View from the Train*, Verso, London 2014, p.163.

22 Sandra Plummer, 'Photography and Time Duration', *Rhizomes*, no.23, 2012, http://www.rhizomes.net/issue23/plummer/index.html, accessed 7 April 2014.

23 Henri Bergson, *Matter and Memory* (1896), trans. N.M. Paul and W.S. Palmer, New York 1991, p.30.

24 J.G. Ballard, *The Terminal Beach*, Dent, London 1964, pp.134–55.

25 Paul Virilio, *Bunker Archeology*, Princeton Architectural Press, New York 1996, p.11.

26 Alan Trachtenberg, 'Albums of War: On Reading Civil War Photographs', *Representations*, no.9, Winter 1985, pp.1–32, p.27.

27 See Andy Stafford, *Photo-Texts: Contemporary French Writing of the Photographic Image*, Liverpool University Press, Liverpool 2010, p.174.

28 Baer 2005, p.7, cited in text from presentation by Adam Broomberg and Oliver Chanarin, Barbican Art Gallery, London, 4 December 2008.

29 Robert Capa, *Slightly out of Focus* (1947), Random House, New York 1991, p.137.

30 'Beachheads of Normandy, Crawling through the Water', *Life*, 19 June 1944, p.27.

31 Cited in http://sabotagetimes.com/people/through-a-lens-darkly-robert-capa-and-d-day/, accessed 30 June 2014.

32 *Life*, 19 June 1944.

33 Capa 1991, p.152.

34 cphmag.com/convo-broomberg-charnarin, accessed 12 June 2014.

35 *Life*, 19 June 1944.

36 Cecil Beaton, *British Photographers*, Collins, London 1944, p.48.

37 Capa, 1991, p.148.

38 Ibid., p.149.

ON OMAHA BEACH
David Alan Mellor

Conflict, Time, Photography, both as an exhibition and in this accompanying book, takes us beyond the conventional association of war with photo-journalism and the immediacy of reportage. It shows, by contrast, that not only has the camera been used to document events and their after-effects, but that photography has the power to reflect on the passage of time over the longer term. That as well as depicting action and incident, photographs can sustain deep reflection on moments in the distant past, their repercussions in the present and even possible alternative projected futures. It is to this kind of meditative and principled practice that *Conflict, Time, Photography* turns, not only to tell us about the histories of those who have endured the trauma of war, conflict, destruction and displacement, but to show us the lasting legacies of the people and places that survive. The history of the camera and the photographic medium has developed alongside the drives to improve and refine the mechanical and digital means by which war has been waged. Beyond this parallel, however, what is of most interest to us in this exhibition are the ways in which artists have responded to the effects of such transformations: both in individual works and installations made for gallery walls, but also in the form of photobooks; publications that define the history of the medium.

It is sad but appropriate that *Conflict, Time, Photography* also coincides with the passing away of two major figures whose practice has been defined by the relationship of the imagery of the effects of conflict to the apparatus of the camera. On the one hand Michael Schmidt, whose work *Berlin Nach 45* is a key component of the exhibition and this publication, and who must be counted among the most important postwar photographers; and on the other, Harun Farocki whose investigations of the relationship of military technology to the concept of vision and the production of knowledge have been so important and so influential over the past thirty years. For self-evident reasons we would like to dedicate this exhibition to their memories.

The original concept for this very timely project, and its delivery both as an exhibition and publication were the responsibility of Simon Baker, Curator of Photography and International Art, Tate and Shoair Mavlian, Assistant Curator, Tate Modern, working alongside Professor David A. Mellor of the University of Sussex. But equally we are hugely grateful to Timothy Prus and his colleagues at the Archive of Modern Conflict: Barbara Adams, Tony Cairns, Kalev Erickson, Maria Gafarova, Leo Griffin, Ed Jones, Melanie Mues, Lizzie Powell and James Welch, for their unique and highly original contribution to the exhibition. We also appreciate very much the involvement and collaboration of our tour partners for this exhibition: Tobia Bezzola and his team at Museum Folkwang Essen; and Dr Hartwig Fischer and his team at Staatliche Kunstsammlungen Dresden.

AFTERWORD
Chris Dercon

Achim Borchardt-Hume, Head of Exhibitions at Tate Modern, has offered invaluable advice at each stage of the project. The logistical oversight of the exhibition and tour were the responsibility of Helen Sainsbury, working with Rachel Kent, Carol Burnier and Lucy Fisher; while the exhibition design and installation was overseen by Phil Monk, Rhona O'Brien and Ryszard Lewandowski. We would also like to thank everyone else in the curatorial team at Tate Modern for their contributions behind the scenes, but especially Katy Wan, and the exhibition's intern Cory Scozzari, as well as all our colleagues in the conservation department, press office, design studio and marketing team. Thanks for their exemplary work on this book are due to Judith Severne and her colleagues Bill Jones and Miriam Perez at Tate Publishing, as well as Adam Hooper at Hoop Design, but also Simon Bolitho and his colleagues in the interpretation team; Megan Bullock, Minnie Scott and Corinne Scurr, for their collaboration on the texts for each work.

As always there are also a great many other people and organisations to thank, without whose hard work and support the exhibition would not have been possible. First and foremost the artists and their estates. But we would like to thank the following lenders, as well as those who wish to remain anonymous: Artworkers Retirement Society, David Knaus, Martin Parr, Charles Skinner, Mrs Yasuko Tomatsu, Mr and Mrs Eftihis Vassilakis, Jane and Michael Wilson, Berlinische Gallery, Library of Birmingham, Centre Pompidou Paris, David Roberts Art Foundation, The National Gallery of Canada, Ottawa, Tokyo Metropolitan Museum of Photography, The Victoria and Albert Museum, The Wilson Centre for Photography. For their generous donations to Tate associated with the exhibition we would like to thank: Artworkers Retirement Society, Michael Hoppen, David Knaus, The Roy Lichtenstein Foundation, Jane and Michael Wilson. And for their help with loans: Paul Bonaventura, Ruskin School of Art; Justin Brancato, The Roy Lichtenstein Foundation; Polly Fleury, The Wilson Centre for Photography; Clément Kauter, Placart; Lou Miller, Andrea Rollefson, the staff of Atelier Michael Schmidt: and the following galleries, Gallery Asymetria, Warsaw, Hamiltons Gallery, London, Michael Hoppen Gallery, London, Kalfayan Galleries, Athens and Thessaloniki, Magnum Photos, London, Murray Guy, New York, Parotta Contemporary Art, Stuttgart, Photo Gallery International, Tokyo, Stevenson Gallery, Cape Town and London, François Sage, Paris, Taka Ishii Gallery, Tokyo. The exhibition has been made possible by the provision of insurance through the Government Indemnity Scheme. Tate Modern would like to thank HM Government for providing Government Indemnity and the Department for Culture, Media and Sport and Arts Council England for arranging the indemnity.

Chris Dercon
Director, Tate Modern

AFTERWORD
Chris Dercon

Jules Andrieu 1816–1876
Désastres de la guerre, Hôtel de Ville Galerie des Fêtes
Disasters of War, Hôtel de Ville Galerie des Fêtes
1871
Photograph, albumen print
29 × 37
Sir Benjamin Stone Collection, Library of Birmingham
[pp.18–19]

Pierre Antony-Thouret
Reims au Lendemain de la Guerre
Reims after the War
127 heliogravure plates, published by Jean Baudry, Paris 1927
32.5 × 49 each
Private collection, London
[pp.26–32]

Nobuyoshi Araki born 1940
Tokyo Radiation August 6–15, 2010
2010, printed 2014
Book, published by Wides Shuppan, Tokyo 2010
10 photographs, gelatin silver prints on paper
32.1 × 47.8 each
Collection of the artist, courtesy Taka Ishii Gallery, Tokyo
[pp.166–8]

George N. Barnard 1819–1902
Photographic Views of Sherman's Campaign
1866
Plate 35, *Scene of General McPherson's Death*
Photograph, albumen silver print
25.4 × 36.1
Wilson Centre for Photography, London
[p.52]

Photographic Views of Sherman's Campaign
1866
Plate 44, *Destruction of Hood's Ordnance Train*
Photograph, albumen silver print
25.5 × 35.7
Wilson Centre for Photography, London
[p.53]

Adam Broomberg born 1970
Oliver Chanarin born 1971
The Press Conference, June 9, 2008, The Day Nobody Died
2008
Photograph, unique C-type on paper
72.6 × 600
Courtesy the artists
[pp.6–7]

People in Trouble Laughing Pushed to the Ground
2011
196 photographs, fibre-based prints on paper, 1 digital C-print on paper
25.5 × 20.5 each, and 150 × 190
Courtesy the artists
[pp.76–7]

Luc Delahaye born 1962
US Bombing on Taliban Positions
2001
Photograph, digital C-print on paper
112.4 × 238.8
Tate. Lent by the Tate Americas Foundation, courtesy Jane and Michael Wilson 2012
[pp.2–3]

Ambush, Ramadi
2006
Photograph, digital C-print on paper
166.5 × 240
Wilson Centre for Photography, London
[pp.4–5]

Patio civil, cementero San Rafael, Malága
2009
Photograph, digital C-print on paper
251 × 207.1
Wilson Centre for Photography, London
[pp.180–1]

Chloe Dewe Mathews born 1982
Shot at Dawn
2013
5 photographs, digital C-prints on paper
120 × 150 each
Courtesy the artist. Commissioned by the Ruskin School of Art at the University of Oxford as part of 14–18 NOW, WW1 Centenary Art Commissions
[pp.190–1]

Ken Domon 1909–1990
Hiroshima
Book, published by Kenko-Sha, Tokyo 1958
35.5 × 26.2
Collection Martin Parr
[pp.80–1]

Ken Domon 1909–1990 and
Shomei Tomatsu 1930–2012
Hiroshima–Nagasaki Document
Book, published by The Japan Council Against the A and H bombs, Tokyo 1961
28 × 17.5
Collection Martin Parr
[pp.98–9]

Matsumoto Eiichi 1915–2004
Shadow of a soldier remaining on the wooden wall of the Nagasaki military headquarters (Minami-Yamate machi, 4.5km from Ground Zero)
1945
Photograph, gelatin silver print on paper
31.5 × 20.7
Tokyo Metropolitan Museum of Photography, Tokyo
[pp.16–17]

Roger Fenton 1819–1869
The Valley of the Shadow of Death
1854–5
Photograph, salted paper print from a wet collodion glass negative
25.5 × 34.4
Victoria and Albert Museum, London
[p.34]

The Valley of the Shadow of Death
1856
Photograph, salted paper print from a wet collodion glass negative
28.4 × 35.7
Musée d'Orsay, Paris, France
[p.35]

Ernst Friedrich 1886–1954
Krieg dem Kriege!
War Against War!
Book, published by Freie Jugend, Berlin 1924
2 volumes, 22.7 × 15 each
Private collection, London
[pp.68–9]

Toshio Fukada born 1928
The Mushroom Cloud – Less than twenty minutes after the explosion
1945
2 photographs, gelatin silver print on paper
25.9 × 21.7
Tokyo Metropolitan Museum of Photography, Tokyo
[pp.10–11]

Jim Goldberg born 1953 (and
Kamel Khelif born 1959)
Open See (Democratic Republic of Congo)
2008
Photograph, gelatin silver print and mixed media on paper
Collection of the artist
[pp.64–7]

Kenji Ishiguro born 1935
Hiroshima Now
Book, published by Shinya Sosho-Sha, Tokyo 1970
26 × 24
Collection Martin Parr
[pp.140–1]

Kikuji Kawada born 1933
The Map
1959–65
Installation, 90 photographs, gelatin silver print on paper, Japanese screen and book published by Bijutsu Shuppan-sha, Tokyo 1965
Collection of the artist.
Courtesy PGI Gallery, Tokyo
[pp.112–21]

An-My Lê born 1960
Untitled, Vietnam
1994–8
7 photographs, gelatin silver prints on paper
50.8 × 60.9 each
Courtesy the artist and Murray Guy, New York
[pp.100–3]

Jerzy Lewczyński born 1924
Pessimistic Triptych
1960
Photograph, gelatin silver print on paper
6 × 23
Tate. Purchased with funds provided by the Photography Acquisitions Committee 2013
[pp.82–3]

Wolf's Lair / Adolf Hitler's War Headquarters
1960
12 photographs, gelatin silver prints on paper
9 × 14 each
Galeria Asymetria, Warsaw
[pp.84–7]

Emeric Lhuisset born 1983
I heard the first ring of my death / Homage to Sardasht Osman
2011
Installation, 3 photographs digital C-prints on paper
Courtesy the artist
[pp.52–3]

Don McCullin born 1935
American Troops Looking across the Wall, Berlin
1961, printed later
Photograph, gelatin silver print on paper
37 × 34.5
Tate. Purchased 2012
[p.90, bottom]

East Berlin
1961, printed later
Photograph, gelatin silver print on paper
36.5 × 36.5
Tate. Purchased 2012
[p.92]

East German Guards Looking into West, Berlin
1961, printed later
Photograph, gelatin silver print on paper
37 × 34.5
Tate. Purchased 2012
[p.93]

Friedrichstrasse, Berlin
1961, printed later
Photograph, gelatin silver print on paper
41 × 40
Tate. Purchased 2012
[p.90, top]

Looking into East Berlin
1961, printed later
32.5 × 50.5
Tate. Purchased 2012
[pp.94–5]

Near Checkpoint Charlie, Berlin
1961, printed later
Photograph, gelatin silver print on paper
37.5 × 37.8
Tate. Purchased 2012
[p.91]

The Battlefields of the Somme, France
2000
Photograph, gelatin silver print on paper
29 × 42
Tate. Purchased 2012
[pp.182–3]

Shell-shocked US Marine, Vietnam, Huê
1968, printed later
Photograph, gelatin silver print on paper
152.4 × 102
Courtesy Hamiltons Gallery, London
[pp.8–9]

Agata Madejska born 1979
25–36
2010
Photograph, digital C-print on foam board and varnished MDF
220 × 161
Courtesy the artist and Parrotta Contemporary Art, Stuttgart
[pp.186–7]

Diana Matar born 1962
Evidence
2012–13
15 photographs, gelatin silver prints on paper and text on paper
50.8 × 50.8 each
Courtesy the artist
[pp.50–1]

Susan Meiselas born 1948
Reframing History: Nicaragua 25th Anniversary Mural Project
2004
DVD, 12 minutes
Photographs: Susan Meiselas, Video: Alfred Guzzetti, Sound: Pedro Linger Gasiglia
Courtesy the artist
[pp.136–7]

Simon Norfolk born 1963
Afghanistan: Chronotopia
2001–2
9 photographs, digital chromogenic prints on paper
33 × 43.8 each
Tate. Promised gift of David Knaus
[pp.12–15]

João Penalva born 1949
From the Weeds of Hiroshima
1997
6 photographs, gelatin silver prints and ink on paper
59.2 × 44.7 each
Courtesy the artist and SAGE Paris
[pp.160–1]

Richard Peter 1895–1977
Dresden: Eine Kamera Klagtan
Dresden: A Camera Accuses
1945, published 1949
Book, published by Dresdener Verlagsgesellschaft KG, Dresden, 1949
28 × 24
[pp.46–9]

Walid Raad born 1967
The Atlas Group
My Neck is Thinner than a Hair: Engines
2000–3
100 photographs, digital C-prints on paper and wall text
25 × 35 each
Tate. Purchased using funds provided by the 2004 Outset / Frieze Art Fair Fund to benefit the Tate Collection 2005
[pp.74–5]

Jo Ractliffe born 1961
Terreno Ocupado
2007
Installation, 18 photographs, gelatin silver and inkjet prints on paper
Dimensions variable
Courtesy the Charles Skinner collection and the artist
[pp.58–63]

As Terras do Fim do Mundo
2009-10
Installation, 15 photographs, gelatin silver prints on paper
Dimensions variable
Courtesy the Artworkers Retirement Society, Charles Skinner collection and the artist
[pp.124–5]

Sophie Ristelhueber born 1949
Fait
1992
71 photographs, gelatin silver prints on aluminium
100 × 124 each
National Gallery of Canada, Ottawa. Purchased 2013
[pp.36–45]

Julian Rosefeldt born 1965
Hidden City
1994, printed 2010
28 photographs, gelatin silver prints on paper
Dimensions variable
Courtesy the artist, ARNDT Berlin / Singapore and Barbara Gross Galerie, Munich
[pp.156–8]

Hrair Sarkissian born 1973
istory
2011
3 photographs, archival inkjet prints
150 × 190 each
1 photograph: Private collection, Athens. Courtesy the artist and Kalfayan Galleries, Athens – Thessaloniki
2 photographs: Courtesy the artist and Kalfayan Galleries, Athens – Thessaloniki
[pp.188–9]

Michael Schmidt 1945–2014
Berlin nach 45
1980
55 photographs, gelatin silver prints on paper
16 × 22 each
Berlinische Galerie, Berlin
[pp.144–51]

Ursula Schulz-Dornburg born 1938
Train Stations of the Hejaz Railway
2003
8 photographs, gelatin silver prints on paper
44.4 × 51.2
Tate. Purchased with funds provided by the Photography Acquisitions Committee 2012
[pp.184–5]

Kurchatov – Architecture of a Nuclear Test Site
2012
17 photographs, gelatin silver prints on paper
48.7 × 48.7
Courtesy the artist
[pp.134–5]

Indrė Šerpytytė born 1983
(1944–1991) Former NKVD – MVD – MGB – KGB Buildings
2009
15 photographs, digital C-prints on paper, notebook, wooden sculptures
50 × 60 each
Courtesy the artist and David Roberts Art Foundation
[pp.164–5]

Stephen Shore born 1947
Ukraine
2012–13
36 photographs, C-prints on paper
40.6 × 50.8 each
Promised Gift of Jane and Michael Wilson. Courtesy the Wilson Centre for Photograhy
[pp.172–9]

Shunk-Kender (Harry Shunk
1942–2006 and **János Kender**
1937–1983)
World Tour
c.1960s
25 photographs, gelatin silver prints on paper
27.9 × 35.5 each
Tate. Gift of the Roy Lichtenstein Foundation in memory of Harry Shunk and János Kender 2014
[pp.104–11]

Taryn Simon born 1975
A Living Man Declared Dead and Other Chapters I–XVIII, Chapter VII
2011
Photographs, archival inkjet prints and text
3 parts, overall 213.5 × 302.7
Tate. Lent by the Tate Americas Foundation courtesy Jane and Michael Wilson 2012
[pp.96–7]

A Living Man Declared Dead and Other Chapters I–XVIII, Chapter XI
2011
Photographs, archival inkjet prints and text
3 parts, overall 213.5 × 302.5
Tate. Lent by the Tate Americas Foundation courtesy Jane and Michael Wilson 2012
[pp.170–1]

Shomei Tomatsu 1930–2012
Atomic Bomb Damage: Wristwatch Stopped at 11:02, August 9, 1945, Nagasaki, 1961
1961
Photograph, gelatin silver print on paper
25.3 × 25.1
Tokyo Metropolitan Museum of Photography, Tokyo
[p.131]

Bottle Melted and Deformed by Atomic Bomb Heat, Radiation and Fire, Nagasaki
1961, printed 1991
Photograph, gelatin silver print on paper
34.6 × 32.8
Shomei Tomatsu – Interface, Courtesy Taka Ishii Gallery, Tokyo
[p.128]

Angel Statue Crashed by Atomic Bomb Blast
1961, printed 1998
Photograph, gelatin silver print on paper
35 × 32.7
Shomei Tomatsu – Interface, Courtesy Taka Ishii Gallery, Tokyo
[p.130]

Hibakusha Tsuyo Kataoka, Nagasaki
1961, printed 2000
Photograph, gelatin silver print on paper
27.7 × 40
Shomei Tomatsu – Interface, Courtesy Taka Ishii Gallery, Tokyo
[p.127]

Hibakusha Senji Yamaguchi, Nagasaki
1962, printed 1986
Photograph, gelatin silver print on paper
41.5 × 28.4
Shomei Tomatsu – Interface, Courtesy Taka Ishii Gallery, Tokyo
[p.129]

Steel Helmet with Skull Bone Fused by Atomic Bomb, Nagasaki, 1963
1963
Photograph, gelatin silver print on paper
22.6 × 30.3
Tokyo Metropolitan Museum of Photography, Tokyo
[pp.132–3]

11:02 Nagasaki
Book, published by Shashin dojin-sha, Tokyo 1966
22.5 × 19.8
Collection Martin Parr
[pp.126–7]

Hiromi Tsuchida born 1939
Hiroshima korekushon
Hiroshima Collection
1982–95
6 photographs, inkjet prints on paper
118 × 130; 118 × 160
Courtesy the artist
[pp.152–3]

Marc Vaux 1895–1971
Untitled photograph
1920
Photograph, gelatin silver print on paper
10.1 × 15.2
Bibliothèque Kandinsky, Centre Pompidou, Paris
[pp.66–7]

Paul Virilio born 1932
Bunker Archéologie
1975
10 photographs, gelatin silver prints on paper
20.3 × 25.4 each
Bibliothèque Kandinsky, Centre Pompidou, Paris

Bunker Archéologie
Bunker Archaeology
Book, published by Centre Georges Pompidou, Paris 1975
24 × 20
Collection Martin Parr
[pp.122–3]

Kurt Vonnegut, Jr 1922–2007
Slaughterhouse-Five
Book, published by Delacorte Press, New York 1969
21.5 × 14.3
Private collection, London
[pp.194, 203]

Nick Waplington born 1965
Wir leben wie wir träumen: allein
We live as we dream, alone
1993
7 photographs, digital C-prints on paper
101.6 × 152.4 each
Collection of the artist
[pp.154–5]]

Jane Wilson born 1967
Louise Wilson born 1967
Biville
2006
Photograph, laserchrome print on aluminium
180 × 180
Tate. Purchased 2011
[p.163]

Urville
2006
Photograph, laserchrome print on
aluminium
180 × 180
Tate. Purchased 2011
[p.162]

ANONYMOUS

Les Vandales en France
The Vandals in France (Special Issue
of *L'Art et les Artistes* 1914–15)
Magazine, Paris 1915
30.4 × 20.8
Private collection, London
[pp.20–1]

Rheims and the Battles for its Possession
Book, published in the series
*Illustrated Michelin Guides to the
Battlefields 1914–18*, Clermont-
Ferrand & London 1919
20.5 × 14
Private collection, London
[pp.22–3]

Les Champs de Bataille de France
The Battlefields of France
Book, published by Les Chemins de
Fer du Nord et de l'Est c.1919
21.5 × 13.7
Private collection, London
[pp.22–3]

Reims à Soissons
Reims to Soissons
Postcard book, published by
Editions Reims Cathedrale, c.1919
8.9 × 14.8
Private collection, London
[pp.24–5]

Verdun: Guide Historique Illustré
Verdun: Illustrated Historic Guide
Book, published by Michelin,
Clermont-Ferrand (n.d.) c.1919
13.5 × 21
Private collection, London
[pp.22–3]

Hiroshima: Scenes of A-Bomb Explosion
Book, published 1953
90 × 90
Collection Martin Parr
[pp.70–1]

VARIOUS AUTHORS

*Living Hiroshima: Scenes of A-Bomb
Explosion*
Book, published by the Hiroshima
Tourist Association, Hiroshima 1948
9 × 26
Collection Martin Parr
[pp.56–7]

Hiroshima 1960
Book, published by Mugishobo,
Tokyo 1960
26 × 18
Collection Martin Parr
[pp.88–9]

The Testimony of Nagasaki
Book, published by Nihon Realism
Shashinshudan, Nagasaki Genbaku
Hiensha Kyogikai, Nagasaki 1970
25.8 × 18.7
Collection Martin Parr
[pp.138–9]

Hiroshima Hiroshima Hiroshima
Book, published by The Association
of Student Photographers of Japan,
1972
24 × 18
Collection Martin Parr
[pp.142–3]

ARTISTS BOOKS

Araki, Nobuyoshi. *Skyscapes.* Hatje Cantz, Ostfildern 1999

Araki, Nobuyoshi. *Araki.* Heibonsha, Tokyo 2000

Araki, Nobuyoshi. *Tokyo Radiation, August 6–15, 2010.* Wides Shuppan, Tokyo 2010

Araki, Nobuyoshi. *Self, Life, Death.* Phaidon, London 2011

Barnard, George N. *Photographic Views of Sherman's Campaign.* Dover Publications, New York 1977

Broomberg, Adam, and Oliver Chanarin. *People in Trouble Laughing Pushed to the Ground.* Mack, London 2011

Broomberg, Adam, and Oliver Chanarin. *War Primer 2.* Mack, London 2011

Broomberg, Adam, and Oliver Chanarin. *Holy Bible.* Mack, London 2013

Broomberg, Adam, and Oliver Chanarin. *Dodo.* Mack, London 2014

Delahaye, Luc. *Luc Delahaye: 2006–2007.* Steidl, Göttingen 2011

Dewe Mathews, Chloe. *Shot at Dawn.* Ivorypress, Madrid 2014

Domon, Ken. *Hiroshima.* Kenko-sha, Tokyo 1958

Domon, Ken. *Living Hiroshima.* Tsukiji Shokan, Tokyo 1982

Fenton, Roger, and Richard Pare. *Roger Fenton (Masters of Photography).* Aperture, New York 1987

Fenton, Roger. *Roger Fenton: Photographer of the 1850s.* Hayward Gallery, London 1988

(Fenton, Roger) Baldwin, Gordon. *All the Mighty World: The Photographs of Roger Fenton 1852–1860.* Yale University Press, New Haven 2004

Goldberg, Jim, and Wolf Böwig. *War Is Only Half the Story: The Aftermath Project.* Aperture, New York 2008

Goldberg, Jim. *Open See.* Steidl, Göttingen 2009

Kawada, Kikuji. *Theatrum Mundi.* Tokyo Metropolitan Museum of Photography, Tokyo 2003

Kawada, Kikuji. *Chizu / The Map* (1965). Reprint, G ha, Tokyo 2005

Kawada, Kikuji. *Chizu / The Map* (1965). Reprint, Akio Nagasawa, Tokyo 2014

Lê, An-My, and Richard B. Woodward. *An-My Lê: Small Wars.* Aperture, New York 2005

Lewczyński, Jerzy, and Krzysztof Jurecki. *Jerzy Lewczyski: 'Archeologia fotografii': prace z lat 1941–2005.* Kropka, Września 2005

Lhuisset, Emeric. *Souvenirs de Syrie.* [Self-published] 2013

McCullin, Don. *The Destruction Business.* London, Macmillan 1971

McCullin, Don. *Is Anyone Taking Any Notice?* MIT Press, Cambridge, MA 1973

McCullin, Don, and Susan Sontag. *Don McCullin.* Jonathan Cape, London 2003

McCullin, Don. *Shaped by War.* Jonathan Cape, London 2010

McCullin, Don. *The Impossible Peace.* Skira, Milan 2012

McCullin, Don. *Don McCullin.* The Archive of Modern Conflict, London 2013

Madejska, Agata. *Agata Madejska.* Distanz, Berlin 2013

Matar, Dana. *Evidence.* Schilt Publishing, Amsterdam 2014

Matsumoto, Eiichi. *Gangā: haha naru indo no seiga Matsumoto eiichi shashinshū,* Tokyo 2002

Meiselas, Susan. *Encounters with the Dani: Stories from the Baliem Valley.* International Center of Photography, New York 2003

Meiselas, Susan, and Claire Rosenberg. *Nicaragua: June 1978 – July 1979.* Aperture, New York 2008

Meiselas, Susan. *Susan Meiselas: In History.* International Center of Photography, New York 2008

Norfolk, Simon. *Afganistan Zero.* Peliti Associati, Rome 2002

Norfolk, Simon. *Afghanistan Chronotopia.* Dewi Lewis Publishing, Stockport 2002

Norfolk, Simon and John Burke. *Burke + Norfolk: Photographs from the War in Afghanistan.* Dewi Lewis Publishing, Stockport 2011

Penalva, João. *João Penlava.* CAM / Fundaçao Calouste Gulbenkian, Lisbon, 2011

Raad, Walid. *The Atlas Group and Walid Raad: My Neck is Thinner than a Hair: Documents from The Atlas Group Archive.* Walther König, Cologne 2005

Raad, Walid. *Scratching on Things I Could Disavow.* Culturgest, Lisbon 2007

Ractliffe, Jo, and Okwui Enwezor. *Terreno ocupado.* Warren Siebrits, Johannesburg 2008

Ractliffe, Jo. *As terras do fim do mundo / The Lands of the End of the World.* Michael Stevenson, Cape Town 2010

Ristelhueber, Sophie, and Marc Mayer. *Fait: Koweit 1991.* Errata Editions, New York 2008

Ristelhueber, Sophie, David Mellor, and Bruno Latour. *Operations: Sophie Ristelhueber.* Thames & Hudson, London 2009

Rosefeldt, Julian, and Bert Rebhandl. *Living in Oblivion.* Kerber, Bielefeld 2010

Sarkissan, Hrair, and Murtaza Vali. *Extra/ordinary: The Abraaj Group Art Prize 2013.* Art Dubai, Dubai 2013

Schmidt, Michael, and Thomas Weski. *U-ni-ty.* Scalo, Zurich 1996

Schmidt, Michael, and Janos Frecot. *Berlin Nach 1945.* Steidl, Göttingen 2005

Schmidt, Michael, and Thomas Weski. *89/90.* Snoeck, Cologne 2010

Schulz-Dornburg, Ursula. *Architectures of Waiting: Photographs. Bus Stops in Armenia Train Stops of the Hejaz Railway in Saudi Arabia.* Walther Konig, Cologne 2007

Schultz-Dornburg, Ursula, and Wolfgang Scheppe. *Ursula Schulz-Dornburg: Some Works.* Hatje Cantz Verlag, Ostfildern 2014

Šerpytytė, Indrė. *1944–1991. Indrė Šerpytytė,* London 2010

Shore, Stephen, and Christy Lange. *Stephen Shore.* Phaidon Press, London 2007

Simon, Taryn, and Homi Bhabha. *A Living Man Declared Dead and Other Chapters, I–XVIII*. Mack, London, and SMB, Berlin 2011

Simon, Taryn. *An American Index of the Hidden and Unfamiliar*. Steidl, Gottingen, 2007

Tomatsu, Shomei, and Ken Domon. *Hiroshima–Nagasaki Document 1961*. The Japan Council against Atomic and Hydrogen Bombs, Tokyo 1961

Tomatsu, Shomei. *Nagasaki 11:02, 1945* (1966). Reprint, Photo Musee / Shinchosha, Tokyo 1995

Tomatsu, Shomei. *Traces: Fifty Years of Tomatsu's Work*. Tokyo Metropolitan Museum of Photography, Tokyo 1999

Tomatsu, Shomei. *Chewing Gum and Chocolate*. Aperture, New York, 2014

Tsuchida, Hiromi. *Hiroshima Collection*. Hiroshima Peace Memorial Museum, Tokyo 2007

Tsuchida, Hiromi. *Hiroshima Monument II*. Tosei-sha, Tokyo 1995

Virilio, Paul, and George Collins. *Bunker Archeology*. Princeton Architectural Press, New York 1994

Waplington, Nick. *Settlement*. Mack, London 2014

Waplington, Nick. *Wir leben wie wir träumen: allein We live as we dream, alone*. Mörel Books, London 2014

Wilson, Jane, Louise Wilson and Darian Leader. *Jane & Louise Wilson*, Haunch of Venison, Zurich 2007

FURTHER READING

Addison, Paul, and Jeremy A. Crang. *Firestorm: The Bombing of Dresden 1945*. Pimlico, London 2006

Akçam, Taner. *The Young Turks' Crime against Humanity: The Armenian Genocide and Ethnic Cleansing in the Ottoman Empire*. Princeton University Press, Princeton, NJ 2013

Allawi, Ali A. *The Occupation of Iraq: Winning the War, Losing the Peace*. Yale University Press, New Haven, CT 2007

Anderson, Scott. *Lawrence in Arabia: War, Deceit, Imperial Folly and the Making of the Modern Middle East*. Anchor, New York 2014

Azoulay, Ariella. *The Civil Contract of Photography*, Zone Books / MIT Press, New Haven 2012

Babington, Anthony. *For the Sake of Example: Capital Courts-martial, 1914–1920*. Rev. edn, Leo Cooper, London 1993

Baer, Ulrich. *Spectral Evidence: The Photography of Trauma*, MIT Press, Cambridge, MA 2002

Barfield, Thomas J. *Afghanistan: A Cultural and Political History*. Princeton University Press, Princeton, NJ 2010

Batchen, Geoffrey (ed.) *Picturing Atrocity: Photography in Crisis*, Reaktion, London 2012

Beevor, Antony. *The Battle for Spain: The Spanish Civil War, 1936–1939*. Penguin Books, New York 2006

Brittain, Victoria. *Death of Dignity: Angola's Civil War*. Pluto Press, London 1998

Brothers, Eric. *Berlin Ghetto: Herbert Baum and the Anti-Fascist Resistance*. Spellmount, Stroud 2012

Caputo, Philip. *A Rumor of War*. Pimlico, London 1999

Chielens, Piet, and Julian Putkowski. *Unquiet Graves: Execution Sites of the First World War in Flanders. Guide*. Francis Boutle, London 2000

Coll, Steve. *Ghost Wars: The Secret History of the CIA, Afghanistan, and Bin Laden, from the Soviet Invasion to September 10, 2001*. Penguin Books, New York 2005

Coogan, Tim Pat. *The Troubles: Ireland's Ordeal, 1966–1996, and the Search for Peace*. Palgrave for St Martin's Press, New York 2002

Corns, Cathryn, and John Wilson. *Blindfold and Alone: British Military Executions in the Great War*. Cassell, London 2005

Crawford, Alex. *Colonel Gaddafi's Hat: The Real Story of the Libyan Uprising*. Collins, London 2012

Davenport, Meredith. *Theatre of War*, Intellect Books, London 2014

Deibert, Michael. *The Democratic Republic of Congo: Between Hope and Despair*. Zed Books, London 2008

Devlin, Larry. *Chief of Station, Congo: Fighting the Cold War in a Hot Zone*. PublicAffairs, New York 2007

Dyer, Geoff. *The Missing of the Somme*. Phoenix Press, London 2001

Ean, Grigoris, and Peter Balakian. *Armenian Golgotha*. Alfred A. Knopf, New York 2009

Engel, Jeffrey A. *Into the Desert: Reflections on the Gulf War*. Oxford University Press, Oxford 2012

Enwezor, Okwui. *Archive Fever: Uses of the Document in Contemporary Art*, International Center of Photography, New York 2008

Farrell, J.G., and John Banville. *Troubles* (1970). Reprint, New York Review of Books, New York 2002

Figes, Orlando. *The Crimean War: A History*. Picador, New York 2012

Fink, Carole. *Cold War: An International History*. Westview Press, Boulder, CO 2014

Finlan, Alastair. *The Gulf War 1991*. Osprey Publishing, Oxford 2003

Freedman, Lawrence, and Efraim Karsh. *The Gulf Conflict 1990–1991: Diplomacy and War in the New World Order*. Princeton University Press, Princeton, NJ 1995

Friedman, Thomas L. *From Beirut to Jerusalem*. 1st edn, Farrar, Straus, Giroux 1989

Fussell, Paul. *The Great War and Modern Memory* (1975). Reprint, Oxford University Press, New York 2000

Gaddis, John Lewis. *The Cold War: A New History*. Penguin Press, New York 2005

Gross, Jan Tomasz. *Revolution from Abroad: The Soviet Conquest of Poland's Western Ukraine and Western Belorussia*. Expanded edn, Princeton University Press, Princeton NJ 2002

Ham, Paul. *Hiroshima Nagasaki: The Real Story of the Atomic Bombings and their Aftermath*. Thomas Dunne Books, New York 2014

Harvey, Frank P. *Explaining the Iraq War: Counterfactual Theory, Logic and Evidence*. Cambridge University Press, Cambridge 2012.

Hayden, Tom. *The Zapatista Reader*. Thunder's Mouth Press/Nation Books, New York 2002

Hersey, John, and Jack Foreman. *Hiroshima*. Recorded Books, Clinton, MD 1982

Herwig, Holger H. *The Marne, 1914: The Opening of World War I and the Battle that Changed the World*. Random House, New York 2009

Hilsum, Lindsey. *Sandstorm: Libya in the Time of Revolution*. Penguin Press, New York 2012

Hyslop, Stephen G., Neil Kagan, and Andrew Harris. *Atlas of Civil War: A Comprehensive Guide to the Tactics and Terrain of Battle*. National Geographic Society, Hanover, NH 2008

Jaeger, Stephan, and Elena Baraban, eds. *Fighting Words and Images: Representing War Across the Disciplines*, University of Toronto Press, Toronto 2012

Jawad, Rana. *Tripoli Witness*. Gilgamesh, London 2011

Jones, Ed, and Timothy Prus. *Nein, Onkel: Snapshots from Another Front 1938–1945*, Archive of Modern Conflict, London 2007

Kapuściński, Ryszard, and William R. Brand. *Another Day of Life*. Vintage Books, New York 2000

Karnow, Stanley. *Vietnam: A History*. 2nd revised and updated edn, Penguin Books, New York 1997

Kaufmann, J.E. *The Atlantic Wall: History and Guide*. Pen & Sword Military, Barnsley 2011

Kaufmann, J.E., and H.W. Kaufmann. *Fortress Third Reich: German Fortifications and Defense Systems in World War II*. Da Capo, Cambridge, MA 2007

Kelly, Cynthia C. *The Manhattan Project: The Birth of the Atomic Bomb in the Words of its Creators, Eyewitnesses, and Historians*. Black Dog and Leventhal Publishers, New York 2007

Kennedy, Liam, and Caitlin Patrick. *The Violence of the Image: Photography and International Conflict*, I.B. Tauris, London 2014

Khadduri, Majid, and Edmund Ghareeb. *War in the Gulf, 1990–91: The Iraq–Kuwait Conflict and its Implications*. Oxford University Press, Oxford 2001

Kinzer, Stephen. *Blood of Brothers Life and War in Nicaragua*. Harvard University Press, London 2007

Kraus, Karl. *In These Great Times: A Karl Kraus Reader*, Carcanet Press, New York 1984

Langley, Andrew. *Hiroshima and Nagasaki: Fire from the Sky*. Compass Point Books, Minneapolis 2006

Lieven, Anatol. *The Baltic Revolution: Estonia, Latvia, Lithuania and the Path to Independence*. 2nd edn, Yale University Press, New Haven 1994

Linfield, Susie. *The Cruel Radiance: Photography and Political Violence*, University of Chicago Press, Chicago 2012

Mackey, Sandra. *Lebanon: A House Divided* (1989). Reprint, W.W. Norton, New York 2006

McKittrick, David, and David McVea. *Making Sense of the Troubles: The Story of the Conflict in Northern Ireland*. New Amsterdam Books, Chicago 2002

Marx, Karl. *Writings on the Paris Commune* (1871). Reprint, Red and Black Publishers, St Petersburg, FL 2008

Merewether, Charles. *The Archive Documents of Contemporary Art*, Whitechapel, London 2006

Meyer, G.J. *A World Undone: The Story of the Great War, 1914–1918*. Bantam Dell, New York 2007

Murphy, David. *The Arab Revolt 1916–18: Lawrence Sets Arabia Ablaze*. Osprey, Oxford 2008

Murray, Williamson, and Robert H. Scales. *The Iraq War: A Military History*, Belknap Press of Harvard University Press, Cambridge, MA 2003.

Nolan, Keith William. *Battle for Huê: Tet, 1968* (1996). Presidio Press, Novato, CA 1983

Nori, Franziska, and Walter Guadagnini (eds.). *Territori Instabili: Confini E Identità Nell'arte Contemporanea / Unstable Territory: Borders and Identity in Contemporary Art*, Mandragora, Florence 2013

Preston, Paul. *The Spanish Civil War*. Rev. edn, W.W. Norton & Co., London 2007

Putkowski, Julian, and Julian Sykes. *Shot at Dawn: Executions in World War One by Authority of the British Army Act*. 7e dr. ed., Leo Cooper, London 1997

Quesada, A.M. *The Spanish Civil War 1936–39*. Osprey Publishing, Oxford 2014

Rabinovich, Itamar, and Itamar Rabinovich. *The War for Lebanon, 1970–1985*. Rev. edn, Cornell University Press, Ithaca 1985

Rabinowitz, Or. *Bargaining on Nuclear Tests Washington and its Cold War Deals*. Oxford University Press, Oxford 2014

Richards, Anthony. *Report of the War Office Committee of Enquiry into 'Shell-shock' (Cmd. 1734): Featuring a New Historical Essay on Shell Shock*. Imperial War Museum, London 2004

Rosenheim, Jeff L. *Photography and the American Civil War*, Yale University Press, New Haven 2013

Royle, Trevor. *Crimea: The Great Crimean War, 1854–1856*. Palgrave Macmillan, New York 2000

Rubin, Barnett R. *Afghanistan in the Post-Cold War Era*. Oxford University Press, Oxford 2012

Sacco, Joe. *Safe Area Goražde: The War in Eastern Bosnia 1992–95*. Fantagraphics Books, Seattle, WA 2000

Sacco, Joe, and Adam Hochschild. *The Great War: July 1, 1916. The First Day of the Battle of the Somme – An Illustrated Panorama*. W.W. Norton & Co., New York 2013

Senn, Alfred Erich. *Lithuania 1940: Revolution from Above*. Rodopi, Amsterdam 2007

Shafer, David A. *The Paris Commune: French Politics, Culture, and Society at the Crossroads of the Revolutionary Tradition and Revolutionary Socialism*. Palgrave Macmillan, New York 2005

Shapiro, Susan, and Ken Trebincevic. *The Bosnia List: A Memoir of War, Exile, and Return*. Penguin Books, New York 2014

Sherman, William T., and Brooks D. Simpson. *Sherman's Civil War: Selected Correspondence of William T. Sherman, 1860–1865*. University of North Carolina Press, Chapel Hill, NC 1999

Sompel, Ronald van de, and Belgium Louvain. *Art and Culture in Times of Conflict: Contemporary Reflections*, M-Museum, Leuven 2014

Sontag, Susan. *Regarding the Pain of Others*, Penguin, London 2004

Stallabrass, Julian (ed.). *Memory of Fire: Images of War and the War of Images*, Photoworks, Brighton 2013

Sumner, Ian, and Graham Turner. *The First Battle of the Marne, 1914: The French 'Miracle' Halts the Germans*. Osprey, Oxford 2010

Taylor, Frederick. *Dresden: Tuesday, 13 February 1945*. Bloomsbury, London 2005

Thomas, Nigel, and Darko Pavlovic. *Germany's Eastern Front Allies (2): Baltic Forces*. Osprey Military, Oxford 2002

Thomson, David (ed.). *82*, Archive of Modern Conflict, London 2013

Toal, Gerard, and Carl Dahlman. *Bosnia Remade: Ethnic Cleansing and its Reversal*. Oxford University Press, New York 2011

Tollebeek, Jo., and Eline van Assche (eds.). *Ravaged: Art and Culture in Times of Conflict*, Yale University Press, New Haven 2014

Troubetzkoy, Alexis S. *A Brief History of the Crimean War: The Causes and Consequences of a Medieval Conflict Fought in a Modern Age*. Robinson, London 2006

Trudeau, Noah Andre. *Southern Storm: Sherman's March to the Sea*. Harper Perennial, New York 2008

Tuchman, Barbara Wertheim. *The Guns of August* (1964). Reprint, Ballantine, New York 2004

Tucker, Anne Wilkes, and Will Michels. *War/Photography: Images of Armed Conflict and its Aftermath*, Museum of Fine Arts, Houston, and Yale University Press, New Haven 2012

Turner, Thomas. *The Congo Wars: Conflict, Myth, and Reality*. Zed Books, London 2007

Vorkian, Raymond H. *The Armenian Genocide: A Complete History*. I.B. Tauris, London 2011

Weigert, Stephen L. *Angola: A Modern Military History, 1961–2002*. Palgrave Macmillan, New York 2011

Wilson, A.N. *Hitler*. Basic Books, New York 2012

Zimmermann, Matilde. *Sandinista: Carlos Fonseca and the Nicaraguan Revolution*. Duke University Press, Durham NC 2000

First published 2014 by order of the Tate Trustees
by Tate Publishing, a division of Tate Enterprises Ltd,
Millbank, London SW1P 4RG
www.tate.org.uk/publishing

Edited by Simon Baker and Shoair Mavlian
With contributions by
David Alan Mellor, Simon Bolitho, Megan Bullock,
Minnie Scott, Corinne Scurr

on the occasion of the exhibition
CONFLICT·TIME·PHOTOGRAPHY
The Eyal Ofer Galleries, Tate Modern, London
26 November 2014–15 March 2015

Museum Folkwang, Essen
10 April–5 July 2015

Staatliche Kunstsammlungen Dresden
31 July–25 October 2015

A catalogue record for this book is available from the British Library

ISBN 978 1 84976 320 2

Distributed in the United States and Canada by ABRAMS,
New York

Library of Congress Control Number applied for

Designed by hoopdesign.co.uk
Colour reproduction by DL Imaging Ltd, London
Printed and bound in Italy by Industria Grafica SIZ srl

Front cover: Richard Peter, *Dresden after Allied Raids, Germany* 1945
(see pp.46–9)
Back cover: Shomei Tomatsu, *Steel Helmet with Skull Bone Fused by
Atomic Bomb, Nagasaki, 1963* 1963 (pp.132–3)
Inside covers: Kikuji Kawada, *The Map* 1959–65 (detail; see pp.112–13)

Measurements of artworks are given in centimetres, height before
width

FSC
www.fsc.org
MIX
Paper from
responsible sources
FSC® C005613